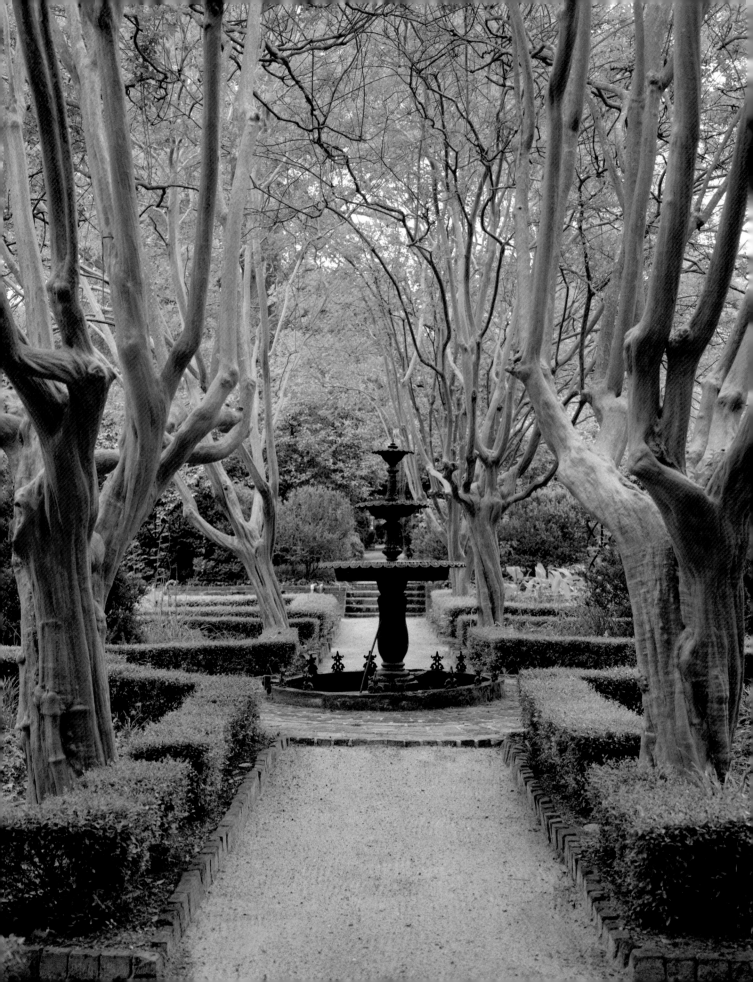

A n n L i b e r m a n

Governors' Mansions
of the South

Photographs by Alise O'Brien

Foreword by Governor Jeb Bush

University of Missouri Press Columbia and London

Library of Congress Cataloging-in-Publication Data

Liberman, Ann, 1940–
 Governors' mansions of the South / Ann Liberman ; photographs by Alise O'Brien ; foreword by Governor Jeb Bush.
 p. cm.
 Summary: "Explores the history, architecture, and furnishings of the thirteen magnificent governors' mansions of the
American South. Emphasizing the mansions themselves, Ann Liberman describes each building's architectural history,
including renovations, in light of the history of each state. Alise O'Brien's lavish color photographs illuminate the inte-
riors and exteriors of the mansions"—Provided by publisher.
 Includes bibliographical references and index.
 ISBN 978-0-8262-1785-1 (alk. paper)
 1. Governors—Dwellings—Southern States. 2. Governors—Dwellings—Southern States—Pictorial works. 3.
Mansions—Southern States. 4. Historic buildings—Southern States. 5. Architecture, Domestic—Southern States. 6.
Interior decoration—Southern States. 7. Southern States—History, Local. I. O'Brien, Alise. II. Title.
 F210.L53 2008
 725'.17'0975—dc22
 2008005825

♾™ This paper meets the requirements of the
American National Standard for Permanence of Paper
for Printed Library Materials, Z39.48, 1984.

Design and Composition: Jennifer Cropp
Printer and binder: Four Colour Imports, Ltd.
Typefaces: Minion, Bembo, and Medici Script

To Lee and our nine grandchildren:

David

Michael

Jeanne

Zoey and Babe

Jessen

Ben

Annabelle

and

Charlotte

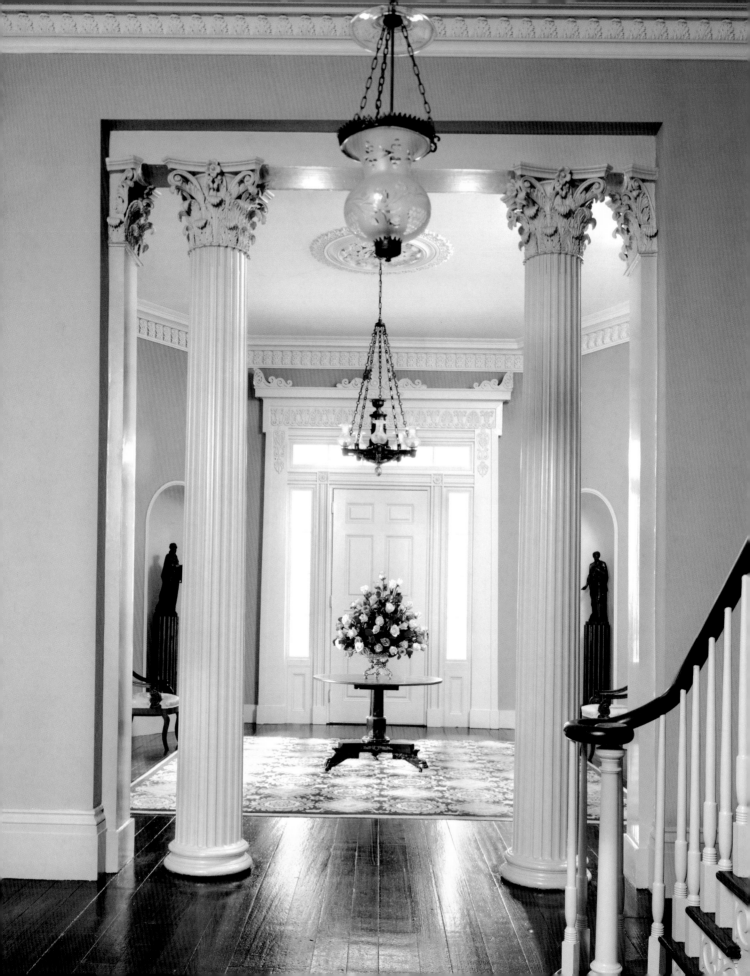

Contents

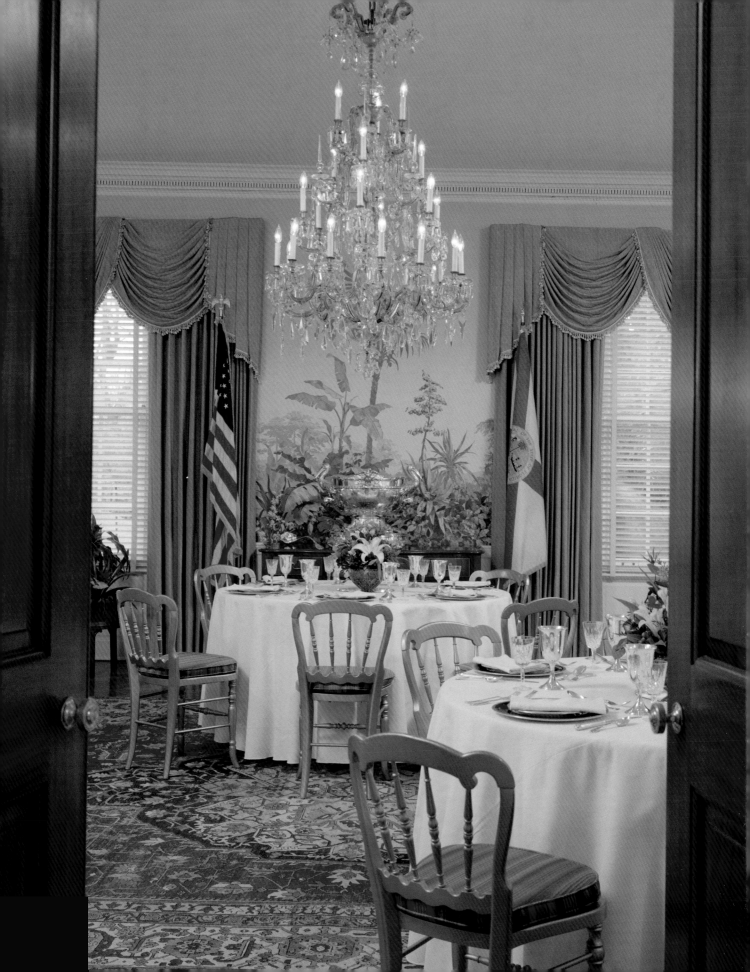

Foreword

By Governor Jeb Bush

Ann Liberman's *Governors' Mansions of the South* is a splendid book that reveals through words and pictures the architecture, the lore, the traditions, and the symbolism of these historic public homes.

The interesting stories of these edifices—how their locations were chosen, how they were designed and decorated, how they were financed, the images they were intended to convey, and how they have been preserved, lost, and transformed over the years—is a tangible reflection of broader historic, social, political, and economic trends in the South.

These buildings also provide a more personal connection between the public and their government. Thousands of visitors every year visit the homes they provide as the public residences for their elected leaders. Living in the Governor's Mansion is a remarkable honor, but it is also a constant, humbling reminder that the people who occupy the mansions are, indeed, the public's servants.

My family and I were privileged for eight years to call "the People's House" in Florida home. The Governor's Mansion in Florida, like all governors' mansions, is a very special place, combining grand public spaces and gardens with the technology needed to govern and the personal privacy of a residence. What makes it all work is the dedicated curators and staff who manage these unique facilities over many years, while governors come and go.

Enjoy this book, and take the time to pay a visit to some of these unique and historic executive mansions.

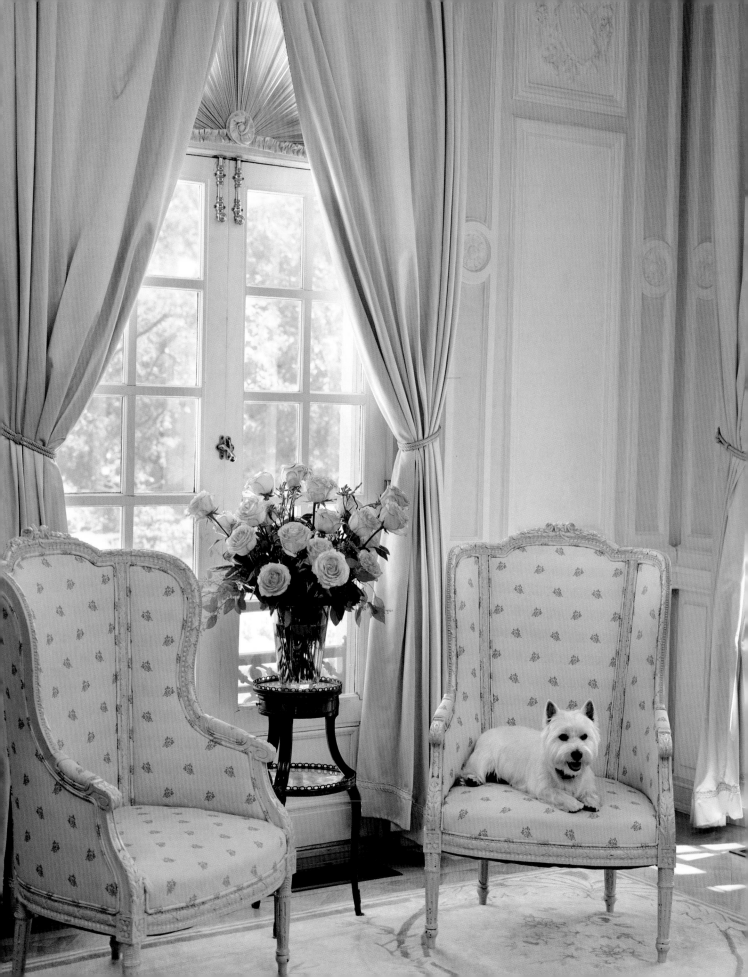

Acknowledgments

I thank all the governors' families for their cooperation in allowing their homes to be photographed. Photography in these mansions is disruptive for a day or a day and a half, and I deeply appreciate the efforts and hospitality of their mansion staff.

I sincerely thank the University of Missouri Press and its great staff, including Beverly Jarrett, Jane Lago, Karen Renner, Dwight Browne, and Julianna Schroeder. Their enormous help and effort have made this project possible.

The cooperation of numerous people in these mansions has made things run smoothly, and I thank the following individuals particularly: in Alabama, First Lady Patsy Riley, her assistant, Lea Southern, and mansion administrator Lucile Waller; in Arkansas, Governor Mike Huckabee, First Lady Janet Huckabee, Don Bingham, and current administrator Ron Maxwell; in Georgia, First Lady Mary Perdue, former mansion director Sharon Burrow, Natalie Strong, press assistant to Governor Perdue, Heather Hedrick Teilhet, press secretary to Governor Perdue, and Roderick A. Hardy, A.S.A.; in Kentucky, Kenny Bishop, mansion director, and Katherine Montague, administrative assistant; in Louisiana, Governor Kathleen Blanco, Irene Shepherd, governor's mansion coordinator; in North Carolina, B. J. (Betty Jo) Stephens, former executive assistant to the first lady, and Amanda Williams, present executive assistant to the first lady; in Tennessee, Jody Folk, first lady's assistant; in Texas, Ellen Read, mansion administrator, and Jane Karotkin, Friends of the Governor's Mansion administrator; in Virginia, Amy Bridge, mansion director, and the assistant to the mansion director, Laura Moffett; and in West Virginia, Governor Joe Manchin III, First Lady Gayle Manchin, and Sheree Kesler, mansion director.

I am overwhelmed by the helpfulness of the mansion curators who gave so much of their time to this project: Carol Graham Beck of Florida, Nancy Bunch of South Carolina, and Mary Lohrenz of Mississippi. No matter how many favors I asked, they immediately and cheerfully responded. I have relied heavily on them.

I am also grateful to Rickie L. Brunner, Department of Archives and History in Alabama; Roderick A. Hardy, ASA, of Hardy/Halpern, Inc., Atlanta, Georgia, appraisers; Peggy Hunt,

Foundation for Historical Louisiana; Lucy Allen, director of the Museum Division, Mississippi Department of Archives and History; and James E. Wootten, executive director, Capitol Square Preservation Council, Richmond, Virginia. I also thank Christopher Stewart, the Butler Center, Little Rock; Mike Brubaker, Atlanta History Center; and Ruth Cole for her help in Mississippi.

My sincere gratitude goes to those who have given generously of their personal knowledge and firsthand experience with these mansions: Ridley Wills II, Tish Fort Hooker, Margaret A. Lane, and former first lady Margaret Godwin.

Nothing brightens up a book like good photography. I am honored to once again be able to present the gifted work of Alise O'Brien, my stepdaughter, whose stellar photography conveys the real magnificence of these historic mansions; her one-of-a-kind images are consistently fabulous. My deepest thanks go to her and to her invaluable assistant Teanne Chartrau and former assistant Matt Hughes. I also thank photographers Eric Beggs of Austin and Cramer Gallimore of Raleigh. A special kind of thanks goes to Abby, the West Highland terrier in the photograph facing the acknowledgments, and her trainer, Allyson Buchta. Abby is a Kentucky star, belonging to Governor and Mrs. Ernie Fletcher.

I greatly appreciate Governor Jeb Bush for his words of inspiration. Governor and Mrs. Bush truly appreciate the impact and the importance of governors' mansions in our history and for our future.

Finally, I thank my friends and family. Among them is a former teacher of mine who didn't know at the time that he was a deciding factor in my book-writing life. Robert W. Duffy, the former long-term cultural news editor and architectural critic for the *St. Louis Post-Dispatch*, is currently a professor of journalism at Washington University in St. Louis and associate editor of *Platform*. He is my best critic and one of my favorite people.

Wonderful friends who have been particularly helpful in so many different ways are too numerous to mention, but they know who they are and how deeply grateful and touched I am by their generosity. Another special thanks goes to those who have opened new doors for me. They are Ellen and John Wallace of St. Louis, Mary Ruth Shell of Nashville, Mary Tucker Cassell of Albuquerque, and Ellen and Ewell Muse of Austin.

Last, I appreciate the understanding of my family. While this project has been a labor of love and fun for me, my absenteeism has sometimes been untimely for them. Yet they have maintained their interest in the project and provided good cheer.

Governors' Mansions
of the South

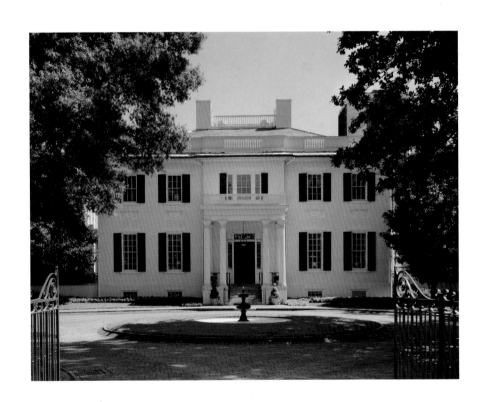

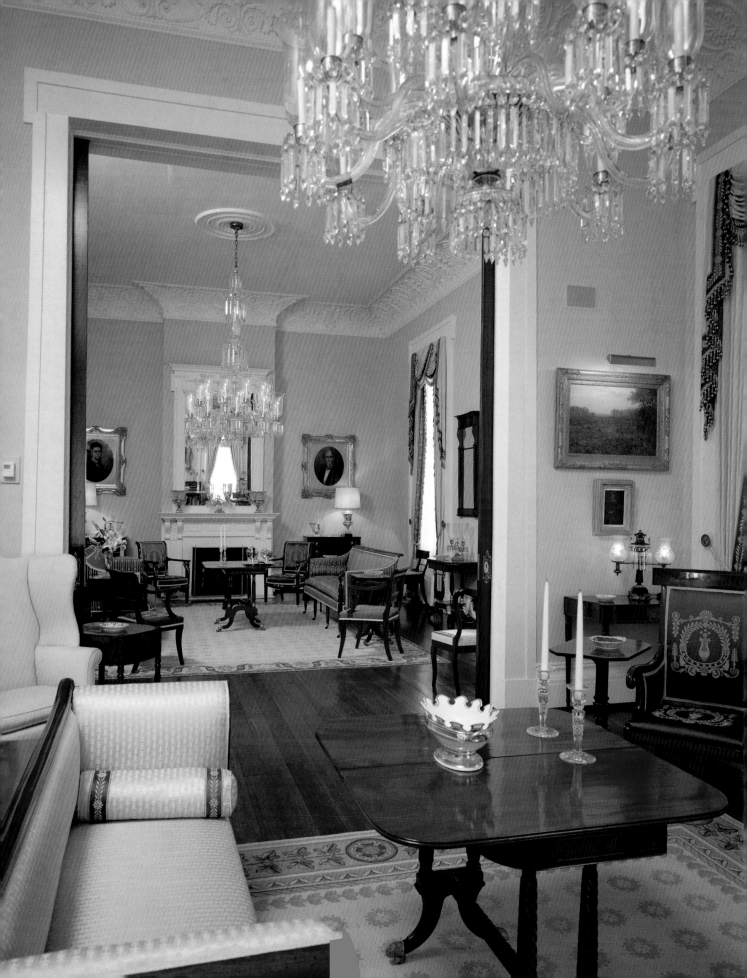

Introduction

I have a long-standing interest in architectural history, and a few years ago I decided to write about some very important buildings—the governors' mansions of our various states. I decided on a regional approach, and because I live in Missouri, it made sense to start with the Midwest. The first book, *Governors' Mansions of the Midwest*, was published in 2003 by the University of Missouri Press and covered twelve states ranging from Ohio to Kansas to North Dakota.

In this second book, *Governors' Mansions of the South*, I have defined the South as the original eleven Confederate States, plus Kentucky and West Virginia, since they are generally regarded as southern states. This book thus covers thirteen of our nation's states, and the two books together cover half of the states in our country.

I chose the South for my second book because of my close association with both Texas and Florida, having grown up in the former and now living part time in the latter, but of course I was also attracted to the gracious, refined architecture of the antebellum South.

Before writing the Midwest book, I thought there would be regional similarities in the houses and, as I mentioned in that book, I discovered that idea was false—there is a great diversity in architectural styles in the midwestern governor's mansions. In the South, however, I discovered the governors' mansions exhibited more architectural similarity than is true of those in the Midwest. The early Georgian, Federal, and Greek Revival styles so common in the South imbue those antebellum houses with a classical solidity. Although the Victorian era of architecture gave rise to irregular, asymmetrical house styles, which were popular in the Midwest and the Northeast, these styles were rarely seen in the destitute South, whose languishing post–Civil War economy precluded most building. Only one governor's mansion—North Carolina's, built in 1890—is a Queen Anne style denoting that era.

America's idea of housing its governors in a style that befits their station is an inherited tradition with European roots. England's royalty lived and lives in palaces, and France and Spain have had their castles. When the adventurers from these countries came to America they

brought their traditions. The governors from the ruling countries called their residences governor's palaces. This was true, for example, in British colonial Virginia, North Carolina, and Spanish colonial Texas. As a political extension and a cultural follower of Virginia, Kentucky named its original 1797 residence the governor's palace.

After the American Revolution, and particularly after the War of 1812, when the British troops burned our new capital city of Washington, Americans were no longer inclined to emulate British culture and discontinued calling their governors' houses palaces. They generally substituted the less-royal word mansion, in line with ideals of their new democracy. Our nation wanted to provide fine residences for governors that would not be lavish or grandiose. Individual states, proud of their accomplishments, wanted their governors to live in a style that reflected their station, and in a house that symbolized the state's progress, but without an appearance of palatial opulence.

The oldest governor's residence in this country that has been continually used for its intended purpose is that of Virginia. Begun in 1811 in the Federal style, it closely follows an English style of architecture called the Adam style. Thomas Jefferson's strong dislike of English architecture and his adherence to the styles of ancient Rome and Greece motivated him to attempt to influence the architecture of that intended governor's mansion. His proposal was considered too monumental for the times, and the present Federal style house was built as originally planned.

Five of the southern governors' mansions that still survive today were built in the 1800s. Four of these are antebellum: Mississippi, South Carolina, Texas, and Virginia. The Mississippi and Texas houses are Greek Revival, and they also have been continually in use as governors' mansions since their construction. Three of the antebellum houses—Mississippi, Texas, and Virginia—are particularly notable and have been designated National Historic Landmarks.

Houses built between 1820 and 1860 reflected the ancient world of Greek classicism. In *American House Styles,* John Milnes Baker, AIA, summarizes the cultural impulses behind this architectural revival: "America felt both a kinship with the democratic ideals of the 5th century B.C. and an empathy with the modern Greeks who fought their own war of independence from the Turks between 1821 and 1830." So it was that buildings inspired by the architecture of ancient Greece and the Roman Empire flourished in the South.

Four of the mansions—those of Alabama, Kentucky, Tennessee, and West Virginia—were built between the turn of the twentieth century and 1931. In the Beaux Arts era of architecture, wealthy industrialists built expensive, opulent homes that proudly displayed their success. The eclectic styles imitated European great houses or palaces. The Classical designs revived Colonial and European styles. These formal houses were built away from the noise and clamor of the city, in parklike utopian areas.

The four remaining mansions covered in this book were built near the middle of the twentieth century. All represent revival architecture: three are Greek Revivals (one being a Colonial Greek Revival), and the fourth is a Georgian Colonial Revival. The Greek Revivals were inspired by the architecture of earlier beloved Greek Revival buildings.

State and Mansion Reference

State	Joined Union	Current Governor's Mansion Completed
Alabama	1819	1907
Arkansas	1836	1950
Florida	1845	1956
Georgia	1788	1967
Kentucky	1792	1914
Louisiana	1812	1963
Mississippi	1817	1841
North Carolina	1789	1891
South Carolina	1788	1855
Tennessee	1796	1931
Texas	1845	1856
Virginia	1788	1813
West Virginia	1863	1925

In 1962, when Jackie Kennedy used television to introduce the world to the interior of the White House, she opened the door of the drawing room to showcase fine arts at their very best and paved the way for serious historical preservation in this country. Her interest in history and aesthetics and her efforts and determination to preserve the best inspired many first ladies of governors' mansions to adopt high standards for historic preservation. This added to the legacies of their state mansions.

Mrs. Kennedy enlisted her friend and advisor Henry F. du Pont, founder of the Winterthur Museum in Delaware, to be the chairman of the newly formed Fine Arts Committee for the White House. As a serious collector of the finest eighteenth- and early-nineteenth-century American furniture and objects, du Pont brought impeccable scholarship to the project. In choosing the finest furnishings for the White House, the committee acquired or retained the best of each era to preserve part of America's heritage. In following that example, many governors' mansions have established mansion-preservation trusts not only to raise money for important acquisitions and to collect with meaning, but also to maintain authentic furniture from the early years of the governor's mansion. This is a departure from earlier, informal times when first ladies were tempted to overload a house with the fashion of the time, or to change the decor or furniture on a whim.

In the elite houses of our highest elected officials, the past and the present will always come together. The state's heritage is symbolically maintained by the preservation of historic objects and furnishings. For example, Texas has preserved Sam Houston's bed and Stephen F. Austin's

desk, and these objects somehow make these men's lives more "real" to us. Knowing that particular heroes had lived at one time in these houses dramatizes history and gives it concrete detail. But these houses are not merely displays of a kind of "living past." As the center of a sitting governor's private and public life, and as the home for a state's future governors, the governor's mansion is a multigenerational symbol that daily connects people from the past, the future, and the present.

Alabama
Governor's Mansion

National Register of Historic Places

Location: 1142 South Perry Street, Montgomery

Construction Year: 1907

Cost: $100,000.★

Size: 8,700 square feet

Number of Rooms: 17

Architect: Weatherly Carter

Architectural Style: Classical Revival

Furniture Style: Reproductions in the Queen Anne
and Chippendale styles and American Empire antiques

★ Cost to state when purchased in 1950; there
are no records of the original cost of the house.

When in 1540 the harsh conquistador Hernando de Soto and his band of 500 fearless Spaniards were trekking through the Deep South searching for gold they attacked the Choctaw near present-day Montgomery. Fighting a fierce all-day battle, Chief Tuscaloosa's men outnumbered de Soto's but suffered defeat—more than two thousand of them perished while engaged in one of the bloodiest battles between Indians and Europeans fought on the continent.

The Spanish explorers made only temporary settlements; the first permanent one in what is now Alabama was made by the French in 1702 when, after discovering Dauphin Island, the brothers Iberville and Bienville planted a colony north of what is today the city of Mobile. In 1711 it was moved downriver to its present location. At that time, Alabama was part of the Louisiana Territory, and Mobile was the seat of government of the territory until 1722, when the territorial capital was moved to New Orleans.

About the time that English settlers began moving into what is now northern Alabama, a series of wars was raging between Great Britain and France that continued until 1763. That year, Alabama and areas east of the Mississippi River came under British rule under the terms of the Treaty of Paris. While the thirteen original colonies were moving closer to a break with England, the citizens of Alabama had little interest in revolution. Their life under British rule was largely tranquil and secure.[1]

After the American Revolution, Alabama was fought over, passed around, and divided up; in 1798, Congress created the Mississippi Territory, which included most of present-day Alabama and Mississippi except for a sliver along the Florida Panhandle and the Gulf of Mexico. In 1817, when Mississippi entered the Union, Alabama became its own territory, and two years later it also entered the Union as the twenty-second state.

Huntsville, only a temporary capital from the outset, served for less than a year when the official site moved to Cahaba, which, with its propensity for flooding, residents soon realized was a poor choice. In 1827, the capital then moved to Tuscaloosa and remained there for almost twenty years. Then, the citizens of Montgomery convinced the legislature to move the capital one final time. Montgomery was a growing river town of about 3,800 located on the Alabama River and the Federal Road, amid fertile farmland.[2] If the town's position as a major shipping and transportation center with a strong cotton market did not provide enough reason for the relocation, the persuasive city fathers won over the legislature by paying not only the moving expenses from Tuscaloosa to Montgomery, but also the construction costs of a new capitol building. Montgomery became the new capital in 1846.

With the formation of the Confederate States of America in 1861, Montgomery functioned as the first capital of the Confederacy. Within five months, the new Confederacy moved to Richmond, which was more central to the action of the war. In losing its role as the seat of the

1. Daniel Savage Gray, *Alabama: A Place, a People, a Point of View*, 13.
2. Mills Lane, *Architecture of the Old South: Mississippi and Alabama*, 85.

Confederate government, Montgomery became somewhat removed from the line of fire that would be levied on key military targets. War came to the northern part of the state in 1862, but Union troops did not capture Montgomery until 1865.

At war's end, the economic heart of Alabama had been torn out. The state was shattered and on the threshold of bankruptcy. Military rule replaced home government, and when Reconstruction in Alabama ended in 1874, it closed the era of the carpetbag government that had spent much to renew and extend the railway system. In response to the devastating economic panic of 1873, Governor David Peter Lewis had been able to wipe away 75 percent of the state's railroad debt. This gave him a bit of new support from the claimants of runaway carpetbag spending.

New institutions in the 1880s and 1890s boosted the state's outlook. Alabama created its Department of Agriculture to promote newer farming methods and to encourage migration to the area. The abundant mineral resources inspired the opening of new mines, including coal, and ironworks. The transformation of Alabama pig iron into steel created speculative growth as well as real corporate profits.

During its first ninety-two years of statehood, Alabama offered its governors no dedicated official residence. Some governors lived in rented places, some in their own homes, and some in houses leased by the state. But in 1911, the state purchased the elegant residence of the successful and wealthy merchant Moses Sabel. Credit for the purchase goes to Governor Emmett O'Neal of Florence, a son of former governor Edward Asbury O'Neal. Emmett, a lawyer and classical scholar who was considered the state's first scholar-governor, created a larger capitol complex, including the residence for the governor.[3] In 1912, he became the first of nine governors to live in that house. The brick-and-stone two-story French house with a mansard roof, built in 1906 of Beaux Arts design, became a victim of benign neglect until it was too run-down to continue as a governor's residence. A proposal to renovate was rejected in 1948 because the State Capitol Building Commission did not consider the house worth the investment. In 1959, the state sold the property, and the house was demolished in 1963 to make way for Interstate 85 through Montgomery. The last governor to live in the old house was "Big Jim" Folsom, who played a pivotal role in acquiring the present governor's mansion.

Today's mansion, built in 1907 in an era of resurrected styles of architecture, is in the Classical Revival style. The revival of earlier architectural styles gained great popularity in the early twentieth century. Architects frequently combined styles, and many of these buildings were imbued with Greek Revival and Neoclassical elements. The house is officially considered Classical Revival, but it contains Greek Revival, Colonial Revival, and Neoclassical details.

Robert Fulwood Ligon Jr., a wealthy Alabama attorney and a brigadier general of the

3. Edward Asbury O'Neal III, grandson of Emmett, became a key agricultural advisor to President Franklin D. Roosevelt and was president of the National Farm Bureau. *Fortune Magazine* called him "the most spectacular farm leader in the U.S." (Gray, *Alabama*, 217).

Alabama National Guard, was a son of a veteran of the Civil War who had later served as lieutenant governor of Alabama. General Ligon commissioned architect Weatherly Carter to create a landmark period house for his family, and the resulting home became known as one of Montgomery's finest and most elegant mansions. General and Mrs. Ligon lived there until their deaths over forty years later.

When "Big Jim" Folsom occupied the governor's residence, a few blocks south of the Ligon mansion, he was inspired by the look of the big white two-story house with its raised terrace across the front and sides. On one of his usual neighborhood strolls, he met the widow Aileen Ligon and mentioned to her his esteem for the house and his thoughts that it would make an excellent governor's mansion. His interest stemmed from what he considered the perfect neighborhood, historic and fashionable; the house being only a short distance from the old governor's mansion, which was still in use; and the home's very southern and colonial look, which he felt perfectly symbolized the state. When Mrs. Ligon died in 1950, her daughter and the state reached a final agreement on the price of $100,000 for the mansion. Governor Gordon Persons was the first governor to live in the new acquisition. When he spent $132,000 of the state's money to renovate the house, the press and the public complained. But when Governor Persons opened the house for a public reception attended by some six thousand visitors, the reports were complimentary.

Governor Folsom returned to office in 1954, and the state purchased the house and lot adjoining the rear of the governor's residence. This purchase added considerably to the mansion property, and over the years, more additions provided privacy, parking, an office building, and a swimming pool in the shape of the state of Alabama. In 1959, a wrought-iron-and-brick wall and two brick gatehouses were added.

The imposing white governor's mansion has four fluted towering columns and an ornate recessed second-story balcony with roof pediment. The balcony has iron grillwork. A full-height portico dominates the facade. Flanking one side of the house is a porte cochere while the other side has a sunporch. Among the windows in the front are two that are arched with ornate entablature. Technically the columns and their capitals are of the Composite order, although some mansion descriptions refer to them as Corinthian. The Composite is of the Roman order and combines the Corinthian and the Ionic. But some of today's architects consider the Composite (or Roman) as a variety of the Corinthian rather than a separate order.[4]

Many Greek Revival features can be seen on the interior as well as the exterior of the house. There are two stairs descending from the upstairs landing of the grand staircase; these meet and create a wide stair that cascades to the first floor. This elaborate stair is beautifully ornate and is complemented by the parquet floors and the exceptional room moldings of the stately and graceful entrance foyer. The antique crystal chandelier over the grand stair and the chandelier in the dining room both originally hung in the old Grunwald Hotel in New Orleans. Additional

4. John H. Parker, *A Concise Dictionary of Architectural Terms*, 181–82.

fluted pilasters in the entry frame the entrances to the public rooms. Their capitals are gilded.

Upon entering the house, one notices the natural light flooding the grand entrance hall and staircase, maximizing the brightness of the spacious interior. The first parlor on the left, previously a library, is now designated the First Ladies' Parlor. In 1968, Lieutenant Governor Albert Brewer replaced Governor Luraleen Wallace, who died of cancer while in office. In this room, First Lady Martha Brewer installed portraits of former first ladies who had lived in this governor's mansion; Luraleen Wallace's portrait is also here, as she had been a first lady as well as a governor.

The living room of the mansion is also the music room, an elegant and formal space. With the continuation of the parquet floors, the ornate grand piano, the gold leaf floor-to-ceiling pier mirrors, and the pink marble surrounding the fireplace, the room shows off its genteel old age to the finest advantage. The mirrors, lights, fireplace, and wall sconces are original to the house and were put there by the first owners, General and Mrs. Ligon. The medallions and cornices reminiscent of the Greek Revival are present throughout the rooms.

In 1963, Governor George Wallace began the first of four terms as governor. Two of them were successive and two were separated by sixteen years. In 1967, his wife and first lady, Luraleen, became governor and served a partial term before her death in 1968. When George Wallace returned to office in 1971, State Representative Walter Owens sponsored a bill to form the Governor's Mansion Advisory Board, which began its work in 1972. Mansion renovation received an allocation of $100,000, but the money was necessarily diverted when the attempt on Governor Wallace's life left him confined to a wheelchair. A large part of the renovation funds were then needed to install an elevator and in other ways increase its handicap-accessibility.

In May 1963, Luraleen Wallace had officiated at the groundbreaking for a second governor's mansion in Gulf Shores, Alabama. The land was donated by developers, and the construction costs were largely paid for by residents of that area, which created very little capital expense for the state. Unfortunately, in 1979, hurricane Frederick practically destroyed it. Due to restrictive ownership complexities, the damaged house has not been repaired nor used by the governors for twenty-five years.

The National Register of Historic Places added the Alabama governor's mansion in November 1972. Along with this honor the house became eligible for federal funds. This source, Housing and Urban Development, provided matching money of $100,000, and the state provided $200,000. This major renovation began in 1974 and lasted two years. On November 9, 1972, an article in the *Clayton Record*, described the building's historical and architectural importance: "Although the Governor's Mansion has served as the official state residence of six Alabama governors, it is also recognized as one of the finer examples of Neo-Greco-Roman Classic Revival architecture in Alabama."

In 1977, Governor Wallace's second wife, Cornelia, started Friends of the Mansion to raise private money for furnishings from the periods 1820 to 1907, particularly seeking items with a history relating to former governors. Some monies were raised, but after the Wallaces' divorce, the organization faded for lack of leadership within the governor's mansion.

In 1984, the porte cochere columns and moldings were replaced. The Roman Ionic original columns had complemented the Composite ones on the portico and those of the pilasters around the exterior of the house. The replacements, of the Greek Ionic order, are less ornamental, and the decorative molding of the entablature is also minimized. Despite this technicality, enough design remains to command attention—open balustrades around the perimeter of the roof draw the eye upward and over to the mansion itself, where its beauty shines down from the height of the slight hill containing elegant old trees and fine landscaping.

From time to time over the years, Alabamans have considered building a new governor's mansion. But feasibility studies to determine whether to retain and enhance the governor's mansion or to build anew have resulted in recommendations to stay put.

Meanwhile, there have been other developments. When the house next door became available for purchase and renovation, it presented the opportunity for expansion. Thus the adjoining property was purchased for $350,000 by the Friends of the Alabama Governor's Mansion in the year 2000 after five months of fund-raising. This "friends" organization was unrelated to the earlier group started by Mrs. Wallace and shows there have been conscientious efforts of different individuals and groups over the years. Their achievements can be seen in the fetching appearance of the governor's residence today.

Governor and Mrs. Bob Riley moved into the mansion in 2003 and began initiating programs and events in the residence to make it more open to the public as well as to raise money for important mansion needs. On their arrival, the Rileys had the public spaces repainted and the furniture reupholstered; in general, they saw to general renovation work that had not been done in a long while. Regarding the next-door property, the Hill House, that is now a part of the governor's mansion complex, First Lady Patsy Riley announced a plan to raise money for the restoration of that house, which will be used as an event space; the restoration process is under way at the time of this writing.

When discussing the house's history and occupants in a general way, Mrs. Riley expressed a belief in the importance of the evolving changes to the house as different governors' families rotate through it. She did not feel that the house should always conform to one look, color, or decorative style, but that it should represent the various lives and styles of its occupants.[5]

Montgomery today has moved a long way from the days of the Confederacy and the Montgomery Bus Boycott. The city remains respectful of its history but refuses to stagnate; its present and future are bright with industry and manufacturing. The magnolias, a timeless part of the landscape, still blossom and give shade not just at the governor's mansion but all over the city. The spirit of home and garden transcend the particulars of history. Amid the old azaleas and Spanish moss, southern manners and hospitality convey a sense of calm and kindness, as if to say, "This is how it was meant to be, in this restful old southern city."

5. Patsy Riley, interview with author, June 14, 2005.

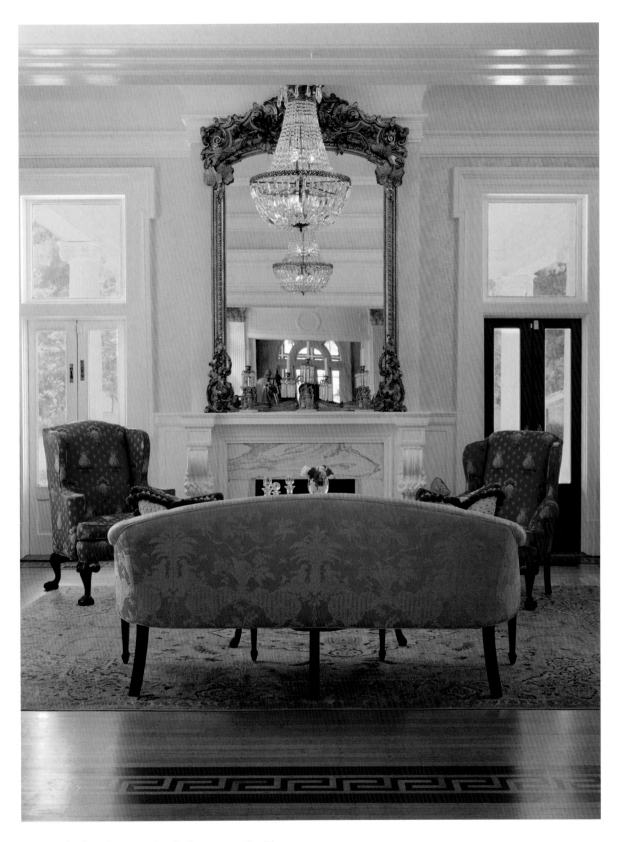

First Ladies' Parlor, previously known as the library.

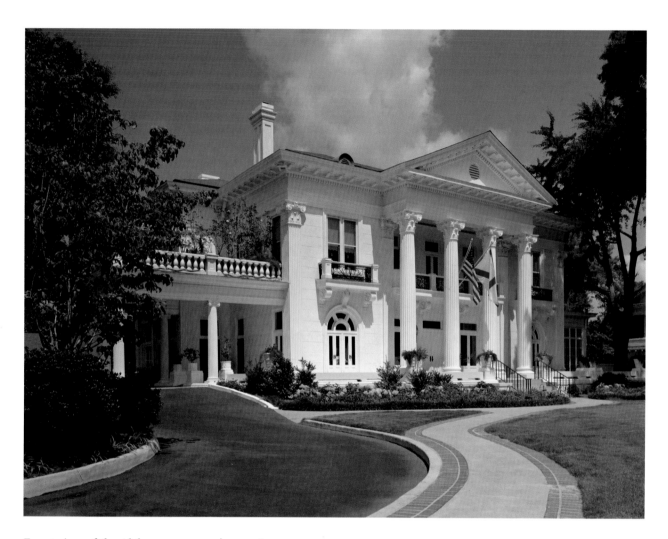

Front view of the Alabama governor's mansion.

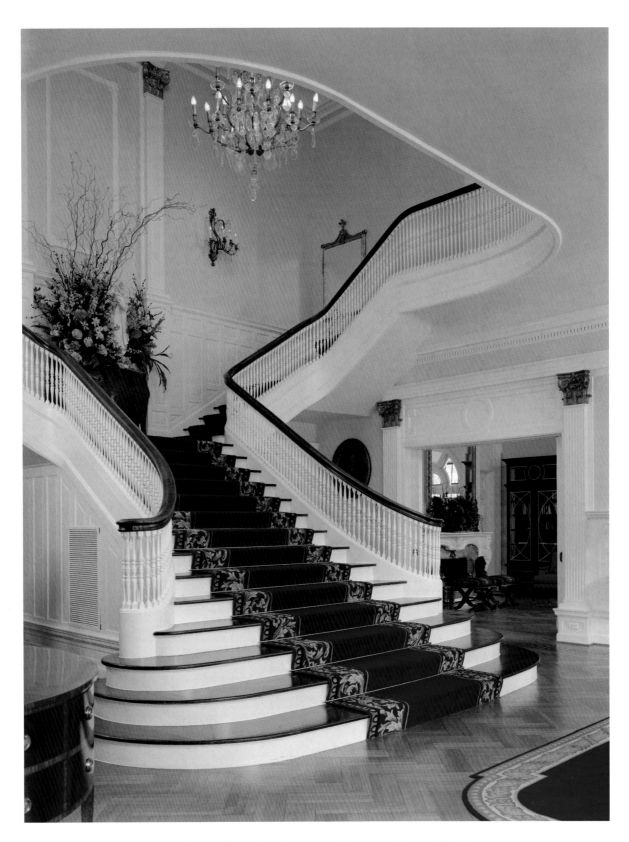

Main foyer, showing the grand stair that splits into two staircases at the first landing.

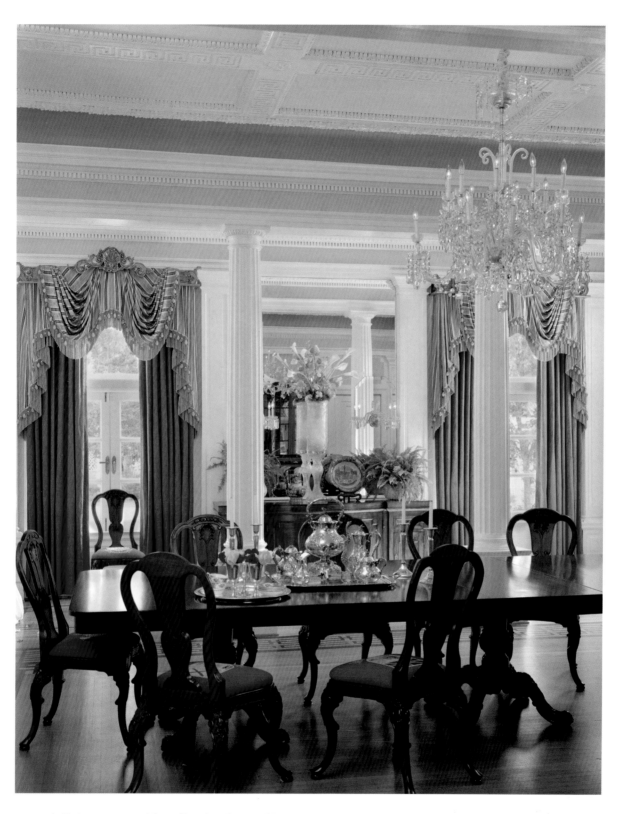

Formal dining room, with coffered ceiling, gilded columns, and
marble fireplace, with enclosed porch in the background.

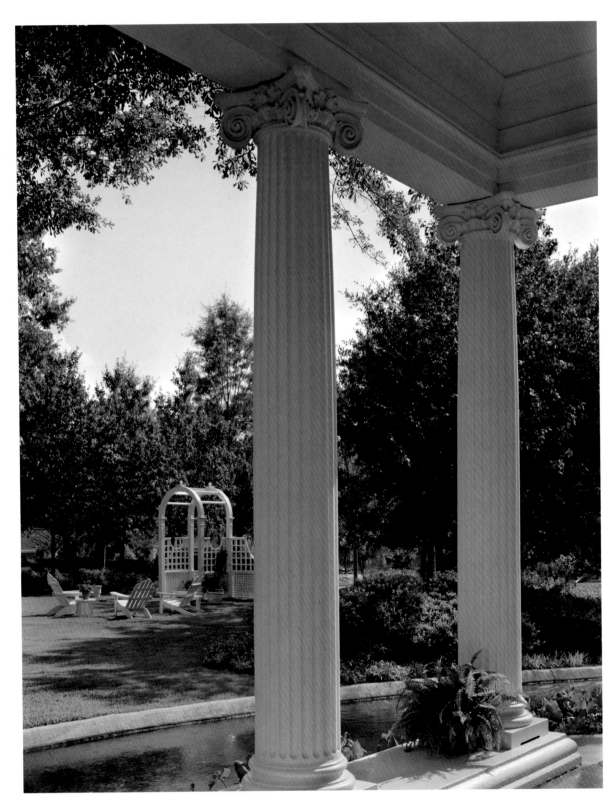

View of side garden, looking from the porch through
the columns, with gazebo in background.

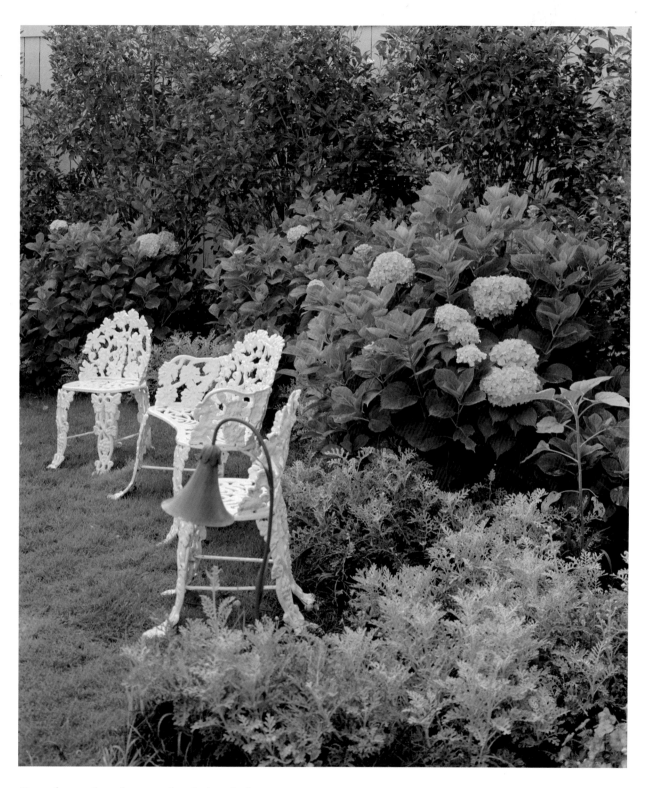

One of several garden areas bordering the house.

Arkansas
Governor's Mansion

Location: 1800 Center Street, Little Rock

Construction Year: 1950

Cost: $197,000

Size: 23,863 square feet

Number of Rooms: 16

Architects: Frank J. Ginocchio Jr. and Edwin B. Cromwell

Architectural Style: Georgian Colonial

Furniture Style: Eighteenth- and nineteenth-century
American and English antiques and reproductions mostly
in the Empire style, including some Chippendale pieces

When René-Robert Cavelier, Sieur de La Salle claimed the Mississippi River Valley for France and named it Louisiana for his king, Louis XIV, the vast area included Arkansas. It was, however, not La Salle, but his second lieutenant, Henri de Tonti, who established the first permanent European settlement in what is now the state of Arkansas in 1686 on the wetlands that form the source of the Arkansas River just above its confluence with the Mississippi River. De Tonti set up a small trading post, naming it the Arkansas Post. This region of Arkansas was occupied by the Quapaw Indians, and de Tonti's settlement became the dominant village in Arkansas and remained so until the 1800s. France had ceded Arkansas to Spain in 1762 but regained possession in 1800. In 1803 the area was sold by France to the United States as part of the Louisiana Purchase, and in 1819 the Arkansas Territory became its own entity, with Arkansas Post as its first capital.

Two years later, a new location for the capital was cleared and settled. Also located on the Arkansas River, the site had moved upriver from Arkansas Post to the center of the territory. The settlement was named Little Rock—distinguishing its location from that of a noted landmark two miles upstream known as Big Rock. The town would become the principal city of the future state. At the time of Little Rock's founding, the choice of the site was politically motivated. The politicians and speculators who had pressed for the Little Rock site outmaneuvered their competitors, who were promoting another small city named Cadron, located on the Arkansas River about twenty-five miles above Little Rock. Substantial tracts of cheap land attracted speculators, who purchased property with the belief that the capital would move there. These speculators were rewarded richly by transferrable land rights, but these transactions were complicated by serious property title disputes. Amid the confusion, the small town of Little Rock was almost dismantled and relocated. But by the close of 1821, the year in which Little Rock was founded, the situation had quieted and the following appeared in the *Arkansas Gazette*:

> Until within a few weeks, the title to the tract of land selected as the town site, has been in dispute; but, happily for the place, and the Territory generally, the parties concerned became sensible of the propriety of settling their conflicting claims in an amicable manner, which they have done, and the soil is now free from dispute.[1]

Arkansas, a rural frontier land, gained admission as a state in 1836. Its economy, based on the production of cotton, created wealth for those in the state's southeastern plantation regions. The federal government granted land for a capitol building in Little Rock on a site that included five sections of land. The site was later sold to Governor William S. Fulton and is now the Governor's Mansion Historic District, which includes the old part of town, the Quapaw area, as well as the governor's mansion.

By 1840, Little Rock's population reached 1,500; goods and services were imported by steamship and stagecoach; and construction of large new buildings and brick homes was well

1. Quoted in Dallas T. Herndon, *Why Little Rock Was Born*, 153.

under way. Meanwhile, the aspiring new state had organized the Bank of the State of Arkansas and overexpanded its system with new banks. By 1843, business was cut off when the bank failed. Without a credit system, the state was unable to invest in or develop its resources.

Governor William S. Fulton, the last territorial governor in Arkansas and the state's first Democratic U.S. senator after statehood, had by 1840 built a Greek Revival house on his newly acquired property. He named his homestead Rosewood and provided in his will that the house be deeded to the state for a School for the Blind, after the deaths of himself and his wife.

When Arkansas officially seceded from the Union during the Civil War, its economic condition was already weak. After the Confederates lost the Battle of Pea Ridge in 1862, the Union army took control of much of the state, and by 1863, the North occupied Little Rock. After the war ended in 1865, Arkansas endured more difficult times due to Reconstruction, which divided the states of the South into military districts and subdistricts governed by federal military appointees. The military government controlled elections, appointments, and voter registration, sometimes denying those who had engaged in Civil War rebellion. During Reconstruction, railroad development added more state debt and more loss of credit. The financial insecurity caused by the Civil War and Reconstruction magnified the existing chaos. Arkansas's Reconstruction period ended in 1874.

In 1868, Arkansas was readmitted to the Union, and the same year the State School for the Blind moved to Rosewood, where it remained until 1939, when the state built a new Blind School in an entirely different location.

A boundary known as the Quapaw Line separated the original city of Little Rock and the Quapaw Indian Nation until 1824, when the Quapaw ceded to the United States all their remaining lands in Arkansas. During the nineteenth century, the Quapaw quarter became the most desirable residential neighborhood, but after the turn of the twentieth century, residential growth moved west of the city to suburbs accessed by streetcars, and the old neighborhood began a general decline. In 1961, the Quapaw Quarter Association developed and led to a greater interest in restoring the older historic buildings in the city.[2]

When the state changed the location of the Blind School, the old buildings remained empty for years. In 1944, the Arkansas Federation of Women's Clubs began a campaign to provide an official residence for the state's governors. The first effort, led by Mrs. Agnes Bass Shinn, president of the Women's Clubs, failed but nevertheless succeeded in raising the issue. In 1947, the legislature passed a bill to create a Governor's Mansion Commission and appropriated $100,000 for the residence. The commission chose the former Blind School property, and by 1948 Governor Benjamin T. Laney laid the cornerstone. In 1950, Governor Sidney S. McMath became the first governor to occupy the new mansion. The Mansion Commission and Governor McMath honored the committee of the Arkansas Federation of Women's Clubs, praising them for their efforts on behalf of the mansion. Many years later, Agnes Shinn gave to the governor's mansion a grand piano that remains there today.

2. Margaret Ross, "A Guide to Little Rock's Nineteenth-Century Neighborhoods."

This symmetrical Georgian Colonial governor's mansion is less than sixty years old, but most of its bricks date back more than a century. The residence was completed in 1950 using three hundred thousand of the old oversized bricks from the Arkansas School for the Blind. The mansion occupies eight and a half acres in the historic Quapaw district of downtown Little Rock. The cost to build the mansion—$197,000, a huge sum in the 1950s—pales in comparison to the cost of the recent Mansion Expansion Project, a multiphase, six-million-dollar undertaking that began in 2001 and includes a house renovation of 1.4 million dollars involving installation of an elevator, new plumbing, and a new electrical system.

The approach to the mansion is behind a brick wall with iron fencing. This creates a stately entrance into a wide courtyard and circular drive. The formal portico is twenty-five feet wide and is supported by four nineteen-foot columns. The three-story rectangular building is flanked by two guest pavilions or cottages that are reached through colonnaded walkways. They resemble the extensions used in Mount Vernon, George Washington's home in Virginia. Over the years, one was sometimes used for a guard station; at other times, it has been used as a governor's office, as it is now. The other remains a guest suite.

Governor Orville E. Faubus served six two-year terms as Arkansas governor beginning in 1955. Although he was known around the country for refusing to integrate the schools in Arkansas and for other well-publicized actions, his daily running and maintenance of the governor's mansion did not share such publicity. The redecoration of the house during his administration in the early sixties was reported to be the first. It is interesting to note that the job was given to George Golden, who had decorated Graceland, Elvis Presley's home in Memphis. Redecoration cost the state seven thousand dollars; knowing how parsimonious Governor Faubus was, it is surprising that any interior decoration would have been done in those years.

The first mansion renovation began when Governor Winthrop Rockefeller took office in 1967 as the first Republican governor since Reconstruction. Although the house was seventeen years old, it was reported that repair work had been minimal and remodeling nonexistent. The Rockefellers lived in a penthouse in the National Old Line Building in Little Rock during the restoration. At that time, the mansion was considered a fire trap. The wiring was a dangerous fire hazard, the basement leaked, and some of the plaster was peeling: "The mansion is a two-story brick dwelling in a deteriorating middle class residential district of south-central Little Rock. . . . From the outside [it] has the look of a suburban funeral parlor in need of paint."[3]

During the renovation, everything was moved out of the house. The laundry facilities and storage spaces were moved to a renovated basement, and a new larger kitchen was created. Oak-pegged floors were installed in the dining room, living room, and conference room. An antique crystal chandelier was disassembled and shipped from France and then reassembled and placed over the staircase. The Rockefellers brought paintings and a number of their personal antiques

3. Homer Bigart, "A Governor Finds Home Is No Castle," *New York Times,* January 15, 1967.

with them to the house, and they also donated antique oriental carpets and some furniture that remained in the house after they left.

Lieutenant Governor Mike Huckabee inherited the governor's office in the summer of 1996, replacing resigning governor Jim Guy Tucker. Although Governor Huckabee abandoned his Senate race to fill the governor's chair, he continued on the job for ten years. He became only the third Republican governor of Arkansas since Reconstruction, and after finishing two years of Governor Tucker's term, Governor Huckabee went on to win gubernatorial elections for four more terms.

Friends of the Mansion, established in 1982 to raise money for mansion improvements that the state would be unable to afford, was intermittently active before Governor Huckabee's administration. The Mansion Association and the Mansion Commission were initiated by Janet Huckabee, who was instrumental in spearheading the drive to raise money. Almost immediately, Governor Huckabee and three former governors conducted fund-raising activities for essential needs within the house, including painting and kitchen equipment. By 2000, the fund-raising efforts had accelerated. Seven living governors combined their skills and launched an enormous fund drive that would renovate the mansion and double its size. Their first activity was a dinner that raised more than $300,000; the participants were the former governors Sid McMath, Dale Bumpers, David Pryor, Bill Clinton, Frank White, Jim Guy Tucker, and Mike Huckabee.

During the $1.4 million initial phase, Governor and Mrs. Huckabee lived in temporary housing next to the mansion site. Their new housing was a $110,000 modular home donated by the Arkansas Manufactured Housing Association containing 2,100 square feet of living space. In conversation, Janet Huckabee enthusiastically defined the trailer as a "triple-wide."[4] The Huckabees lived in the provisional quarters for over a year, which caused a national stir featuring them in countless interview shows on national TV and radio. Although their temporary quarters were not luxurious, they seemed to enjoy it, and in addition, it did save money for the state. At the end of their occupancy, the house trailer was donated to the Arkansas Sheriff's Youth Ranch.

The project's second phase created the Grand Hall, an atrium, a full kitchen, and office suites. Architect George Anderson's enormous addition to the house was seamless. It has an entrance of its own on the side of the house, with access that does not disturb the formal front entry. The Grand Hall seats 220 for events. Before its existence, a tent in the mansion yard had provided extra space when needed. The flooring used in the addition is stone and ornamental wood. The wooden floors are in a geometric parquet pattern. The tall windows and the soaring, twenty-foot ceiling of the Grand Hall produce a room filled with sunlight.

The final phase of the mansion redevelopment, completed in 2007, finishes the complex landscaping and the renovation of the exterior pillars. The massive plan includes irrigation,

4. Janet Huckabee, conversation with author, October 2005.

pavilion construction, hardscape construction, and plants. P. Allen Smith, the designer, created parterres enclosed with hedges and trees, fountains, and heritage roses. Smith had been inspired by the grounds of Rosewood, the Greek Revival home of Governor Fulton that previously stood at the same location.[5]

Governor Mike Beebe began his occupancy in the governor's mansion in 2007 and continues to welcome visitors to the mansion. The house serves as a meeting space for community groups as well as a social and business space for the governor.

In the 1840s, when Governor Fulton built his family home on forty acres just at the edge of Little Rock, he created something important for the state. After Fulton left the house, it served the public as the Arkansas School for the Blind, and even after it had been torn down, its presence continued as the governor's mansion was built using the same antique bricks. The governor's mansion sits on historic ground and strengthens the continuity from Arkansas's earliest days of hardship to the present, when not too long ago it was a home to Winthrop Rockefeller, a person of distinction in American history, and more recently a home to the man who would become the forty-second president of the United States. The mansion, a component of the Governor's Mansion Historic District, has grown to have a significant involvement in the history of the state and that state's contribution to the nation's future.

5. *Arkansas Times*, May 25, 2006.

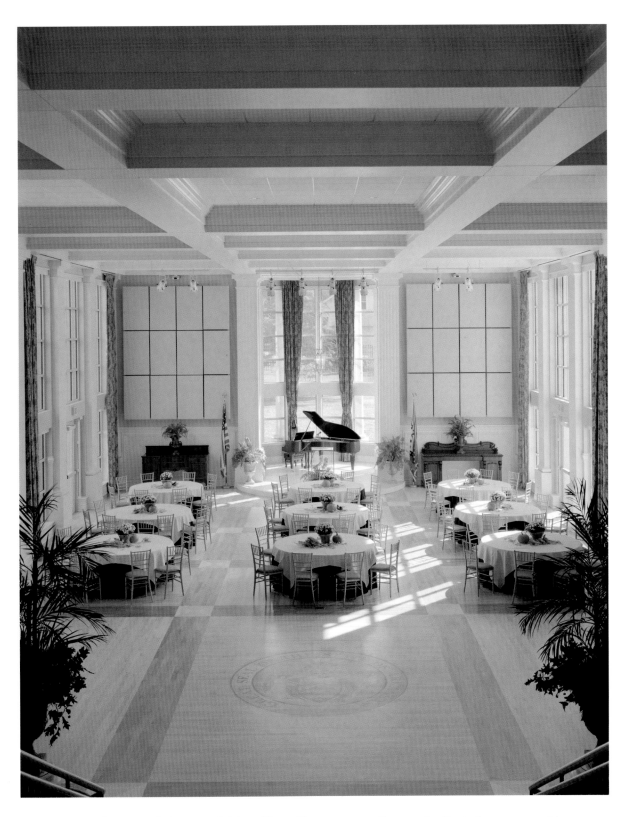

The Grand Hall is part of the new addition. The ceilings, parquet floor, and tall windows are notable.

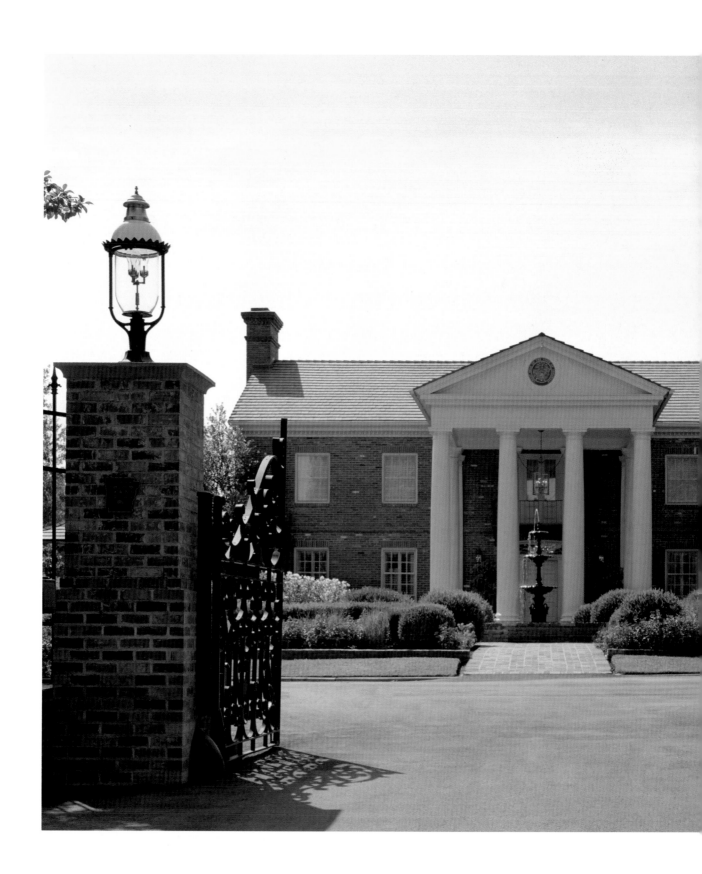

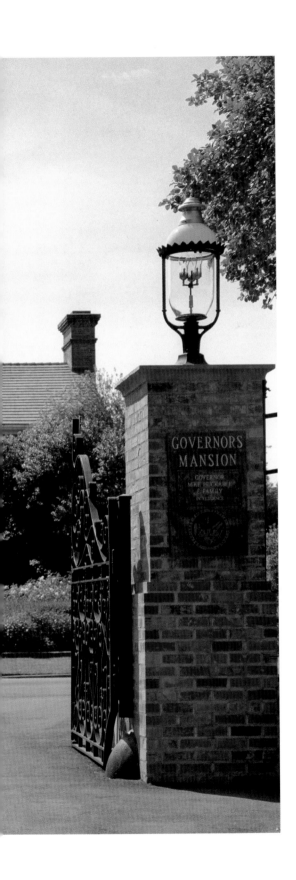

Fence detail.

Front view of mansion, from the courtyard entrance with fountain.

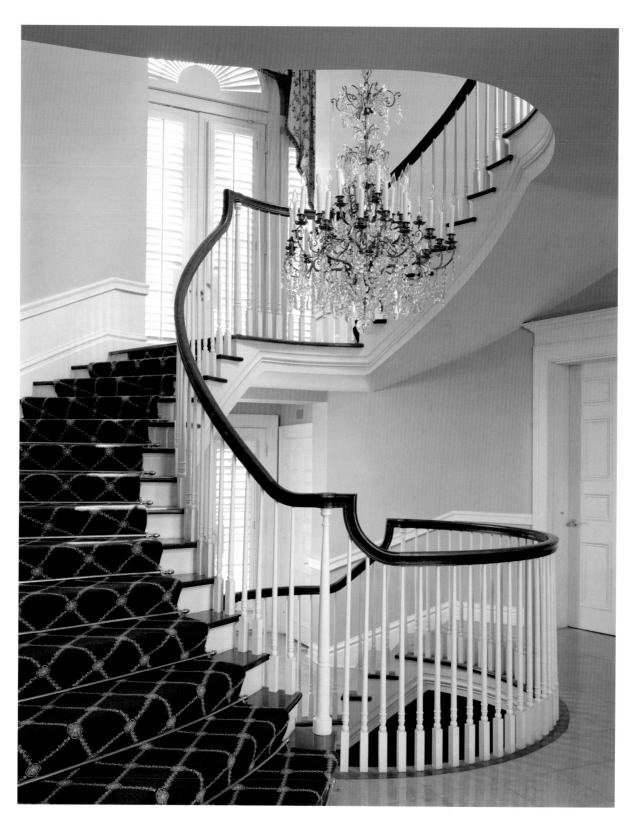

Staircase from the foyer, with a crystal chandelier.

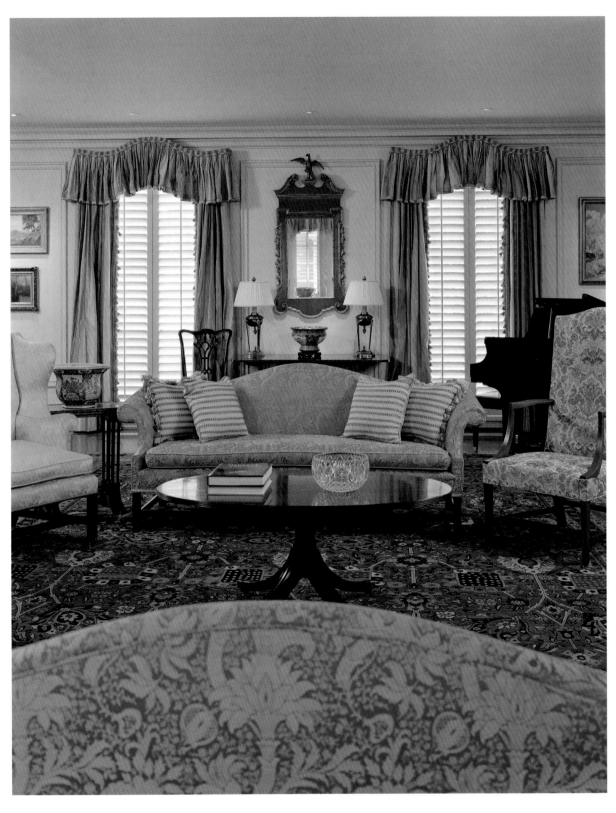

Formal drawing room, with grand piano given to the mansion by Agnes
Bass Shinn, who initiated efforts to build this mansion.

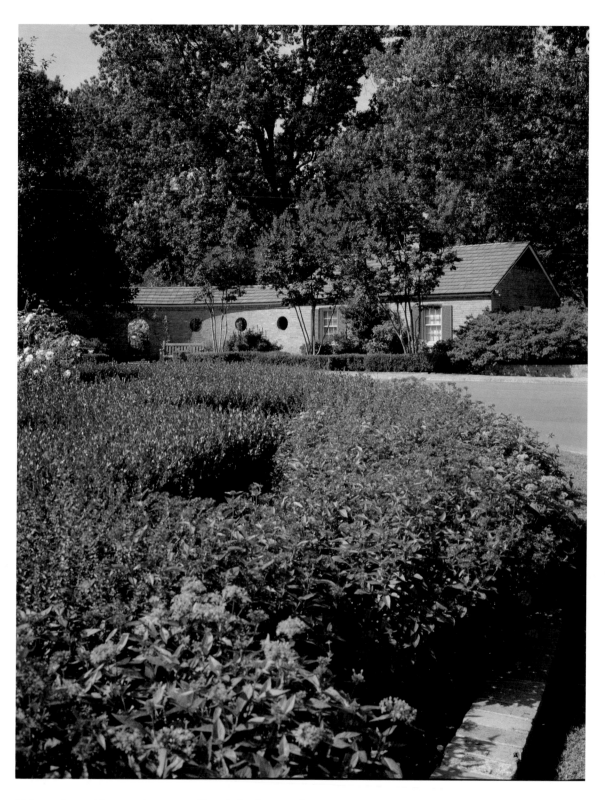

Side garden, with guest house pavilion in background.

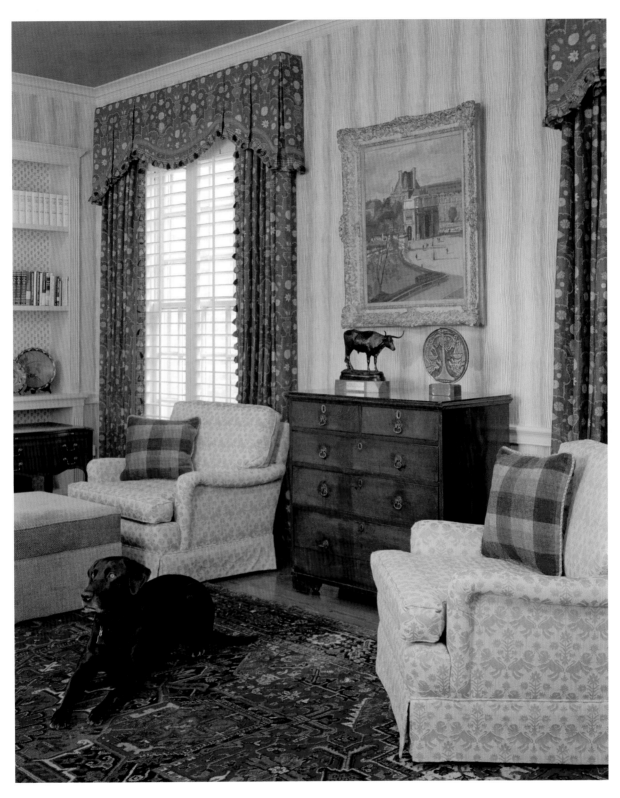

Library with butternut paneling, and Governor Mike Huckabee's black labrador retriever.

Florida
Governor's Mansion

National Register of Historic Places

Location: 700 North Adams, Tallahassee

Construction Completed: 1956

Cost: $350,000 including furnishings

Size: 15,000 square feet

Number of Rooms: 30

Architect: Marion Sims Wyeth

Architectural Style: Colonial Greek Revival

Furniture Style: Eighteenth- and nineteenth-century antiques from the British Isles in the Chippendale, Federal, Queen Anne, and Regency styles; select pieces of American and French antiques; and reproductions from the eighteenth and nineteenth centuries.

After conquering and governing Puerto Rico, the Spanish explorer Juan Ponce de León, motivated by the lure of riches and on a mission to discover the Fountain of Youth, claimed new territory and became the first European in recorded history to set foot in what we today call the state of Florida. Although there is evidence of earlier European landings, they were never recorded and therefore are not official nor recognized. Ponce de León was granted authority by King Ferdinand of Spain to move in and take charge of a new territory, Bimini; they believed it was the same island as Florida and did not know until the summer of 1513 that they were different locales. During Easter of 1513, Ponce de León dropped anchor just south of present-day Cape Canaveral at Melbourne Beach and named the new land "La Florida." The translation links the Easter holiday, Pascua Florida, or Feast of Flowers, with the literal meaning of *la florida*, "the flowery land" or "the flowered one."

In 1521, Ponce de León made a second voyage to Florida—this time to Florida's west coast— and he brought a hundred men and livestock and materials enough to plant a new colony. Within five months, construction halted when a fierce Indian assault overwhelmed the colonists; Ponce de León himself was shot by an arrow and died within days of his immediate withdrawal to Cuba. Although his appointment as governor of both Bimini and Florida happened in 1514, he died not knowing if Florida was an island or a peninsula.

Scorching battles over ownership took place in Florida for two centuries. Between Ponce de León's 1513 claim for the Spanish Empire and the establishment of the first permanent settlement, more than fifty years of expeditions had resulted in combat and massacre. Bloody confrontations with Indians native to the peninsula were supplanted in the 1700s by equally vicious wars with Indians from the southeast who were moving into Florida; these people were later known as the Seminoles. At the same time, the Spanish constantly defended their claim against competition from invading French and English colonists.

The vast area of old Spanish Florida, thought to extend west of the Mississippi River and as far north as southern Canada, was carved up in colonial times by the French and English. The Spanish founders held onto an increasingly smaller Florida until the territory was handed over to the United States in 1821. The U.S. flag was the fourth to fly over Florida.

Beginning as a campsite in a preexisting Timucua Indian village, the town of St. Augustine was established by Spanish settlers in 1565; it is the first permanent European city in the United States. (By the time the English landed at Jamestown in 1607 and at Plymouth Rock in 1620, the settled Spanish St. Augustine was more than fifty years old.) The massive Florida area was governed from St. Augustine until the British declared Pensacola as the western capital. This resulted in dual seats of government for most of the European years, with four hundred miles of wilderness between the capitals, requiring an overland journey of twenty-eight days to traverse.

With an exchange of flags in 1821, President James Monroe formalized the transfer of Florida to the United States from Spain. The president appointed General Andrew Jackson, whose 1818 Seminole War invasion crushed the first Seminole uprising, to be the first American

territorial governor of Florida. The future Florida governor Richard Keith Call had joined Jackson's army and fought with him in earlier campaigns. Call was destined to play a significant role in Florida's future and left the physical legacy of an important five acres of property, including his antebellum house (called the Grove), which continues to play a role today.

In 1824 the territorial governor William P. Duval authorized plans for Tallahassee to be the new seat of government, thereby creating one capital, to be situated halfway between the two leading towns. Prior to that, the state's first legislative session had been held in Pensacola, and "the members from St. Augustine had traveled 59 days by water to attend."[1] Notwithstanding the possibility that the voyage could be completed in twenty days in the *best* of circumstances, shipwrecks and other dangers faced by delegates traveling during bad weather convinced Governor Duval to appoint a commissioner from each town to settle the capital site question. They selected the Indian fields of Tallahassee—the sixteenth- and seventeenth-century home of the Apalachee Indians, a site later occupied by the Creeks. The name Tallahassee comes from a Creek word for "old town." Tallahassee is believed to be the site where, in 1539, Hernando de Soto's expedition celebrated the first Christmas Mass in North America.

Florida joined the Union in 1845 as the twenty-seventh state, and throughout the nineteenth century and into the twentieth, its governors found their own housing, usually living in boardinghouses or hotels. But in 1905 this unsatisfactory situation was remedied when the legislature appropriated $25,000 to build an official residence. Tallahassee banker George Saxon generously contributed four city lots on the north edge of town, just outside the city limits where the present address, 700 North Adams Street, remains the governor's residence and is today very much in the center of the city's commercial and residential growth.

Architect Henry John Klutho (1873–1964), a friend of Frank Lloyd Wright and the first in Florida to be a member of the American Institute of Architects, rebuilt much of downtown Jacksonville after a devastating fire in 1901. During an extended tour of Europe in his training years, he studied classicism, but like Frank Lloyd Wright he was a devotee of the Prairie School of design. Today several Klutho buildings, of both Classical and Prairie design, remain and are on the National Register of Historic Places. As the architect chosen for the governor's residence, he developed a Neoclassical plan for the exterior, fashioning twenty-four Ionic columns with elaborated capitals as well as a wide veranda extending across the front and sides of the white clapboard house. The fourteen-room residence with a Georgian interior featured formal rooms flanking a center hall and a staircase that split into two stairways at the first landing.

Between 1907 and 1955, fifteen families lived in the residence, but as time went by, it became apparent that the lack of interior space sizeable enough for holding large receptions was a serious drawback. As Florida grew and prospered, the governors' need for bigger entertainment areas in the house also grew. In addition, there were some structural problems requiring maintenance that would have cost more than it would have been feasible to spend.

1. Michael Gannon, *Florida: A Short History,* 28.

After Governor Fuller Warren referred to the house in 1949 as "the State Shack"—a building in immediate need of rehabilitation, where the paint was peeling and the plaster was falling—it was no surprise when, in 1952, he recommended an appropriation for building a new mansion. The legislature appropriated $250,000 in 1953.

The mansion's contents, including furnishings and architectural pieces from the old house, were publicly auctioned in 1955, and the proceeds of $7,500 were used to help furnish the new. A leading expert in colonial interiors in the 1950s, James Lowry Cogar, did the purchasing and planning of the interior furnishings in the new mansion.

While waiting for the new mansion to be constructed, the newly elected Governor LeRoy and Mrs. Collins lived next door to the mansion site in Mrs. Collins's conveniently located ancestral home. Mary Call Collins's great-grandfather, Richard Keith Call, had arrived in Florida as a protégé of Andrew Jackson, but unlike Jackson, he had stayed permanently in Florida. Twice a territorial governor himself, Call had built his Greek Revival style home in 1825; the building not only continues to survive, but also is occupied by his great-grand-daughter Mary Call Collins. The estate, the Grove, has generously been given to the state of Florida for use by the governors after Mrs. Collins's death.

Palm Beach architect Marion Sims Wyeth, a distant relative of the famous American painter Andrew Wyeth, designed many elaborate homes in Florida but is noted especially for creating, in 1923–1927, one of the most famous houses in the country, Mar-A-Lago, a 117-room pink villa situated on 17.7 acres between Lake Worth and the Atlantic Ocean, for Mrs. E. F. Hutton (Marjorie Merriweather Post of Post Cereals.)[2] Today the estate belongs to Donald Trump. Among the more than one hundred homes Wyeth created were the Norton House in 1925 (now a museum), the E. F. Huttons' home prior to Mar-A-Lago, and a house for Sir Harry Oakes, the owner of the largest gold mine in North America, today owned by a former U.S. ambassador.

Wyeth, born in New York, may have been a Yankee by birth, but he considered himself a southerner based on the deep roots of his forebears in the Old South and the Carolinas. Following his study at Princeton and at France's official school of architecture, the École des Beaux-Arts in Paris, and after working in New York, first with Bertram Grosvenor Goodhue and then with the firm of Carrère and Hastings, he opened his Florida practice in 1919 after declining an offer to work for Addison Mizner, a Palm Beach celebrity architect. By the time Wyeth received the governor's mansion commission, he was himself a Palm Beach celebrity architect.

2. Following Wyeth's design of the basic floor plan and layout, Marjorie Merriweather Post hired Viennese architect and set designer Joseph Urban to create plans for an imaginative, theatrical exterior, and the two worked together. Frustrated with Urban's exceptional extravagance, Wyeth left the project but later returned at the owners' request, whereupon Urban's role became that of decorator (Morton D. Winsberg, *Florida's History through Its Places: Properties in the National Register of Historic Places*, 92; Nancy Rubin, *American Empress: The Life and Times of Marjorie Merriweather Post*, 154–56).

As the chosen architect for the new governor's mansion, Wyeth's solid credentials, long career, and attention to financial details were significant factors in his selection and unanimous endorsement by cabinet members and their wives, including Governor and Mrs. Collins as well as the Governor's Mansion Advisory Committee.

Wyeth performed his job with admirable precision; Rhea Chiles, in her history of the mansion, described his task: "As instructed, Wyeth used the Hermitage, the Tennessee home of President Andrew Jackson, as his exterior model. Like that of the Hermitage, the facade of the mansion is comprised of a two-story center section fronted by six Corinthian columns."[3] And just as a palm-frond motif is detailed in the capitals of the Hermitage columns, it is also present in those at the governor's mansion. Unlike the Hermitage, the governor's mansion has one-story wings extending from the two-story center section. At the Hermitage, the extensions are pavilions joined to the center of the house. The red brick of the governor's mansion is called "Kingsport Hermitage Colonial" style, manufactured in Tennessee to look like the brick used in the Hermitage. Meanwhile, old bricks salvaged from Tampa after the city removed its trolley tracks were used for the walkways and drive. These old bricks, favored by the architect for their patina, add another visual detail that conveys the atmosphere found in southern buildings and in southern towns.

Governor and Mrs. LeRoy Collins, the first to occupy the new mansion, guided the project, overseeing many of the details; they also suggested in 1957 that the legislature establish a Governor's Mansion Commission. This body oversees the preservation of the style of the original plan of the house and its furnishings. In 1955, prior to the creation of the commission, Governor Collins appointed an advisory committee. This distinguished team of Tallahassee residents made numerous decisions and was given a huge responsibility.

Constructed on the site of the first governor's mansion, the house was completed in 1956 at a final cost of $350,000, including furnishings. The original plan for the house called for more rooms than were actually created—due to budget restraints, the extra spaces were eliminated. This slight detraction from the size of the house in no way impacted the final appearance and nature of the mansion. It sits on one and a half acres facing another acre and a half of parkland surrounded by palms and flowering trees. The understated beauty of the pink and white camellias enhance the overall old southern personality of the property. Contributing to the atmosphere are live oaks festooned with so much Spanish moss that they seem to be weeping.

The museum quality of the interior begins with the fine woods used in the floors, moldings, frieze work, and doors and continues through a complete inspection of the antiques and paintings, the silver, and even the wallpaper.

The first-floor entrance opens to the formal entry hall and from there to the reception and dining rooms. The staircase and second floor are part of the governor's private family quarters and are not visible as one enters. This practical arrangement separates the spaces clearly yet

3. Rhea Chiles, ed., *700 North Adams Street*, 30–31.

seamlessly. It is almost as if there are two houses side by side. In providing for public and private space, the architect ingeniously created a beautifully unified exterior and an equally elegant divided interior. There is no overlapping of official space and the private residence, giving the utmost preservation protection to the historic antiques and superb interiors that have been purchased for or given to the house. Fine paintings are on loan from the John Ringling North Museum in Sarasota.

In addition to the formal rooms for official state functions, the main floor contains a guest bedroom, a Florida room, a public kitchen and pantry, and a library. The family space is in the south wing and has the family kitchen, dining room, and sitting room as well as a guest bedroom and family living quarters. The governor's mansion staff and security also occupy offices in the south wing.

One of the first noticeable things one encounters upon entering the house is a Chippendale grandfather clock with a moon dial that is dated 1790 and still works and accurately displays the phases of the lunar cycle. Another is an enormous full-length oil portrait that one hopes would be of Ponce de León, but is instead an exquisite portrait of an officer of the Dutch army in full military dress and dates from the seventeenth century—it is on an extended loan from the Ringling Museum. There is also a 1780 George III bachelor's chest.

In the state reception room is a Chippendale mahogany desk and a tall bookcase from England circa 1770; in front of the latter is a Queen Anne walnut side chair, the oldest piece of furniture in the house, dating from 1740. A tall mahogany Hepplewhite bureau bookcase made in the late eighteenth century is on the opposite side of the room balancing the Chippendale desk.

On each side of the fireplace is a mahogany console table. Stunning, carved-wood, gilt mirrors flank the fireplace above the tables; these were all made in the eighteenth century.

James Cogar, the expert in colonial interiors, devised a plan for the acquisition of the antique and quality reproduction furniture for the official residence. As the first curator at Colonial Williamsburg, whose seventeen-year tenure there put him in charge of its early furnishing, he was the clear choice of the Governor's Mansion Advisory Committee. He advised, purchased, and coordinated all of the interiors of the house, and working within a $100,000 budget Mr. Cogar found most of the antique furniture in the British Isles, concentrating on the eighteenth and nineteenth centuries. Reproductions were called for in some heavily used rooms, such as sofas and club chairs. These were primarily purchased from an American furniture company, Kittinger. Its quality and workmanship were superior and the company had also been used in Williamsburg.

The dining room is exuberant. The walls are beautifully papered with an Italian scene that is a copy of an 1840s design by Jean Zuber and Company of Rixheim, France, that uses woodblocks to print historic wallpapers. This one, as did the original, required 742 woodblocks and 85 separate colors. It was made exactly as it had been done in the nineteenth century using the same wooden blocks. It depicts an island in Lake Maggiore bursting with tropical foliage, flowers, and birds against a multicolored skyline. Zuber scenic wallpaper, although not this particular design, was installed in the White House by Jackie Kennedy in 1961.

In addition to the fine antique furniture of each room, an enormous Louis XV–style cut-glass dining room chandelier dates from 1760 that reportedly originally hung in a French castle. A Florida silver service, consisting of forty-seven pieces made for the USS *Florida* battleship in 1911, is prominently displayed in the dining room. Elaborate, beautiful, and whimsical, it is decorated with large pelicans, lizards, alligators, herons, and shells, as well as a Seminole Indian motif. A great deal of battleship silver now resides in the various mansion collections and is ornate, fine, and beautiful, but the Florida pieces are particularly bold and powerful.

Throughout the Florida mansion are beautiful antique rugs. They enhance every room from the marble of the reception hall and the wood grains of the living room and dining room to the brick of the Florida room.

During the administration of Governor Bob Graham, the Governor's Mansion Foundation, Inc., was established in 1980 for soliciting private funds to refurbish and renovate the almost thirty-year-old mansion's state rooms and grounds. Adele Graham, who spearheaded the founding of the Mansion Foundation and was its foremost fund-raiser, also supervised the addition of a Florida Room in 1985, which gave important elbow room to the public space. It was during this administration that the Zuber paper was purchased for the dining room.

Governor and Mrs. Jeb Bush added a library at the back of the reception room and a portico to the back of the Florida room. They continued the open access to the mansion for student tours and community groups throughout the state. Their care for this house is evidenced in their role as stewards who paid attention to the future life of the residence in working toward its placement on the National Register of Historic Places. The Florida house celebrated its fiftieth anniversary in 2006 and it earned its stripes, being publicly placed on the National Register during the same year. The house especially benefited from the active role of its Mansion Foundation and its amazing curator, Carol Graham Beck, who coordinated and led the efforts. Incoming governor Charlie Crist continues with the same organizational format for the house, showing the importance of continuity.

Today the outdoors includes landscaped grounds and a swimming pool, gazebo, fountain, greenhouse, and the Manatee Sculpture Garden, all adjacent to a private park in the middle of a private city block. But this historic site that contained the first governor's mansion from 1905 until 1955 sits on land and nearby environs of once-overgrown wilderness where Hernando de Soto made winter camp in the 1500s, where Spain's Franciscans established their missions in the 1600s and the English destroyed the same missions in the 1700s, and in the 1800s the Americans fortuitously centralized east and west Florida, creating the state's political center in Tallahassee.

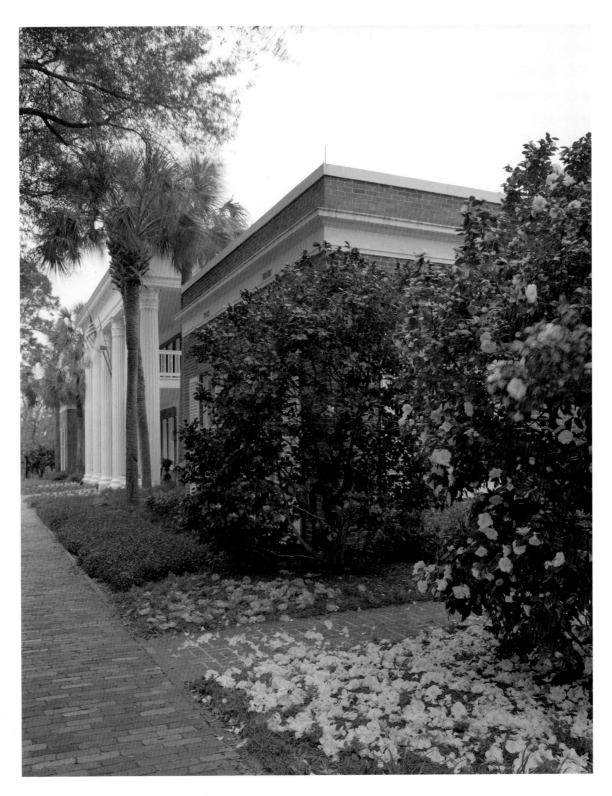

Side view of mansion, with camellias.

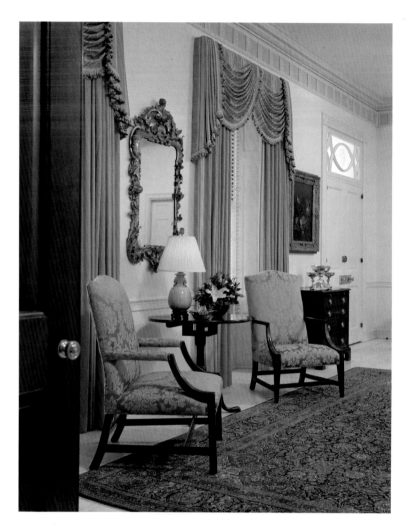

The State Entrance Hall, showing mahogany double doors
and the George III bachelor's chest dating from 1780.

The Florida Room, a former patio space, was enclosed in 1985.
A bright space with multiple windows and French doors, it
overlooks a patio and opens to a portico and garden.

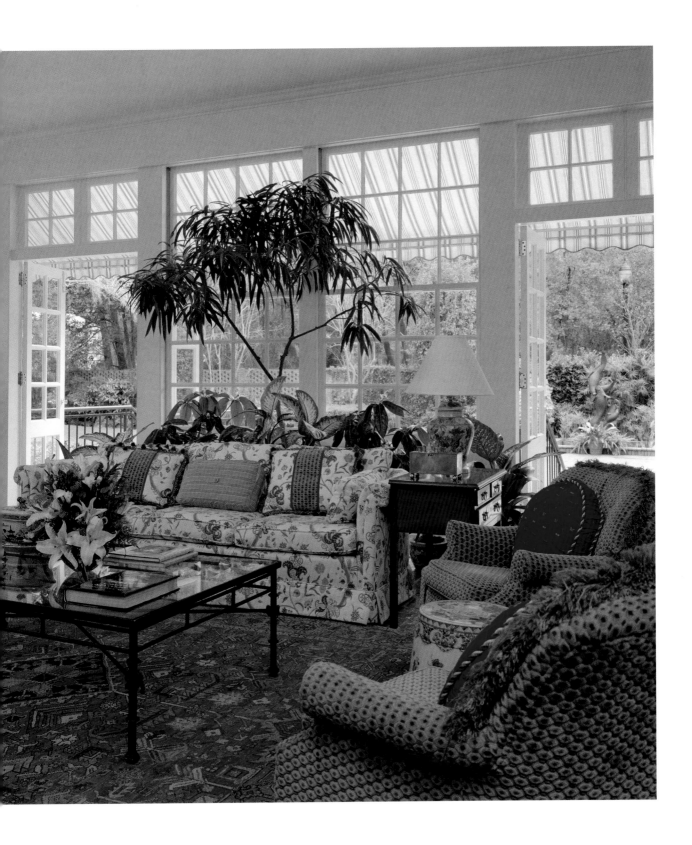

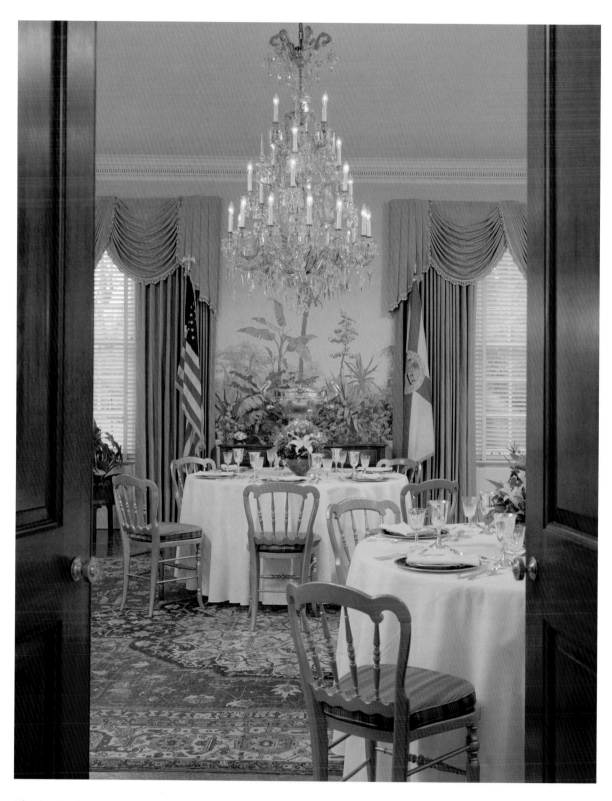

The State Dining Room, with Zuber paper from France. A twelve-gallon silver punch bowl with pelican handles is in the background, and the crystal chandelier is French, circa 1800.

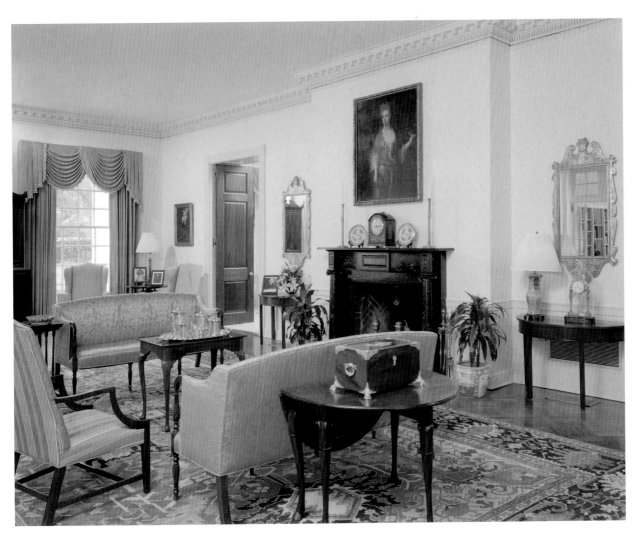

The largest room is the State Reception Room, with a black marble fireplace, antique Heriz rug, and a pair of circa 1770 Neoclassical console tables placed under gilt mirrors.

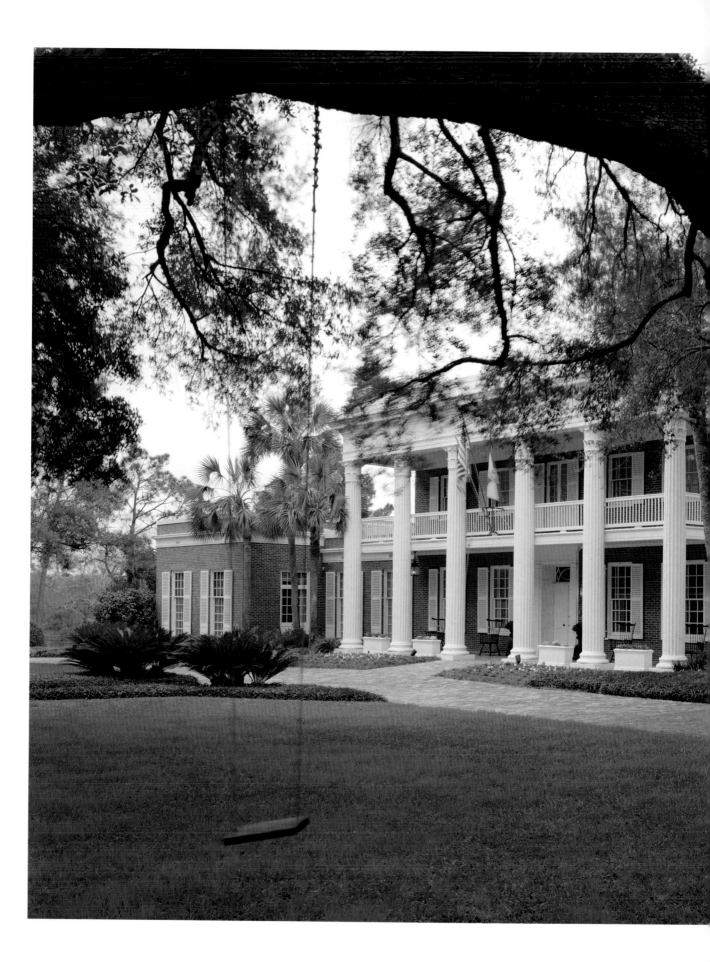

Front view of mansion, with one
of many oak trees in foreground.

Georgia
Governor's Mansion

Location: 391 West Paces Ferry Road NW, Atlanta

Construction Completed: 1967

Cost: $2.5 million

Size: 25,000 square feet

Number of Rooms: 30

Architect: A. Thomas Bradbury

Architectural Style: Greek Revival

Furniture Style: Eighteenth- and nineteenth-century antiques in the American Federal, American Empire, English Regency, English Hepplewhite, and French Restauration styles

around 1810, when Franklin was an ambassador to France. There is also a full-length painting of George Washington, standing, and looking every bit the commander of the army. Charles Peale painted Washington's portrait in 1776, and this is the 1778 commission painted by Samuel King. Samuel King's charge was to paint a copy of Peale's 1776 portrait to present to the French admiral Count d'Estaing.

Throughout the house are significant pieces of furniture attributed to Charles-Honoré Lannuier, a French-born cabinetmaker who lived and worked in New York in the same era of Duncan Phyfe—the early 1800s. One of the Lannuier pieces in this room is the petticoat table, dating from 1815.

More Lannuier furniture is in the library, the dining room, and the state drawing room. An exceptional alcove bed in the guest bedroom is also attributed to him.

The state drawing room is used as the reception center. Its great size—twenty-five by forty feet—lends itself to large gatherings. Details borrowed from early Neoclassical buildings, such as the Greek honeysuckle molding and the ceiling medallions, are accompanied by Scalamandré silk window coverings and upholstery that one would expect to encounter in this formal space. The matching chandeliers in the Drawing Room are nineteenth-century English, and the fireplace mantel is of Italian marble, made in England in 1790. The sofas are attributed to Duncan Phyfe, 1815. There are two portraits, of the John Marstons of Philadelphia, dated 1795, by John Neagle. Another American painter represented in this room is one of the founders of the Hudson River School, Alvin Fisher.

The dining room table, made in Boston by John Seymour around 1810, is fourteen feet long and seats eighteen, but it can also be reduced in size to seat only four. The room is large enough to accommodate fifty people for dinners, which can be accomplished by adding round tables in each corner of the room. (For much larger groups, the lower-level ballroom accommodates hundreds.)

One of the most outstanding pieces of furniture in the collection is the mahogany dining room sideboard with gilded mounts on the front. Made in Philadelphia in 1815, it is attributed to Henry Connelly. American cabinetmakers in that era followed European patterns in creating furniture with brass inlays, gilded mounts, moldings, and sometimes winged eagles and paw feet.

The dining room fireplace mantel is green and white Italian Carrara marble and is one of four antique mantelpieces imported from England. The Waterford chandelier dates from 1800. In this room and throughout the mansion are antique Oriental carpets; the one in this room is a Heriz made in Turkey in 1820.

The exceptional interiors of the mansion represent much of Georgia and America's history that requires hours, at the very least, to absorb. One experiences profound appreciation when viewing the collection. Some pieces have especially interesting historical connections. The chairs in the family dining room date back to 1800 and were owned by Jim Williams, a

Savannah antiques dealer. He is the subject of *Midnight in the Garden of Good and Evil,* by John Berendt. Williams sold these chairs at auction to pay the legal fees for his murder trial. And in the library is a signed first edition of Margaret Mitchell's *Gone with the Wind.*

The monumental interior of the house is notable in everything from the high ceilings, large rooms, and the particularly large ballroom. Bradbury, the architect, followed the model of the 1830s Milledgeville mansion and incorporated its Greek Revival style in the architecture. In addition to serving its official duty as home to the state's chief executive, the house is also a museum displaying room after room of history and scholarship. The antique furnishings are mostly American, but enough English pieces are present to remind us of our nation's early ties to England.

The Atlanta governor's mansion is an estate in keeping with a prestigious neighborhood in the international city of Atlanta. Although the outdoor spaces of rolling lawn, specimen trees, and gardens are unforgettable, they are anticipated in a neighborhood where stately homes and the beauty of mature oak, magnolia, dogwood, and jasmine dominate the landscape.

While he was still serving as a Georgia state senator, President Jimmy Carter considered the proposed price for this mansion too high, and he voted against the appropriation for the new mansion. He was not alone in his opposition; indeed, the cost of the venture practically stopped the project, causing the architect to draft and redraft modified plans for the new mansion at least nine times, beginning in 1961. Later, after the mansion's completion and having lived in the house as governor, President Carter remarked that he was pleased the bill passed anyway.

As the newest of the southern governors' mansions, the Georgia house, completed in 1967, can almost be considered a newborn. To its credit and as a benefit to the public, the large late-model house does not avoid the spotlight. As the symbol of the New South, Atlanta is a beacon, and when interest or curiosity leads one to the mansion, the reward is solid historic content so compelling that it commands attention.

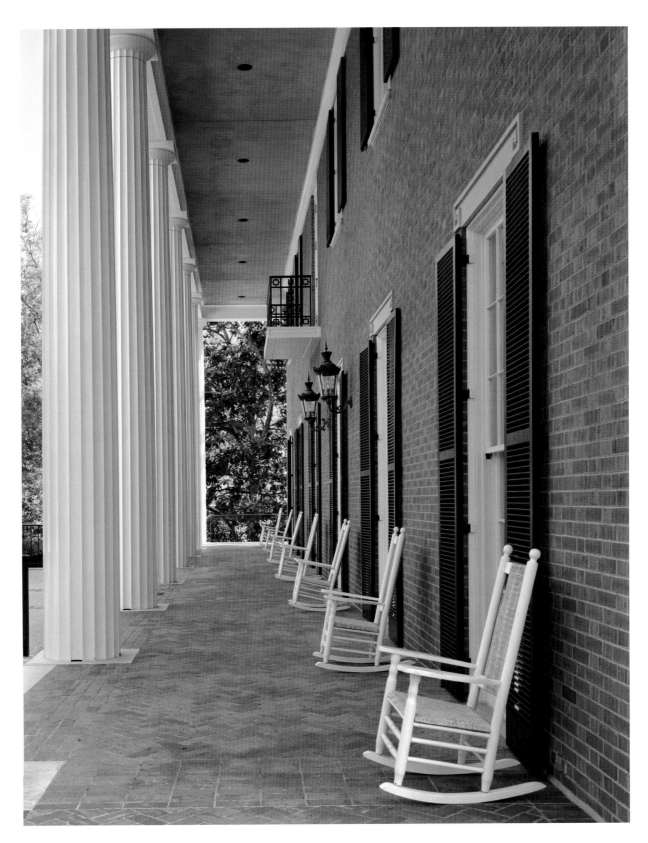

Side porch with rockers.

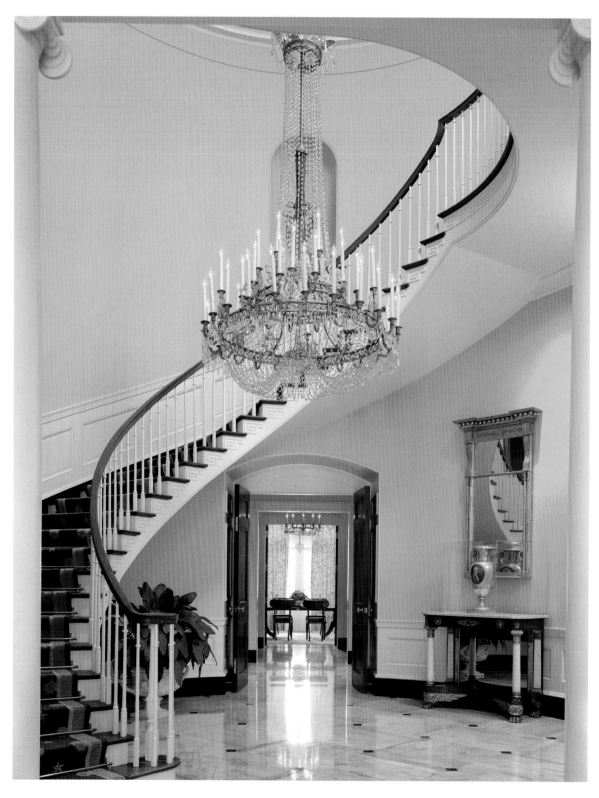

The Circular Hall has Ionic columns that lead to the family dining room in the background. The rarest piece in the house is the Benjamin Franklin French porcelain vase, circa 1810. Franklin's likeness is painted on the twenty-four-carat-gold gilt vase.

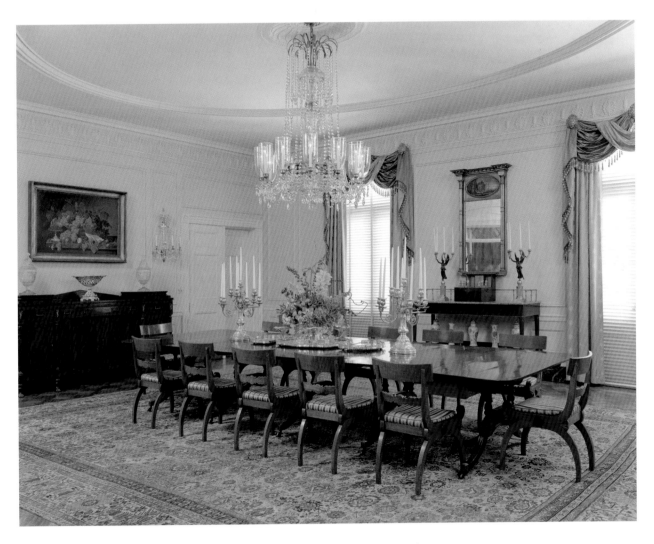

The State Dining Room features an 1810 table made by John Seymour. The 1805
Federal marble-topped serving table is attributed to Charles Lannuier.

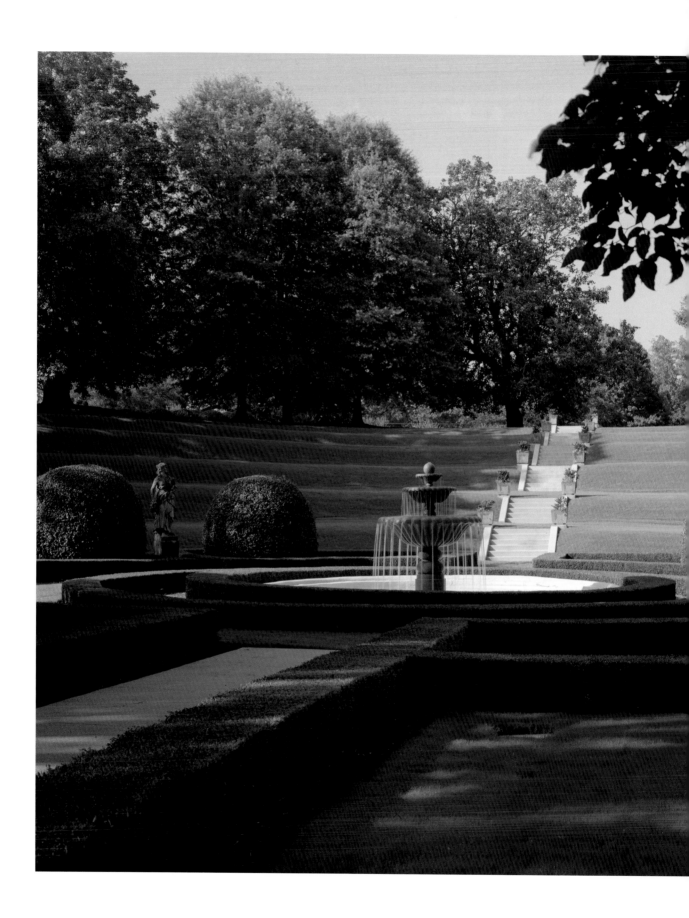

The formal garden, with a fountain and stairs leading to more landscaped grounds. Some of the antique Italian sculptures were imported when the garden was originally constructed by the former owner.

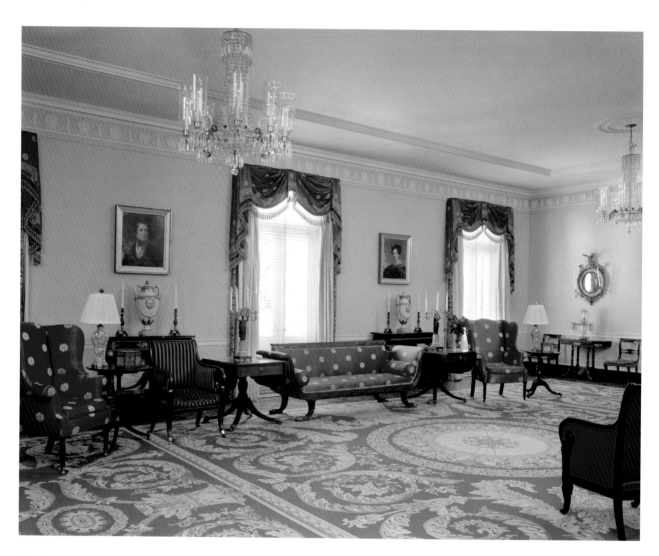

The State Drawing Room is used for meeting with official visitors.
English chandeliers, circa 1815, and fine Federal and Empire
antiques underscore the formality of the space.

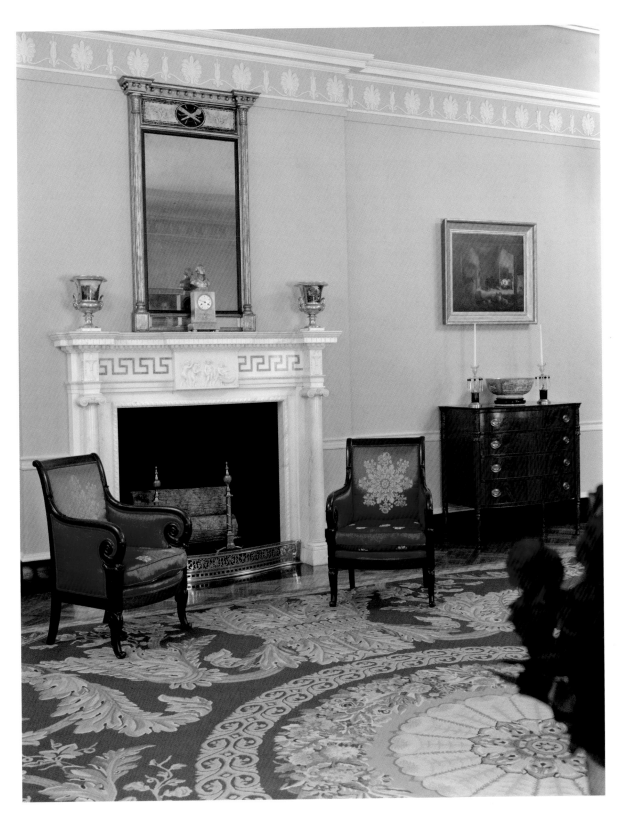

A different aspect of the State Drawing Room; note the Italian
marble fireplace mantel, 1790, made in England.

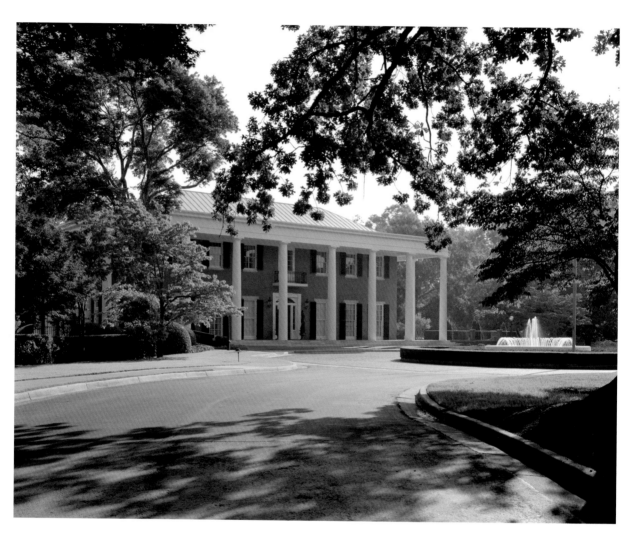

Front of Georgia governor's mansion, with fountain.

Kentucky
Governor's Mansion

National Register of Historic Places

Location: 704 Capitol Avenue, Frankfort

Construction Completed: 1914

Cost: $91,000

Size: 22,100 square feet

Number of Rooms: 25

Architects: Weber Brothers and John Scudder Adkins

Architectural Style: Beaux Arts French Renaissance

Furniture Style: Nineteenth-century antiques and reproductions in the Louis XV and Louis XVI styles and some Empire pieces

Daniel Boone, America's famous hunter, explorer, and pathfinder, who is so well known today for escorting settlers into Kentucky, was but an outsider in 1769 when he made one of his earliest forays into the region and was picked up by a scalping party. Shrewdly negotiating his way around dangerous Indian encounters, Boone was captured over and over by the Shawnee while at the same time establishing a coexistence with them that was intermittently amiable. But peace on the frontier was never a guarantee, and eventually two of Daniel Boone's sons would be killed by Indians.

In 1775, years before Kentucky became a state, Boone and a party of thirty men broke ground for a road that more than two hundred thousand pioneers would travel to settle the West. With axes, they cut their way through brush from the Holston River Valley of western Virginia through the Cumberland Gap, blazing trees to mark the mountainous path, which would come to be known as Boone's Trace. Despite Indian attacks, they eventually cleared two hundred miles and made camp on the south bank of the Kentucky River, calling it Fort Boonesborough, which became the second permanent white settlement in the state. Boone transformed a rough path used by Indians and buffalo into the single-file pack trail through the wilderness that was later widened to accommodate wagon travel and ultimately became known as the Wilderness Road.[1]

Kentucky, at that time part of the vast land area of Virginia, officially became Kentucky County in 1776 when the first act of the Virginia legislature established it as a political extension. During the Revolutionary War, Indians allied with the British assaulted the white settlements in Kentucky and Daniel Boone and George Rogers Clark defended Kentucky, holding their forts more or less together despite a final battle that lost one-third of Kentucky's leaders.

During and following the revolution, immigration into Kentucky soared, and resentment grew against Virginia's rule. Land ownership and speculation became confusing, land titles were neither clear nor secure, and Virginia failed to defend the Kentucky frontier. Virginia was unable to rule its western territory fairly, and Kentuckians clamored for separation.

When Kentucky finally achieved statehood in 1792, becoming the first state west of the Alleghenies, it was the fifteenth state to join the Union. In honor of its parent state, the Commonwealth of Virginia, Kentucky officially calls itself a commonwealth.[2] The Revolutionary War veteran Issac Shelby became its first governor. For decades, easterners seeking to move west had been blocked by the ruggedness of the Appalachians. Boone's Wilderness Trail provided the overland route that spurred settlement and changed history.

The first and second legislative sessions of the new state were held in Lexington. While an investigating committee studied competing claims for a capital site, a generous offer of building materials, property, and money by a group of influential citizens helped convince the committee to choose the centrally located town of Frankfort. It was conveniently situated on the

1. William Allen Pusey, *The Wilderness Road to Kentucky,* 10.
2. The other official commonwealths are Massachusetts and Pennsylvania.

Kentucky River, and agricultural goods produced on the fertile land could be easily transported to faraway markets.

Ill treated by Kentucky for some of his survey work at a time when he could have used governmental approval, Boone lost his property and a bit of his solid reputation over land squabbles. Leaving Kentucky in 1789, he moved to the Kanawha River area, in present-day West Virginia, and later to Missouri, where he lived until his death in 1820, a year before Missouri became a state. Over twenty years later, the Kentucky legislature succeeded in having the remains of both Daniel and his wife, Rebecca, returned to Kentucky. With great pomp and circumstance including a full-dress military procession, speeches, and a hearse pulled by four white horses, the couple's remains were reburied in the Frankfort cemetery overlooking the Kentucky River.[3] The year was 1845 and Boone, the young outsider of early Kentucky days, was honored as a favorite son and granted an eternal resting place on his prized hunting grounds.

Kentucky's first governor, Issac Shelby, whose first term extended from 1792 to 1796, lived in a rented two-story log cabin next to the river. When the new state passed a law in 1795 requiring the governor to reside in the capital city, Shelby, nearing the end of his first term of office, urged the state to provide a place for future governors to live. From a legislative appropriation of twelve hundred pounds, a red-brick Georgian style house was constructed in 1798 in Frankfort, a town with no paved streets or walks and only one or two other brick houses.[4] Despite its modest design, moderate size, and lack of opulence, it was referred to in the nineteenth century as the "Palace" or the "Governor's Palace." The Kentucky legislature intended for the house to be formal but not extravagant. It was important to provide a place for the governor to conduct business as well as to entertain, while at the same time give the governor's family a comfortable dwelling place. This house dedicated to the needs of the governor marked a visible transition in Kentucky's upward mobility. The shift from a borrowed or rented log cabin to a dedicated brick governor's mansion confirmed that Kentucky's cultural outlook was rising.

In 1812, Governor Shelby returned to office, spending his second term in the "Palace." Having occupied the log cabin and later the official mansion, his residency predated by more than one hundred years what would be the future parallel experience of Governor James B. McCreary, who also would preside over two mansions—one, the original brick residence (the Palace), in what had become the commercial center of Frankfort, and the other, a glorious stone edifice that would be built in the open space and bluegrass meadows of South Frankfort.

3. Michael A. Lofaro, *Daniel Boone: An American Life*, 179.

4. Thomas D. Clark and Margaret A. Lane, *The People's House: Governor's Mansions of Kentucky*, 6. Margaret A. Lane has researched the Kentucky Acts of December 1796 and found that during this time the currency system was in chaos. Kentucky followed Virginia's system, and the British pound was the Virginia currency until 1793. Kentucky was still using British pounds at the time of this appropriation (Margaret A. Lane, personal communication with author).

In keeping with its Virginian origins, Kentucky's population and culture echoed that of the Old Dominion. Consequently, the formal architecture of Kentucky naturally followed the example set by Virginia in the design of its Georgian style buildings in the Colonial Williamsburg capital.

But almost from the beginning, the Governor's Palace proved too small to adequately fit the needs of the heads of state. This house was supposed to combine a private family space, plus a governor's office, plus a place for official entertaining. But the governors conducted all of their business here, and this meant almost constant visitation from petitioners as well as government officials. The lack of privacy was one thing, but the incessant wear and tear on the house accumulated from one administration to the next; soon, worn furnishings and sagging floorboards were creating excessive maintenance and almost constant expense.

In their history of the mansion, Thomas D. Clark and Margaret A. Lane summarized the problems: "Three indelible facts are associated with the original governors' residence: it was hurriedly and cheaply constructed, it was meagerly and plainly furnished, and it was not spacious enough to house the numerous children . . . or to accommodate appreciable political and social gatherings."[5]

From 1798 until 1911, the original governor's mansion housed thirty-two families. In its more than two-hundred-year history, the house burned three times, served as a barracks for state troopers, and endured condemnation and several renovations. When Governor McCreary moved to the new mansion in 1914, the old house was in shambles. But today it stands in historic Frankfort as a marker of Kentucky history while serving as a residence for the state's lieutenant governors. Despite everything, the red-brick house with green shutters remains true to its Georgian architectural roots and seems to have become more stately and prominent, perhaps, than ever before. The surrounding neighborhood has changed; happily it no longer overlooks the penitentiary, nor do its residents breathe the smoke from a flour mill. Given the home's location in old Frankfort, its tranquility reigns over a history where one can only imagine the clamor of noise and the smells and dust from the town's gritty struggles with settlement and industrialization.

In 1904, when the Kentucky General Assembly learned it would receive over 1.3 million dollars from the federal government as a settlement for Civil War damages, it appropriated a million dollars to finance a new capitol building, thereby forsaking the famous Greek Revival capitol designed by the architect Gideon Shryock. Also to be replaced was the old capitol's downtown neighbor, the declining governor's mansion. The mansion would follow in the footsteps of the capitol building; the two historic structures, downtown in old Frankfort, today are indispensable to Frankfort's living history.

A 1912 appropriation for the construction of a new governor's residence did not come too soon. The condition of the house was thought by some critics to be beyond repair, and

5. Clark and Lane, *People's House*, 11.

although it was insufficient for a governor's needs, it was beautifully restored in 1956 under the assumption that it would become a historic site. It eventually became the home of the Kentucky lieutenant governors and continues to serve this purpose.

The site chosen for the new mansion was far enough from town to be considered almost rural. The new state capitol building would rest on a neighboring hillock, but three different owners with houses on adjoining properties needed to be convinced to sell their interests in order for the state to proceed with its plans. Then, delays in everything—from problems receiving materials, to late changes in plans (the addition of a ballroom), to debates over contract negotiations—added to cost overruns that caused the initial appropriation to be inadequate. The final cost of the project was $91,500, which included the price of the land, the design and construction, and some furnishings. Although a proposal for landscaping had been created, the appropriation for the house could not be stretched to cover its cost.

Upon seeing this glorious house today, one thinks Kentucky made a wonderful decision—it was a lot of money in 1914, but it is a first-rate mansion by any standards. The massive house has a monumental appearance—three stories high, eighty by two hundred feet, and featuring Bowling Green limestone facing on walls of solid brick. Governor McCreary, said to have an "aristocratic bearing and notions" and an "aristocratic taste," strongly influenced the building's design. He insisted on the need for a ballroom, and his vision has paid dividends, both in compliments and in usefulness. Located at the end of one wing, next to the dining room, it is a valuable extension and an often-used and beautiful space. This luxurious, gilded room would have been at the heart of a French palace (which was its inspiration). The entire governor's mansion is architecturally reminiscent of seventeenth- and eighteenth-century French palaces, but the ballroom has the sort of opulence that stands alone and says volumes about its importance. Whether attending a formal dinner, a ball, or an afternoon meeting in this room, a visitor will never forget the occasion. In celebration of the opening of the building, McCreary hosted a reception for one thousand.

From their hillside setting, the governor's mansion and the capitol building overlook the Kentucky River valley. As elaborate Beaux Arts models, they are architectural complements. Each is a work of stone, with the formality, balance, and symmetry that mark the Classical architectural tradition that originated in Greek and Roman times and extended to influence America's Eclectic buildings so popular between 1880 and 1930. Beaux Arts design, of which the Kentucky governor's mansion is a prime example, was the most popular and typical of the styles produced during the Eclectic era.

The Beaux Arts style had its start in Paris in the middle of the nineteenth century. Many Americans seeking specialized training attended the French school of architecture at the École des Beaux Arts. The decorative style that emerged from this school, known for its embellishments and elegant ornamentation that were inspired by French Renaissance aesthetics, became a favorite American style between 1890 and 1917. Beaux Arts designs, strongly influenced by historical designs, were popularized by both the World's Columbian Exposition in Chicago in

1893 and the Centennial Exposition in St. Louis in 1904. Thus the architecture of the Kentucky mansion connects it not only to its own time but also to eighteenth-century France, and it also glorifies the early architecture of the French Renaissance.

Kentucky's Weber Brothers firm of C. C. and E. A. Weber was the official architect for the new governor's mansion, although the actual design is attributed to John Scudder Adkins. The Weber firm accepted the commission, managed the project, and is generally credited as the designer, but Adkins's architectural contribution is more than a matter of conjecture. Around that time, he was a partner in the firm, which was then listed as "Weber, Werner and Adkins." Moreover, a 1931 obituary of Adkins in the *Cincinnati Enquirer* states, "One of the buildings noted for its architectural splendor which was designed by Mr. Adkins is the Governors' Mansion at Frankfort."[6]

Adkins, an experienced architect from St. Louis, originally worked with a leading Missouri architect, George I. Barnett, designer of landmark buildings including the Italian Renaissance Revival Missouri governor's mansion. Adkins was proficient in Classical architecture and worked for other prominent firms, such as Shepley, Rutan & Coolidge, and Peabody & Stearns. In addition, John Adkins was an associate of F. M. Andrews of the firm that designed and constructed the 1910 Kentucky State Capitol building.

For sixty-eight years, seventeen families have taken turns living in and making demands on the building. The mansion has endured renewals, renovations, and redecorating schemes galore. Although the exterior has remained invincible, the interior changes have prompted controversy and sometimes contention. In addition to painting, decorating, and more, there has been one full-scale, down-to-the-bones restoration that took place during the Governor John Y. Brown administration from 1979 to 1984.

In 1968, at a cost of $79,385, Governor and Mrs. Louie B. Nunn renovated the mansion. Upon moving in, First Lady Beula C. Nunn noted the urgent need for repairs. In addition to having the roof, water-damaged walls, and warped floorboards repaired, Beula Nunn initiated a plan to raise money to buy antique furnishings for the house. Most of the original furniture was missing. By creating the Kentucky Mansion Preservation Foundation, Inc., in 1969, she reached across the state for contributions of money and historic native Kentucky furniture. One of her acquisitions was a four-poster bed with pineapple finials that had belonged to Governor Shelby.

When the house was placed on the National Register of Historic Places in 1972, it was the culmination of the efforts inspired and advanced by Beula Nunn during her husband's administration.

Governor John Y. Brown, owner of the famous Colonel Sanders recipe for Kentucky Fried Chicken and married to former Miss America Phyllis George, became governor in 1979 at a

6. William Seale, *The Kentucky Governor's Mansion: A Restoration*, 18.

time when the state was debating whether to build an entirely new governor's mansion or to launch a massive restoration of the present house.

Phyllis George Brown was a godsend for Kentucky. Her resolution and scholarly persistence saved an architecturally prominent twentieth-century landmark by giving it just what was needed to refuel its lovely legacy. Her belief in the prestige and pride that a restored People's House would confer on the state did not waver. But at the start, even the Browns did not fully understand the extent of the disrepair—until the fire marshal declared the house a firetrap unsafe for occupancy, and they were forced to retreat to their private home, Cave Hill, near Lexington.

In March 1980, the legislature enacted a bill to create a Governors' Mansion Commission to share the oversight of the restoration. Before the tenure of the Browns, there was no oversight, nor were there regulations for maintaining consistency in the stewardship of the house.

In concert with state officials, the Browns determined that the planning for the historic house called for a consultant experienced in period restoration. Historian William Seale of Virginia, endorsed by Kentucky curator of public properties William Floyd, accepted the job as chief consultant.

As a prelude to the restoration, the Browns invited the public to tour the house and hear the plans for its restoration. Phyllis George Brown described some of the anticipated work in the *Frankfort State Journal* on October 4, 1981:

> We have scraped away some of the build-up so you can see for the first time the beautiful plasterwork adorned with tambourines, flutes and laurel leaves, the details of which have long been hidden by 50 coats of white paint. Clearly one of the biggest jobs . . . will be painstakingly removing all of this paint so you can see the master craftsmen's artwork as they lovingly created it by hand in 1915.

This house is described as having been loosely based on the design, look, and manner of the Petit Trianon and the Grand Trianon, both opulent but private retreats for French royalty during the eighteenth century. The best way to conceptualize the mansion is to see it in terms of a small, elegant French palace—it is only "small" compared to full-blown palaces and that, regardless of its size, it is extremely liveable. In researching the Trianons, Phyllis Brown visited them and the nearby Palace of Versailles, the famous royal residence outside of Paris built by King Louis XIV.

The three-year, 3.5-million-dollar restoration, in addition to installing new electrical and plumbing systems, reclaimed the interior of the house from earlier makeovers, acquired French Neoclassical furniture that would make sense in a 1914 Beaux Arts mansion, and installed a garden to complement the house as it would have a similar building in eighteenth-century France or at the Palace of Versailles. The original elaborate parterre garden design was discovered and revised to include a fountain and extensive grading for gardens and walks on three levels as well as new winding drives that created a dramatic approach to the house.

The public rooms of the house are on the first floor, and the end of one wing is devoted to the enormous ballroom with a dinner seating capacity of 125. It contains the opulent trappings of the styles of the last French kings: massive crystal and brass chandeliers, gilded Corinthian columns and pilasters, deep crown molding and intricate cornices, shell and garland plaster motifs, tall wall mirrors, and multiple French doors. The vivid red, white, and gold colors underscore the room's royal ancestry.

The silver-leafed formal dining room is oval, and its ceiling is encircled with a halo of hundreds of lights set in silver-leafed plaster lilies and floral trim. Although the ceiling treatment had been original to the house, it had been removed during an earlier renovation; in the 1982 restoration, it was triumphantly returned.

The Browns started nonpolitical fund-raising with Save the Mansion, Inc. Within the first year, the group raised over seven hundred thousand dollars in private funds for the decorative aspects of the restoration. Eventually the amount raised from private sources totaled $1.5 million from private sources. State appropriations were used for the new wiring, plumbing, air-conditioning, and sewer renovation. Phyllis George Brown and Save the Mansion were awarded the Kentucky Heritage Commission's highest award for historic preservation.

Barely completed in time for Derby Day, 1983, the mansion's opening celebration was a gala Beaux Arts ball followed by the Governor's Derby Day breakfast. Responding to the enthusiasm surrounding the newly ordered mansion and grounds, the festivities were particularly elaborate. The traditional breakfast under tents, one serving four hundred VIPs and another for thousands of well-wishers—always a grand occasion for welcoming important national guests—this year carried an extra sparkle. Kentucky's celebrities and citizens all swelled with pride in admiration of the majesty of the house as they partook of the long-lived Derby Day ritual. Under the VIP tent, against the spectacular backdrop of the mansion's eight limestone Ionic columns, the only limit to the formality was a down-home southern breakfast of country ham, grits, and derby pie—a continuous Derby Day tradition—that was featured along with more gourmet selections.

Georgian architecture, the favorite formal style in eighteenth-century America, predominated in 1798 when the old governors' mansion was built. The house had essentially followed the design of colonial Williamsburg, which itself had been based on designs and styles transferred by its English founders from the motherland to the colonies. Then, in the 1890s, rich Americans began building monumental houses as a testament to their own great wealth. During that era, Beaux Arts was a leading style; when the 1914 mansion was designed in its grand manner, it was an appropriate expression of Beaux Arts tradition. These European designs, as interpreted by American architects, were often combined, using different historical styles within the same building. Rather than merely imitating the past, these architects brought an American expression to the European styles. This Americanization is what we see in the French-inspired Kentucky mansion.

The architects of the Kentucky governor's mansion reproduced styles in a place and time far removed from King Louis XIV, who had built the Palace at Versailles, King Louis XV, who completed the Trianon châteaux, and Marie Antoinette, who had found a place of refuge when she assumed ownership of the Petit Trianon. The architectural achievement demonstrates the impact of the École des Beaux Arts upon American architectural styles around the turn of the twentieth century.

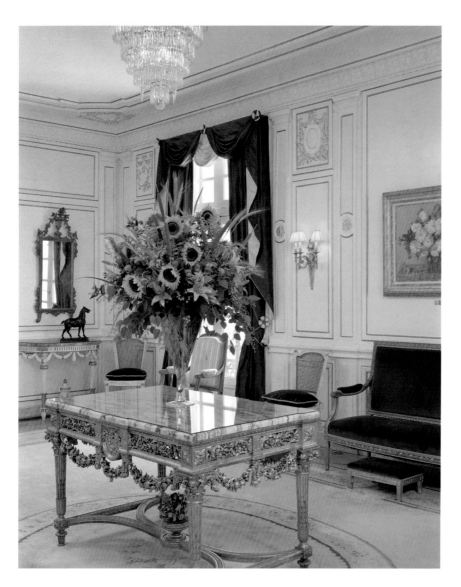

The most formal reception space is the Governor's reception room; the furniture is arranged around the walls as in the 1700s.

The First Lady's Salon, or drawing room, which holds some of the finest French furniture in the mansion. The furniture in this room is arranged to reflect the era in which the house was built.

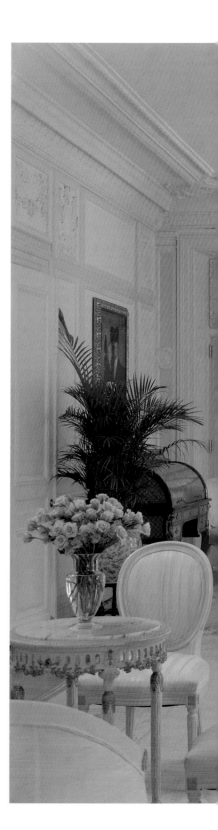

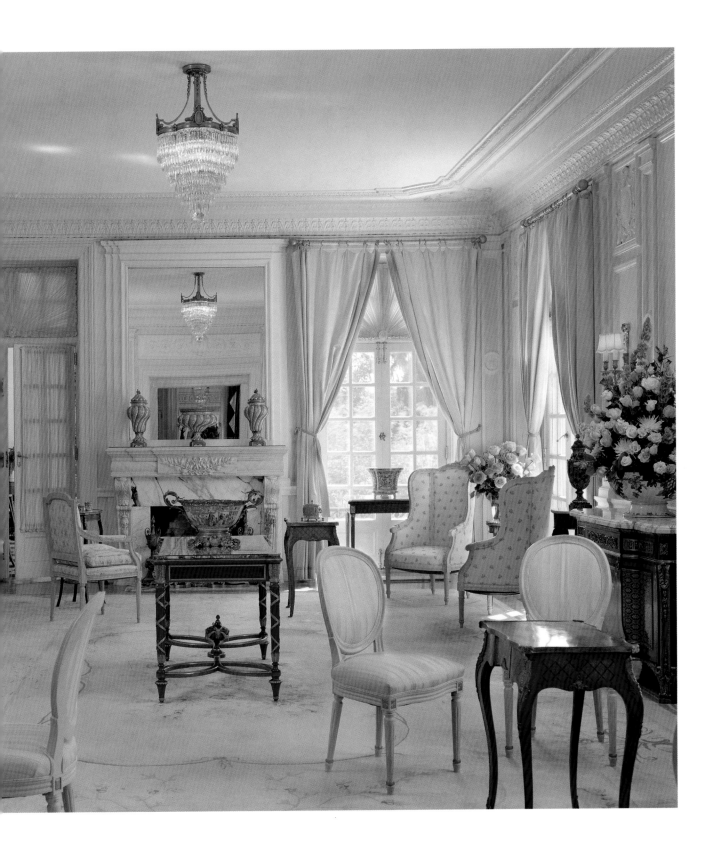

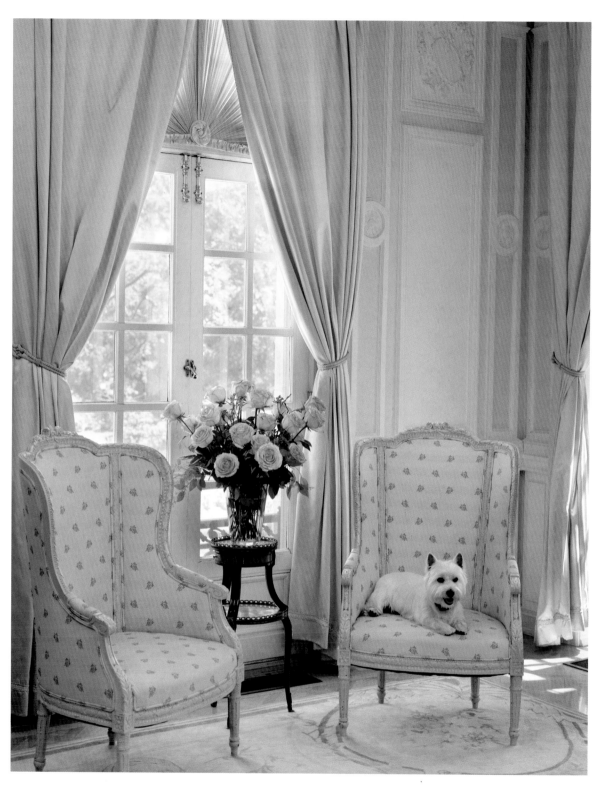

Abby, Governor and Mrs. Ernie Fletcher's dog, in the First Lady's Salon,
is resting on a chair in front of one set of the beautiful French doors.

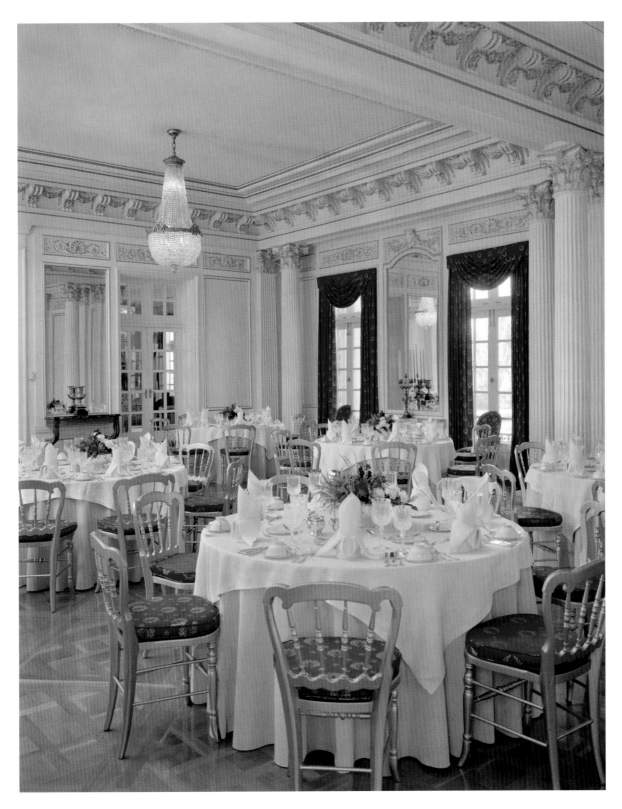

The ballroom is the most ornate room in the mansion. This
corner of the room shows tables set for a large dinner.

The Little Dining Room, or family dining room, has Kentucky poplar woodwork and a red ceiling and contains a fine collection of nineteenth-century Chinese imports.

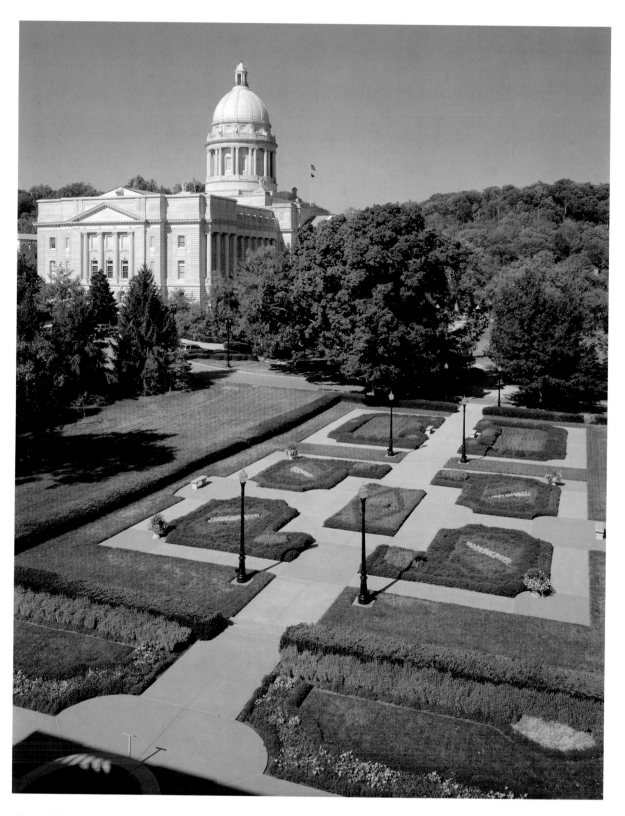

View of the mansion grounds, showing the capitol building in the background
and a view of the parterre garden design of the front lawn of mansion.

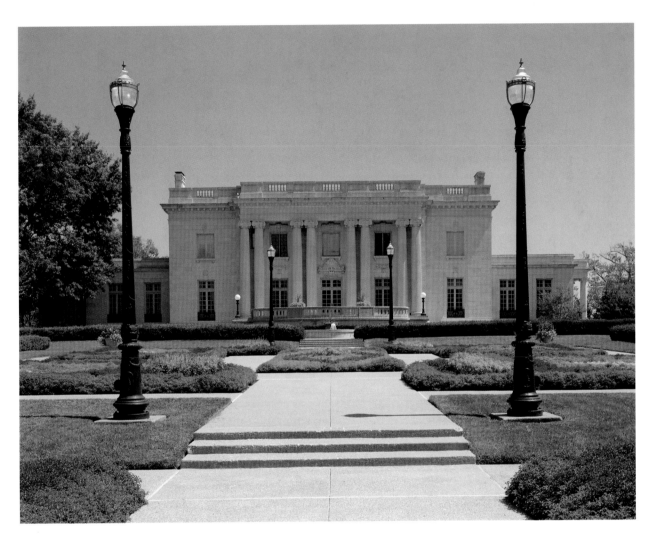

Front view of the Beaux Arts mansion, showing the formality
and symmetry of the grounds and the house.

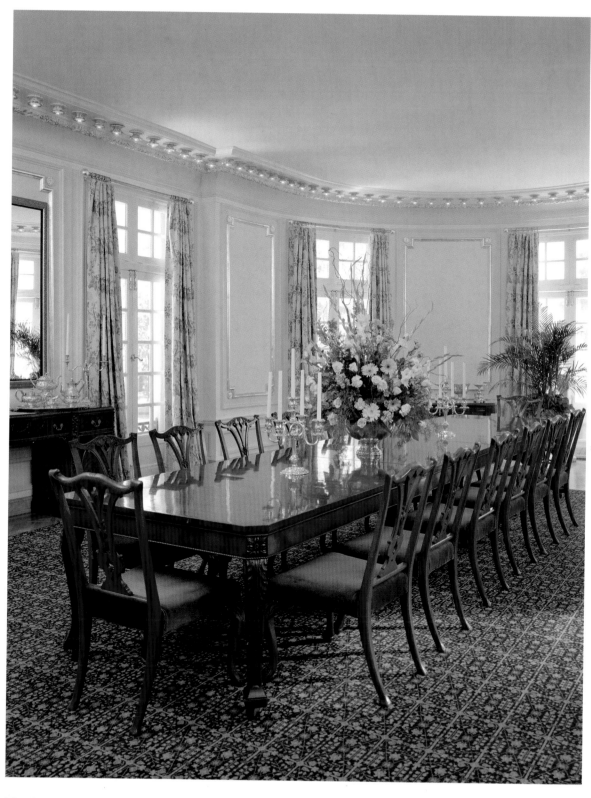

The State Dining Room has hundreds of ceiling lights, creating a halo of silvered lights set in rosettes. Original to the house, they were part of the 1982 restoration.

Louisiana
Governor's Mansion

Location: 1001 Capitol Access Road, Baton Rouge

Construction Completed: 1963

Cost: $893,843

Size: 25,000 square feet

Number of Rooms: 25

Architect: William C. Gilmer

Architectural Style: Greek Revival

Furniture Style: Nineteenth-century American and
English antiques and reproductions in the Georgian,
Federal, Empire, and French Restauration styles

Separated in time by more than 120 years, Hernando de Soto and René-Robert Cavelier, Sieur de La Salle never met, but the paths of the two explorers overlapped as they faced similar challenges while exploring the Mississippi River and its environs. De Soto led Spanish explorers into the lower Mississippi River area on a quest for gold in the name of King Ferdinand of Spain in 1541. In 1682, La Salle traveled down the Mississippi River and claimed the entire Mississippi River valley for France, naming the territory Louisiana in honor of King Louis XIV.

The Louisiana region became an afterthought until France began to fear encroachment from England and Spain and sent Pierre Le Moyne, Sieur d'Iberville to establish a colony there, which, in 1699, officially became the Royal French Colony of Louisiana, much larger than the present state of Louisiana. Iberville would be governor of the royal colony until his death in 1706.

In 1699, on a bluff overlooking the Mississippi River floodplain, Iberville saw a pole, red with blood and covered in animal remains, being used to mark boundaries of the Houmas and the Bayougoula Indian hunting grounds. He named the site Baton Rouge—which translates to "red stick"—and this land later evolved into the capital of Louisiana.

As the settlement of Baton Rouge grew, its buildings clustered around the Mississippi. Squat, half-timbered houses, churches, and other wooden buildings were given French embellishment, trimmed with gingerbread and decorative details.

New Orleans, a small, swampy settlement in the wilderness, was founded in 1718 as a site for a new French capital, but its growth was so slow that when it became the capital in 1722, it remained essentially unsettled. Its ambitious city plan had platted forty-four square blocks, but the settlers were still only projecting and not yet building most of the streets and had only completed a scattering of primitive homes. Nevertheless, successful and progressive planning led to the eighteenth-century New Orleans, which developed around the Place d'Armes or Jackson Square into the unique and beautiful French Quarter, encompassing businesses and the incomparable townhouses with courtyards and decorative cast-iron gates.

President Thomas Jefferson sent his emissary to negotiate with France for the purchase of Louisiana, and in 1803 Napoléon Bonaparte astounded the Americans by selling the entire Louisiana Territory for a mere fifteen million dollars to the United States. Almost doubling the nation's size, the transaction provided the land for thirteen future states. But Baton Rouge was not part of the deal; at the time of the Louisiana Purchase, it was part of Spanish West Florida. It was not until 1810, when the settlers overthrew the Spanish, that it was annexed to the rest of Louisiana.

Louisiana's cosmopolitan population had deep roots, and despite the mix of identities—French, Spanish, Creole, African, Indian, or West Indian—the French culture historically prevailed, although the area passed out of French hands in the 1760s and only returned to French dominion for a short time in the 1790s. In 1812, Louisiana joined the Union as the eighteenth state. In 1815, in the Battle of New Orleans, the British charged toward Louisiana in an attempt

to sever the state from the country. The American victory was profound—there were over two thousand British casualties and only seventy American. General Andrew Jackson and his Kentucky and Tennessee militiamen were joined by the infamous pirate Jean Laffite. They not only defeated the British but also renewed the sense of unity in the population and raised the prestige of the military. Laffite was pardoned by President James Madison, but he later returned to piracy and eventually sailed away from the United States.

New Orleans was designated the first temporary capital until Baton Rouge became the permanent capital in 1846. Then, when Louisiana joined the Confederacy in 1861, the state had become a prosperous agricultural region with a major shipping harbor in the great port city of New Orleans. Formerly dominated by sugar plantations, the Louisiana economy collapsed because of the war and its aftermath. The war ruined the shipping business. Before the Civil War, the state ranked second in per capita wealth in the nation.[1] The Union forces took over Baton Rouge in 1862 and occupied it for most of the Civil War. After the war, Federal troops remained in Louisiana longer than in any other state; Reconstruction ended there in 1877. During the war, the capital moved from place to place and Baton Rouge did not become the capital of Louisiana again until 1882.

Louisiana governors have occupied four official residences in Baton Rouge. Information about the first is sketchy, but we know it was a short stay in a rented house. In 1887, the state acquired a large two-story house built shortly before the Civil War by local businessman and landowner Nathan King Knox. Built in 1857, it was a combination Colonial and Greek Revival style townhouse, and for the next forty years, it served as the governor's mansion.

In 1928, Huey P. "Kingfish" Long became governor and launched a comprehensive building plan. In an effort to leave his mark on a modernized Louisiana, Long constructed roads and bridges, a new state capitol, and a new governor's mansion. When the legislature rejected his request for the new governor's mansion (considering the house to be useful as long as it was still standing), the bold and not-to-be-deterred Long instructed a crew of convicts to demolish the house, calling it dilapidated from termite damage. In 1930, ground was broken for a new mansion, a monument to himself, Governor Huey Long.

"Huey Long wanted to be president, so he built the new house to resemble the White House," said Peggy Hunt, the education coordinator for the Old Governor's Mansion.[2] Reminiscent of the U.S. president's official home, the "Louisiana White House" had four thirty-foot columns, a slate mansard roof, and a carved pediment over the entry. Constructed on the same property as the earlier governor's mansion, it cost $150,000.

The New Orleans architectural firm Weiss, Dreyfous and Seiferth designed the four-story Neoclassical house with Georgian influences, a style popular at the turn of the century. After serving nine governors and for over almost thirty years as the official residence, its great style

1. Leonard V. Huber, *Louisiana: A Pictorial History*, 16.
2. Peggy Hunt, telephone interviews with author, November 2005, October 2006.

lives on. Today the grand scale of the house, both inside and out, is still evident. In addition to being a living museum with nearly perfect restoration, the house is the headquarters for the Foundation for Historical Louisiana. It is on the National Register of Historic Places. Since Hurricane Katrina in 2005, it has been the setting for historic meetings sponsored by the National Trust and the Preservation Resource Center of New Orleans to study and plan for rebuilding and restoration.[3] Additionally, it is frequently used by private and public groups as a site for special events.

Governor James H. Davis served two four-year terms spaced sixteen years apart. Between 1944 and 1948, Governor and Mrs. Davis lived in the house built by Huey Long. But in 1960, during his second term, citing badly needed work and the cost of the repair, Davis promoted selling the house and building anew. Some citizens echoed his sentiment, hoping to replace the Huey Long house with one that would resonate more closely with Louisiana architecture.

Governor "Jimmy" Davis, a celebrated entertainer and actor in the country music world, enjoyed a wide popularity that boosted his success in launching a new governor's mansion project. Still, the state's taxpayers angrily debated the project, and a lawsuit was filed to block construction. But once the lawsuit was thrown out of court, the project quickly proceeded, and within a month of the lawsuit's dismissal, an official groundbreaking took place.

The 1961 groundbreaking for the future Greek Revival house represented a million-dollar price tag. Considered pretentious and extravagant by some, it received support from others who thought it a boon for the state. There were those, as with all new mansion proposals, who suggested having no governor's mansion at all.

Oak Alley, an antebellum Louisiana Greek Revival style house, was the inspiration for the new governor's mansion. In using Oak Alley as a model, the Shreveport architectural firm of Annan and Gilmer did not strictly adhere to the Greek Revival style—for example, the prominent third-floor dormers would not have been typical, and the fanlight over the front doorway entrance and the tall window over the circular stairs in the rotunda were Georgian features. Built in 1839 as a manor house for a wealthy Creole planter in Vacherie, Louisiana, Oak Alley is surrounded by massive white Doric columns, and similarly the governor's mansion is flanked on three sides by lofty Doric columns creating a spacious gallery for three sides of the house. Oak Alley, as in most plantation houses, has a second-story veranda, but the architects did not emulate this feature, thinking it would add an air of informality to the stately design they were seeking.

The grounds and exterior space surrounding this mansion are outstanding. There is privacy for the residence, but there is also great beauty. Most southern gardens seem to be faithfully attended and cared for, and those of the governor's mansion are no exception. A perfectly planned herb and vegetable garden looks as if it could have been lifted from France to

3. *Foundation for Historical Louisiana* (newsletter), fall 2005, 1.

Louisiana—the diagram and arrangement, color and sizes of the plants are perfect. Lovely flower gardens abound in addition to good landscaping, a broad lawn, and trees of boxwood, dogwood, magnolia, and oak.

On the mansion's eight acres are a swimming pool, tennis court, patio areas, arbors, a fountain, and notable sculptures. The parking area accommodates fifty cars. Lampposts lining the parking lot were at one time used to light the streets of Plymouth, England. They have antique copper lanterns that are also from Europe. New Orleans style cast-iron railing decorates the white brick walls that bound the area. The white brick exterior of the mansion is trimmed with a green slate roof and matching slate on the wide porches.

Upon entering the foyer of the governor's mansion, one sees the rotunda with a Classical spiral staircase. Other Greek Revival features are the pilasters and Ionic columns that separate the foyer from the rotunda. The mansion's huge interior contains twelve bedrooms and eighteen bathrooms. The final price of this house was short of the earlier projected one million dollars; in the end it cost $893,843. With the completion of the house under budget, the critics seem to have been mollified. According to an article in the *State-Times,* the mansion is "a sparkling creation" and "the state is getting its money's worth in materials and craftsmanship. What the state has now is a showplace. As the years go by we'll forget some of the differences."[4]

Following the precedence of Louisiana plantation homes, the doors and window casings in the state rooms were designed to emulate trim and embellishment used in houses of the Greek Revival style. Secondary doors lead to the porches from the state rooms as they would in Oak Alley and in the Vieux Carr in New Orleans.

For thirty-three years, between 1963 and 1996, five governors lived in the mansion, minimally maintaining the house and making only sporadic attempts to refurbish. "Indeed there hadn't been a first lady in the mansion for years, and the place, according to some, looked more like a man's lodge than the residence of the state's chief executive."[5] In 1996, Governor and Mrs. Murphy J. Foster moved into the house and found poor-quality, random pieces of furniture and incompatible styles of rooms. Yet these were minor concerns in comparison to the state of disrepair. They launched a full restoration to return the house to a landmark. Alice Foster organized the Louisiana Governor's Mansion Foundation, a Design Advisory Council, and a Circle of Friends Program to raise money statewide and to oversee the project.

In 1998, the legislature, in special session, established a commission charged with managing the residence as a public trust. Alterations, acquisitions, and furniture removal all became subject to approval of the Governor's Mansion Foundation.

A monumental mural painted by the founder of the Fine Arts Museum in New Orleans graces the entrance foyer. It was a contribution to the mansion by generous benefactors, Mr.

4. Charles Richard, *A Place Worth Preserving,* 17.
5. Ibid., 18.

and Mrs. Joseph Canizero of New Orleans. The artist, Auseklis Ozols, spent six months capturing Louisiana scenery in full color, depicting the flora and fauna and important symbols of the state, including representations in the mural of governors who had lived in the mansion. The artist explained his work: "Above the two grand entrances to the parlor and the dining room, I placed two cartouches, one comprised of Louisiana flowers, and the other over the entrance to the dining room of fruits, vegetables and other produce of Louisiana. Of particular interest to me were the large leaves of Perique Tobacco that grow only in St. John Parish and nowhere else in the world. I strove to include our main industries such as oil, fishing and shrimping."[6]

The foyer, or entrance hall, and the rotunda have a floor of Italian marble, with a motif in the rotunda containing twenty-five hundred pieces of marble that form the state seal. The artist and two assistants spent six weeks designing the details. Located in the foyer are a pair of Empire mahogany bergères dating from 1815 and attributed to Henry Connelly of Philadelphia.

In the entrance hall and in the rotunda, the light fixtures, crystal globes, and an Adam lamp are etched with the Great Seal of Louisiana and were brought to this house from the old governor's mansion. Under the chandelier in the foyer is a round burl walnut table sixty inches in diameter, an eighteenth-century reproduction of a European Empire style.

Portraits of the governors who have resided in the house line the stairs of the winding staircase in the rotunda. Under the stair is a hand-carved mahogany settee made by Louisiana furniture maker Glen Armand.

On one side of the reception hall is the drawing room and on the other is the dining room. They are overlarge, the drawing room measuring twenty-five by forty-five feet, and the dining room twenty-five by thirty-five. Their chandeliers are matching five-foot, thirty-branch crystal chandeliers made around 1830. Obtained in Europe, they were fashioned in New Orleans for the governor's mansion. Bronze doorknobs from the old mansion are embossed with the state seal.

Most of the drawing room furnishings are reproductions of eighteenth-century pieces. Two console serving pieces with marble tops are from the old mansion. Their original wooden tops were changed to marble for the new mansion. Alphonse Koble, a cabinetmaker from New Orleans, made many of the eighteenth-century reproductions in the present mansion. Two tables were purchased from the late Rupert Kohlmaier, who was another highly respected New Orleans cabinetmaker.

The dining room table has a twenty-one-foot top made from an antique table from England. It can be used as one table or arranged into six separate tables, each seating six guests. Two Empire pier tables on either side of the fireplace were purchased for the mansion during the administration of Governor David Treen, 1980–1984. They had been purchased in 1825 for a

6. Auseklis Ozols, correspondence with governor's mansion, February 13, 2003, Governor's Mansion files. The mural was completed February 14, 2003.

notable Federal home in Lexington, Kentucky, and were probably made in Philadelphia. An antique sideboard dating from the 1800s, donated to the mansion during the Treen administration, was restored in 1984 by Rupert Kohlmaier. A renovation during the Treen administration removed the original wood mantel and added today's marble mantel.

Designed as a Greek Revival house, the residence in Louisiana is one of six southern governors' mansions of that style. In Louisiana, it became the dominant look after 1830, epitomizing the southern plantation home. Similarly the house's interior contains much that symbolizes the state's geography and rich environment. The architecture, inspired by the historic Oak Alley, represented a change in the house styles of Louisiana: earlier homes used local cypress as the primary material, and those houses were influenced by Spanish and French styles prevalent in the West Indies. But the Greek Revival design is more formal than the earlier vernacular styles. Greek Revival houses were not only for plantations, but also often served as the high-style townhouses of the upper class. As symbols of Greek democracy, they resonated with Americans after they had fought so hard and successfully to free themselves from the unpopular and unwelcome domination imposed by the British.

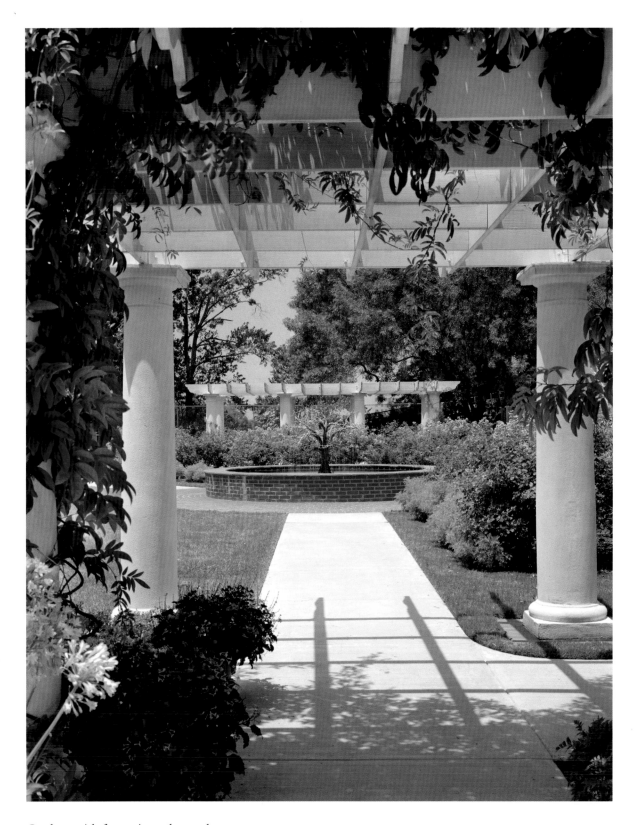

Gardens with fountain and pergolas.

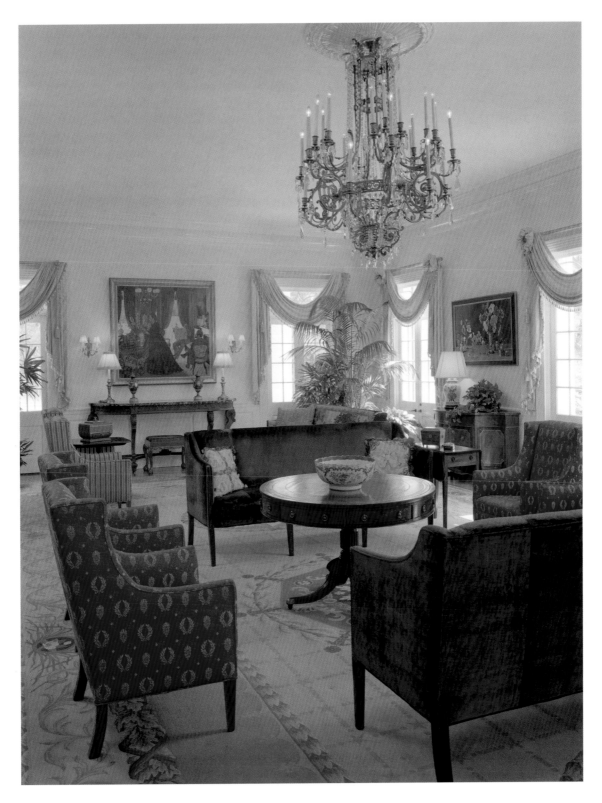

The State Drawing Room, with one of two large marble-topped console
tables that were purchased for the old governor's mansion.

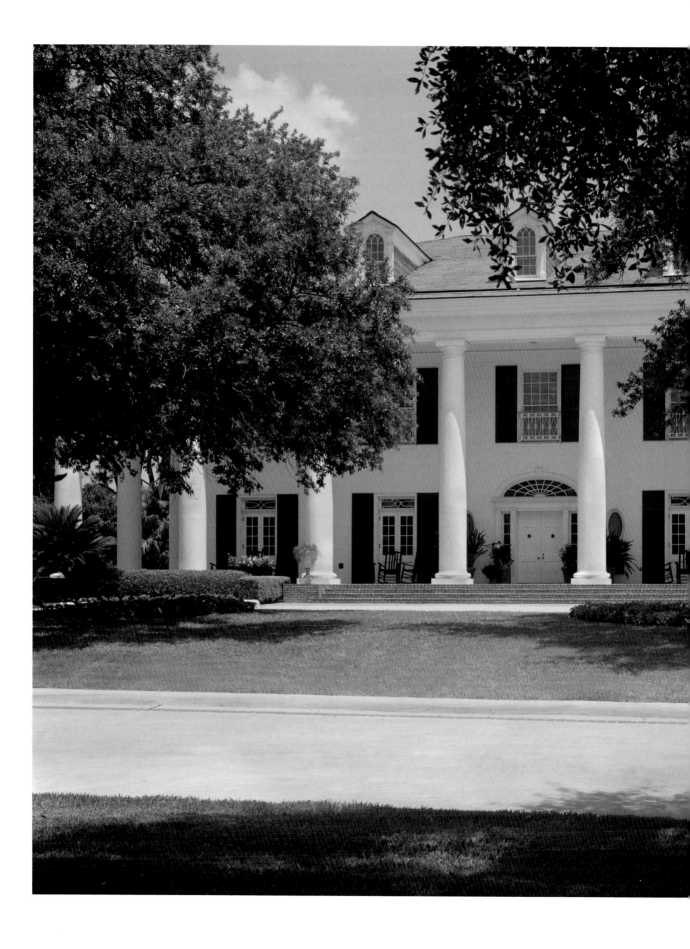

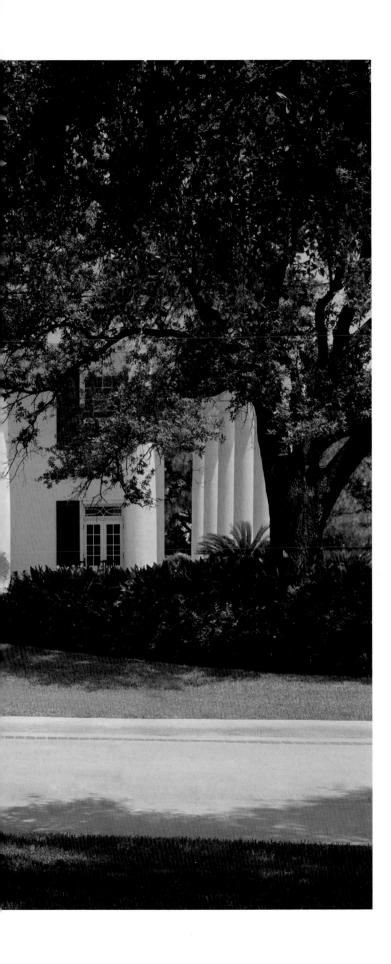

Front view of the Louisiana
governor's mansion.

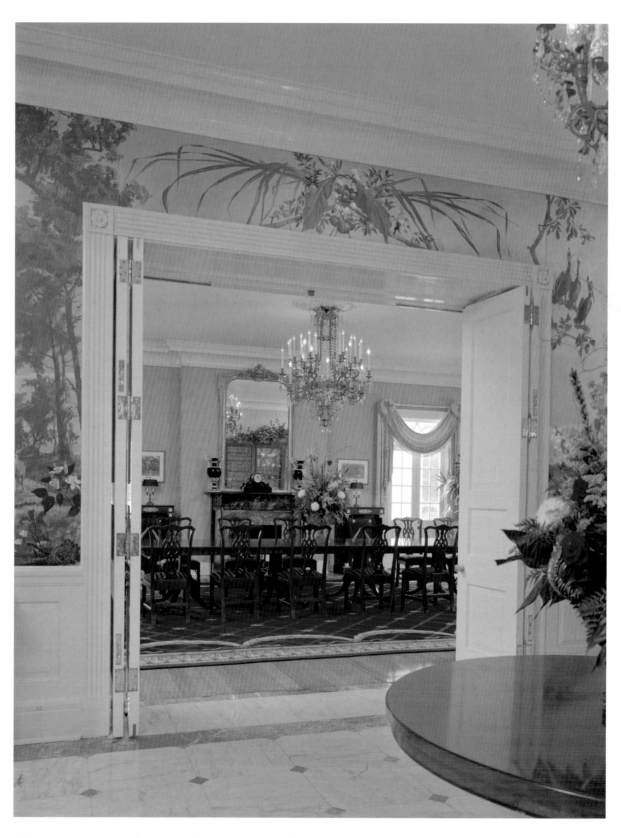

Viewing the State Dining Room from the foyer. The massive tabletop
was made from an antique table brought from England.

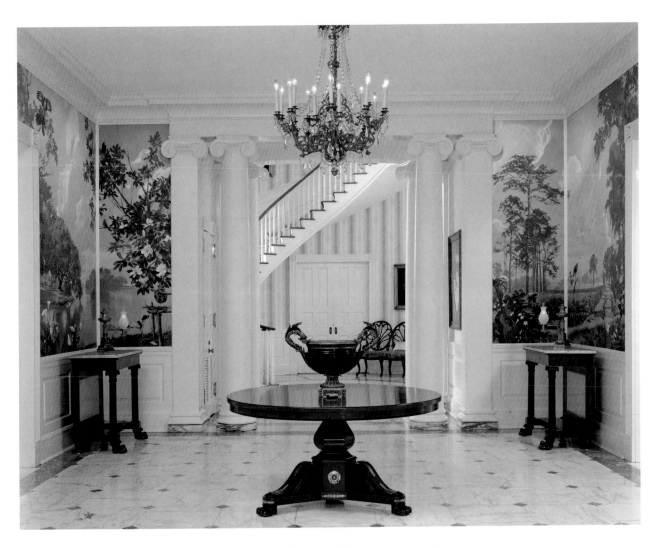

The foyer's mural depicts Louisiana scenery. The foyer and the rotunda seen in the background are paved with imported marble fabricated in Italy. The chandelier, engraved with the state seal, hung in the old governor's mansion.

The herb garden also contains the square foot garden. The sculpture, *Camille,* is the centerpiece of the square foot garden.

Mississippi
Governor's Mansion

National Register of Historic Places

National Historic Landmark

Location: 300 East Capitol Street, Jackson

Construction Completed: 1841

Cost: $50,000–60,000

Size: 10,350 square feet (original); 22,911 square feet (current)★

Number of Rooms: 16 (original); 54 (current)★

Architect: William Nichols

Architectural Style: Greek Revival

Furniture Style: Nineteenth-century American antiques in the Empire style with select pieces of French Restauration, Rococo Revival, Gothic Revival, and Renaissance Revival styles

★ Both measurements include the basement.

The Spanish conquistador Hernando de Soto and his band of explorers entered what we now know as the state of Mississippi in 1540 seeking gold and treasure. Finding none, they moved on, and the next whites to enter the region were French explorers. In 1682, René-Robert Cavelier, Sieur de La Salle led an expedition from the Great Lakes down the length of the Mississippi River to the Gulf of Mexico, claiming the entire Mississippi Valley for King Louis XIV and naming it Louisiana in his honor.[1] This vast area included present-day Mississippi.

In 1699, France made the first permanent settlement in Mississippi at old Biloxi, which was soon followed by another French settlement at present-day Natchez; in 1719, the first slaves were imported from Africa to work as field hands for the French colonists. The Indian tribes who controlled most of the territory fought this encroachment and were later joined by the British in a battle for possession of the land.

Following the French and Indian War in 1763, the signing of the Treaty of Paris gave Britain all of the French territory east of the Mississippi River, thereby putting the Mississippi region under British rule.

Twenty years later, as a result of the British losing the Revolutionary War, the Mississippi region was made part of the newly created United States. The original Territory of Mississippi was organized in 1798, Natchez was named the capital, and the territorial borders included most of present-day Mississippi and Alabama. Mississippi did not acquire its modern boundaries until it joined the Union in 1817, at which time Congress separated Alabama as its own territory.

The site of the city of Jackson was originally a French trading post called Le Fleur's Bluff. Located on the western side of the Pearl River, it was chosen in 1822 as the site for a new capital for the state of Mississippi. In addition to its beauty and large timber resources, it was favored for its central location and proximity to the Natchez Trace and navigable waters. The future held promise for the tiny speck of a place that at the time included only about a dozen families.

The new town was named Jackson in honor of war hero General Andrew Jackson, who defeated the British army in the Battle of New Orleans in 1815 and who vanquished uprisings of the Seminoles in 1817. When the capital was first moved to this site, the governors maintained their residences in other places and traveled to Jackson as needed to perform their official duties. In 1832, when a new state constitution required the governor to maintain an official residence in Jackson, the new Mississippi legislature appropriated ten thousand dollars to build a house for the governor. By this time, the state of Mississippi was growing rapidly, and the Native Americans in the region were being forced to move to the Indian Territory (now Oklahoma). The agricultural economy based on cotton production was thriving. Mississippians welcomed the addition of a governor's mansion as a sign of the state's remarkable economic growth. Building a monumental governor's mansion in 1841 transformed Jackson's identity

1. Anka Muhlstein, *LaSalle: Explorer of the North American Frontier*, 157.

from mere frontier town to sophisticated social and political center. A Natchez newspaperman wrote, "Much is anticipated by the elite here. . . . When the Executive Mansion shall be ready[,] . . . levées, re-unions, routs, conversationes, déjeuners, and soirées, will be the order of the day, and our political metropolis will become more gay, fashionable, and attractive."[2]

The Panic of 1837 forced the suspension of public works projects and also delayed the construction of the governor's mansion. The groundbreaking did not take place until 1839, but the outcome was well worth the wait. Completed in 1841, the mansion's first occupant, Governor Tilghman Mayfield Tucker, who was inaugurated January 10, 1842, took up residence in one of the jewels of fine building design.

Standouts among their peers, the governors' mansions in Mississippi, Texas, and Virginia are the only three official governors' residences to be designated as National Historic Landmarks by the National Park Service, U.S. Department of Interior. This is in addition to their inclusion in the National Register of Historic Places. Mississippi's is the second oldest mansion in the United States designed to house governors and to be continuously used for its original intended purpose.

The original financial allocation of ten thousand dollars proved woefully inadequate for the spacious building now regarded as likely to be "William Nichols' finest in the domestic Greek Revival style."[3] The final cost of the mansion is estimated to have been between fifty and sixty thousand dollars. The professionally trained English architect William Nichols settled in Mississippi after serving as state architect in both North Carolina and in Alabama, where he built a number of important public buildings, although, unfortunately, few of these have survived, including the original capitol building in Tuscaloosa, Alabama.

Hired as the Mississippi state architect, he designed the 1839 state capitol. The now-historic old capitol building survived a spell of disuse and was restored in 1961 to all of its original elegance; it served as the state history museum from 1961 to 2005.[4] It was also a place of honor, where Mississippi's favorite sons and daughters lay in state. Such was the case for Willie Morris and Eudora Welty, famous Mississippi writers whose visitations in the lavish rotunda under the dome were attended by luminaries including John Grisham, David Halberstam, Jim Lehrer, and Roger Mudd. This honor is a rare occurrence, as prior to Willie Morris in 1999, there were probably only two individuals who lay in state in this building in all of the twentieth century.

Nichols finished the governor's mansion after completing the state capitol, and later he designed the Lyceum at the University of Mississippi in Oxford, a three-story brick building with a monumental portico and six Ionic columns that remains at the heart of the campus of today's Ole Miss.

2. *The Governor's Mansion: A Pictorial History,* 5.
3. Helen Cain and Anne D. Czarniecki, *An Illustrated Guide to the Mississippi Governor's Mansion,* 13.
4. Lucy Allen (director, Museum Division, Mississippi Department of Archives and History), correspondence with author, March 6, 2006.

Between 1820 and 1850 the Greek Revival style was so popular that architects were using it for public buildings as well as private homes; in fact, as some have contended, the "style is typical of many antebellum southern mansions but had its greatest triumphs in public architecture." Many of the larger, grander buildings of the era look like Greek temples; the structures are indeed remarkable. "In the lower Mississippi Valley, the Greek Revival reached an apogee of refinement, with attenuated columns like those in Stanton Hall in Natchez and the Governor's Mansion in Jackson, Mississippi."[5]

An entire city block in the middle of downtown Jackson is dedicated to the governor's mansion. The grounds are surrounded by a 1971 brick wall and iron fence that replaced an 1855 iron fence, which was itself a replacement for the original wooden fence. Long gone from the mansion's east lawn are the nineteenth-century outbuildings like the kitchen and the stable, which have been replaced by a formal garden. Also long gone from the rear of the original brick mansion is a one-story cottage that was torn down to build a two-story annex to the mansion. This 1909 annex was later replaced by the 1975 annex, which provides office space and private living quarters for the governor and first family.

As Jackson grew and its downtown center became better established, tall office buildings arose and the serenity of the governor's residence contrasted with the bustle of emerging city life. Yet the governor's mansion remains a calming oasis occupying the busiest street corner in the middle of downtown Jackson.

The architect's intention was "to avoid a profusion of ornament and to adhere to a plain simplicity, as best comporting with the dignity of the state," and he certainly succeeded.[6] A two-story, semicircular portico that has an overhanging balcony is supported by four Corinthian columns. The portico is contained and graceful, enhancing the grand appearance without adding a fancy or pretentious note. Further, this portico somewhat downplays the majesty and power of the big rectangular house by offsetting it with airy lightness rendered by everything from the size of the porch (twenty-eight by twelve feet), the elegance of its curved shape (inspired by the fourth-century BC monument to Lysicrates in Athens, Greece), to the precision of the hand-carved acanthus leaves of the capitals to the fluted columns. While there is nothing demure about the portico, it does not run the full width of the house, and it is of the Corinthian order, the least bold of Greek orders.

The Corinthian columns are also repeated on the interior and serve as unifying elements. These columns separate the octagonal foyer from the back stair hall. In a 1909 renovation, a center staircase replaced the 1841 staircase, and the present one was restructured in the original location to comport with the architect's plan.

5. David G. Sansing and Carroll Waller, *A History of the Mississippi Governor's Mansion,* 10; John Burchard and Albert Bush-Brown, *The Architecture of America: A Social and Cultural History,* 96.
6. Cain and Czarniecki, *Illustrated Guide,* 11.

The interior has exquisite detail and ornamentation. Greek Revival motifs are abundant. A cast plaster acanthus leaf frieze, repeating the motif of the portico, decorates the ceiling cornice molding in the octagonal foyer. Ornately carved wooden architraves with the Greek anthemion of stylized honeysuckle design surround the front door, the smaller parlor doors from the foyer, and the large sliding doors separating the double Rose Parlors on the west side and the State Dining Room and the Gold Parlor on the east side. According to governor's mansion curator Mary Lohrenz, "Architect William Nichols based his design for these beautiful architraves on engravings published in an 1839 pattern book, *The Beauties of Modern Architecture*, by Minard Lafever. William Nichols also used this same pattern book for the rosette design of the wooden mantel, which remains in its original bedroom location. The rosette was yet another popular Greek Revival motif."[7]

Jackson, Mississippi, may seem a placid place today, but it was hardly tranquil during the upheaval of the Civil War. The city was occupied four times by Union troops, and although there were some heavy losses of property, probably not to the extent implied in the post–Civil War nickname *Chimneyville*. Spared by General William Tecumseh Sherman in his July 1863 occupation of Jackson were the governor's mansion, the state capitol, the city hall, as well as private residences.

There is no evidence to support the theory that the Union army used the governor's mansion as headquarters, but a letter written by General Sherman dated July 19, 1863, documents that Union officers entertained themselves at the mansion on at least one occasion. Also, a letter written by a physician, R. N. Anderson, dated May 29, 1863, documents that wounded Confederate soldiers were housed at the mansion.

Following the Civil War, the governor's mansion came under carpetbagger rule, and an acting federal appointee began serving as governor, replacing the elected governor, Benjamin G. Humphreys. Governor Humphreys was forcibly removed from his capitol office in 1868 and commanded to vacate the governor's residence by Federal troops. Federal rule ended in 1876, and the mansion was turned back to a popularly elected governor.

While rebuilding Mississippi was a high priority, it was a slow and costly process. Most of the post–Civil War attention was on physically reconstructing the South as well as rebuilding an economy that had been based on a plantation system using slave labor. The upkeep of the governor's mansion was not a pressing matter to those preoccupied with maintaining a livelihood.

When Governor Edmond Noel began his tenure in 1908, a decision was made to repair and renovate the residence, and the legislature appropriated $30,000 to that end. During the 1908–1909 renovation, a two-story annex was added to the back of the house to better accommodate a governor's family. A layer of yellow pressed brick was applied to the original mansion exterior to match the yellow pressed brick of the two-story annex.

7. Mary Lohrenz, interview with author, October 7, 2004, and telephone interviews and correspondence with author, March and April 2006, and June 27, 2007.

In the 1940s, Governor Paul B. Johnson Sr. had the brick exterior painted white, as it remains today. Also in the 1940s the state authorized funds to acquire furnishings that were mostly period historic pieces.

Inasmuch as periodic appropriations for repairs had been insufficient to maintain the mansion adequately, the state in 1972 commenced a major overhaul and restoration for the house. Two noted consultants were hired—architectural historian Charles E. Peterson, known for his work on Independence Hall, and architect and interior designer Edward Vason Jones, known for his work on the White House. Using historical documentation, the consultants were able to discover important information relating to the origins and workings of the house.

Over the years, certain features of the house had been removed or altered. The original staircase had been removed; a grand central staircase was reconstructed in its 1841 location. In addition, the original yellow heart-pine floor had been covered with a thin hardwood floor, and the wooden front door had been replaced with a beveled glass door. In the restoration, the original wide-planked heart-pine floors were once more displayed as originally intended, and a new wooden front door was designed with a Greek key motif. At this time the two-story 1909 annex was falling apart and had been condemned for use. It was removed and replaced with a structurally sound addition.

The Greek Revival style of the mansion called for furnishings reflecting Classical designs and motifs. Edward Vason Jones selected the elaborate Empire style of furniture, named for Napoléon. It is of the highest quality and features gilt stenciling, ormolu (gilded brass), and motifs such as acanthus leaf, athemion, cornucopia, dolphin, lyre, and rosette. Jones also determined that nineteenth-century furniture connected to past governors should be retained as part of the house. When the restoration was completed in 1975, the house was fully furnished with museum-quality pieces—primarily the Empire style, but also accented with particular pieces in the French Restauration, Gothic Revival, Rococo Revival, and Renaissance Revival styles.

Strong interior colors, typical of a high-style Empire period home, are used for paint on the walls, as well as for the reproduction carpets, upholstery, and window coverings. In the double Rose Parlors the colors are shades of rose and red. The colors continue to the second floor, where the bedrooms are designated by their color—the green bedroom, the pumpkin bedroom, the gold bedroom, and the cream bedroom.

The bedrooms contain a combination of styles including Empire and that of the Rococo, Renaissance, and Gothic revivals. Some of the furniture has a connection with one or another of the earlier mansion occupants, whereas other pieces came from outside Mississippi. The latter is the case in the Pumpkin Bedroom; its early-nineteenth-century tall post bed, Gothic Revival bookcase, and three gondola side chairs were donated to the mansion by Mrs. Ferdinand P. Herff of San Antonio, Texas, in 1975.

William Seale, who has guided many of the restorations for American governors' mansions, has been a consultant for more recent furnishing acquisitions, especially for the mansion bedrooms.

This restoration cost $2.7 million but did not provide for renovation of the grounds. First Lady Carroll Waller raised the money separately, obtaining it from private sources to match a twenty-thousand-dollar grant from the Mississippi American Revolution Bicentennial Commission. Landscape architect Bill Garbo designed formal gardens with paved walkways, boxwood hedges, a Classical urn fountain, and two gazebos to complement the Greek Revival style mansion. A rose garden was encircled by a cast-iron fence, a miniature replica of the fence that surrounded the mansion from 1855 to 1908.

The major restoration and renovation took three and a half years before being completed in 1975, and in June of that year, the mansion ceremoniously and officially reopened. Prior to the restoration, the U.S. Department of Interior had recognized the property by listing it on the National Register of Historic Places, but in 1975 it again honored the house by designating it a National Historic Landmark, an honor given to only two other governors' mansions.

William Nichols's original intent for this house may have been to create a great notable house rather than a grand one, but he did both. The exceptional mansion, in a region with beautiful estates and historic plantation houses, holds its own in every way, including its design and architecture, and when it comes to biography, it probably outshines the others, as it truly is a living touchstone at the historic heart of Mississippi.

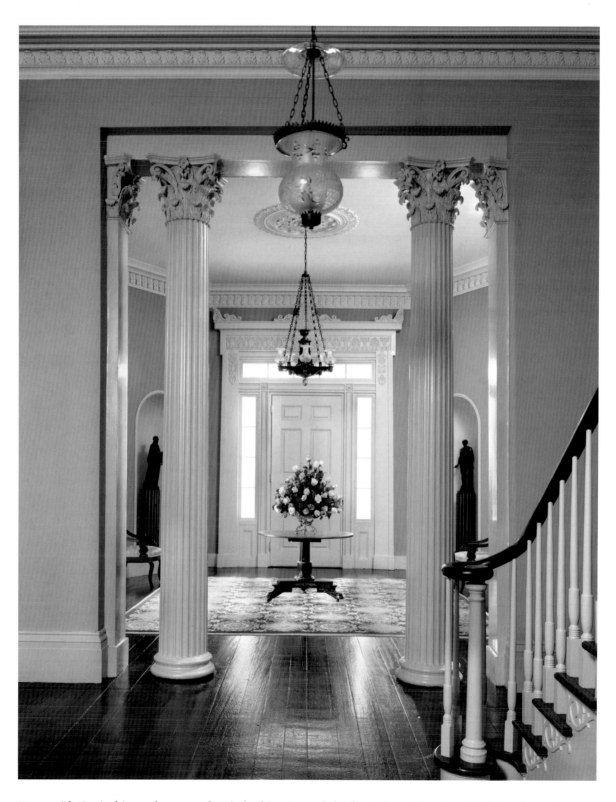

Foyer with Corinthian columns and stair, looking toward the front door. The circa 1825 Empire-style pedestal table has a marquetry top and is attributed to the French-born Philadelphia cabinetmaker Antoine Gabriel Quervelle.

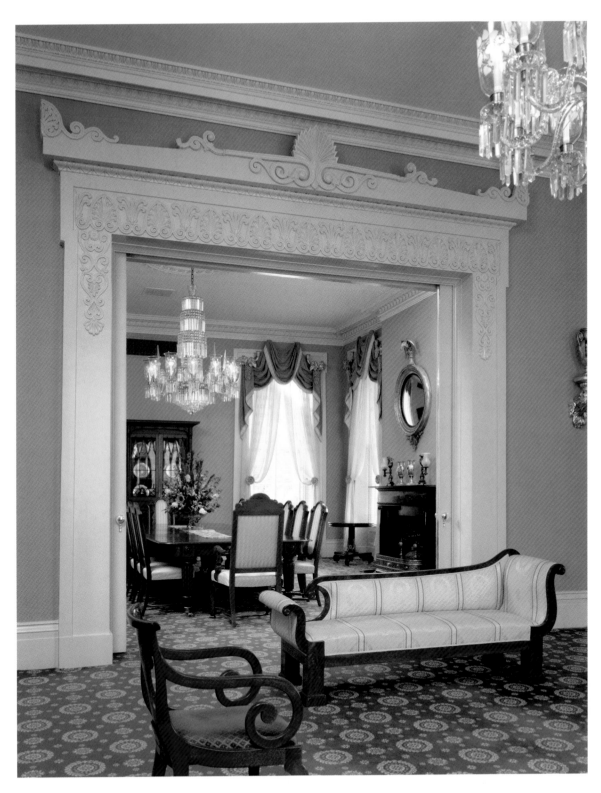

View of the Gold Parlor looking toward the State Dining Room. Note the large architrave over the sliding doors between the rooms. William Nichols patterned this on plate 25 in Minard Lafever's *The Beauties of Modern Architecture* (1839).

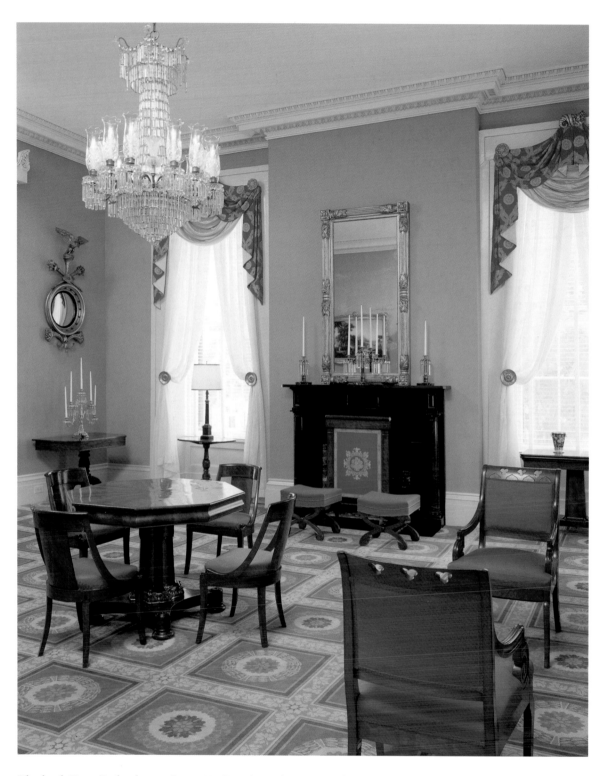

The back Rose Parlor has a circa 1835 Empire style octagonal pedestal table surrounded by circa 1830 French Restauration style gondola chairs with carved swans' heads.

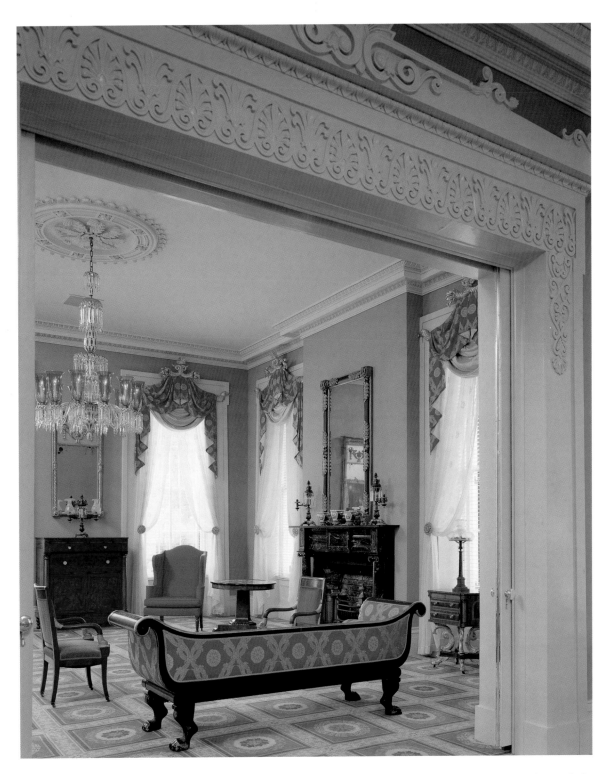

In the front Rose Parlor is a circa 1845 cranberry-overlay crystal chandelier, which is probably English in origin. The circa 1827 Empire style mahogany-veneered fall front desk bears the label of New York cabinetmaker Michael Allison. The circa 1825 Empire style worktable with gilded dolphin supports is attributed to Antoine Gabriel Quervelle.

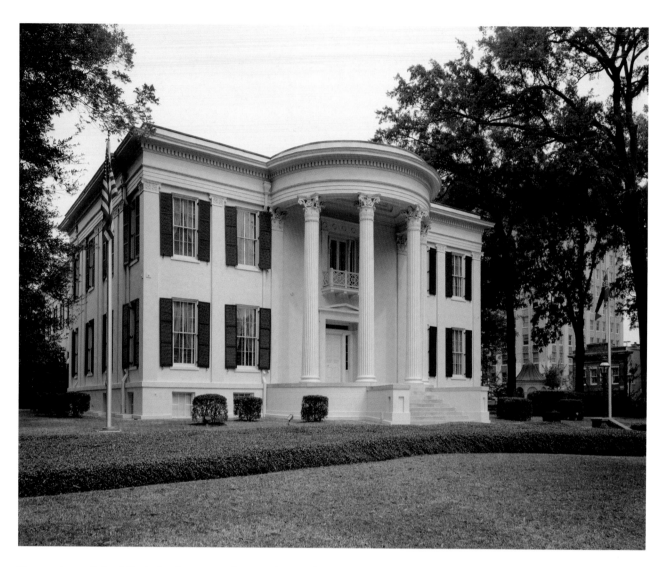

Front view of the Mississippi governor's mansion with its semicircular
portico surrounded by four Corinthian columns.

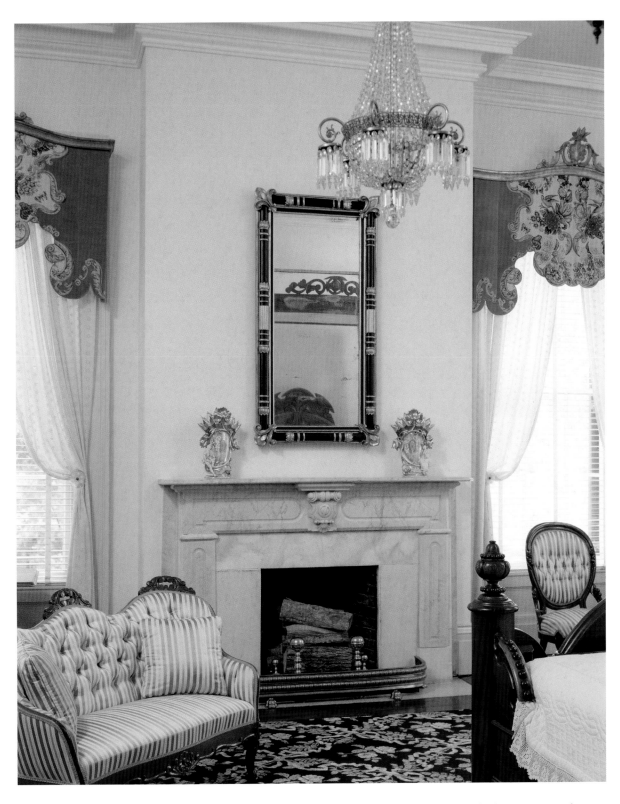

The marble mantel in the Cream Bedroom was originally installed downstairs in the late 1860s and was relocated here in 1975. The Rococo Revival style love seat and chair are American, circa 1870–1880. The bedpost is the only visible piece of the massive Renaissance Revival style half-tester bed.

North Carolina
Governor's Mansion

National Register of Historic Places

Location: 200 North Blount Street, Raleigh

Construction Completed: 1891

Cost: $58,843.01

Size: 35,000 square feet

Number of Rooms: 16

Architects: Samuel Sloan, Adolphus G. Bauer, William J. Hicks

Architectural Style: Queen Anne

Furniture Style: Eighteenth- and nineteenth-century American
and European antiques, mostly but not confined to Federal styles;
there are also Queen Anne, Louis XVI, and Empire pieces

Sir Walter Raleigh, British explorer and confidant of Queen Elizabeth I, has been dead almost four hundred years, but his American connections run deep, and although he never set foot on American soil, his legacy here is thriving.

In 1584, Raleigh dispatched an expedition to America that landed on Roanoke Island off the Carolina coast. Reports were glowing, and the planting of a new colony seemed possible. "Raleigh was knighted and the land was christened 'Virginia' in honor of the unmarried Queen."[1] A second expedition followed in 1585, whereupon arriving at Roanoke, the ship's crew built Fort Raleigh. But after only ten months, supplies were running low, famine was a considerable threat, and the Indians were no longer thought to be friends. Raleigh sent more expeditions, but none of these colonies survived long enough to become permanent. The treacherous North Carolina coast discouraged colonization from afar, and the first permanent British colonies in today's North Carolina originated from Virginia's Jamestown colony in the middle of the seventeenth century, as the overflow of Virginia's settlement pushed southward.

Today, Fort Raleigh is a National Historic Site that memorializes both the colony of Sir Walter Raleigh (1585) as well as the birthplace of Virginia Dare (1587), the first child of British parents born in the New World.

When Charles I in 1629 granted his attorney general, Sir Robert Heath, the southern region of North America to explore and settle, it became known as Carolana (later Carolina), the Latin form of Charles, to honor the king.

When Charles II granted the same area to eight lords proprietors in 1663, the earlier Heath grant was declared void, and the proprietary government took control. Administration of Carolina was a confusing arrangement consisting of essentially two governors. The actual governor lived in Charles Town (later Charleston, South Carolina), and the deputy governor worked from the Albemarle Sound region in the north. In 1712, the lords proprietors finally split the Carolina colony into separate units—North Carolina and South Carolina—to facilitate management. England long understood the ineptness and failure of the proprietary government, and in 1729, King George II ultimately convinced the proprietors to sell their interests to the crown. Hence North Carolina became a royal colony, governed by royal governors appointed by the king. "The transfer of the province from the Lords Proprietors to the crown marked the beginning of a significant era in North Carolina. The history of the colony for the next 40 years was characterized by a steady and rapid growth in population . . . [and] the expansion of agriculture, industry and trade."[2]

After a century of moving the capital from place to place, North Carolina's new royal governor attempted to plant roots in New Bern, the second-oldest town in the province, which he declared the colonial capital. Between 1767 and 1770, Governor William Tryon, in an attempt

1. Hugh Talmage Lefler and Albert Ray Newsome, *The History of a Southern State: North Carolina*, 7.
2. Ibid., 76.

to stabilize the government in one location, built an impressive and regal Georgian style governor's mansion at New Bern—yet the location of the North Carolina capital would not be settled for another twenty-two years. The house that Tryon built, known as the Governor's Palace, was a two-and-a-half-story red-brick main building with a hipped roof and surrounding parapet. There was an elegant forecourt, and the gracious siting of the house on a magnificent piece of property is mentioned in old books, in which drawings and renderings show curved colonnades that connect two wing buildings with the main house. Governor Tryon brought fellow Englishman John Hawks, a builder, to America to design government buildings that included a legislative hall and a governor's house. Designed by Hawks in an English style, the Governor's Palace became a source of pride for the state. The builder ordered materials and brought craftsmen from both Philadelphia and England. This is not to say there were no detractors—indeed, there were many: primarily farmers who did not want to pay taxes to build a plush house for the governor.

Governor Tryon occupied the completed house only a short time before becoming royal governor of New York in 1771. The next royal governor, Josiah Martin, fled the Governor's Palace at the outbreak of the American Revolution in 1775. Early on, the house served more as a state house and reception site than as a residence for the governors. It burned in 1798 and underwent reconstruction in the 1950s based on the original plans. Today, the reconstructed palace is the centerpiece of a fourteen-acre tract overlooking the Trent River. The complex contains gardens and two other restored houses. As a tourist destination, the eighteenth-century palace and town of New Bern are part of a historic district preserving the town center as well as important architecture, interiors, and furnishings.

The state government met in various locations from 1777 until 1792, when a committee appointed by the legislature finally determined a permanent official capital site, ending more than fifty years of moving from one temporary place to another. The commissioners purchased a thousand-acre plantation for the express purpose of mapping out a capital town, and more or less following the grid used in planning Philadelphia's public buildings and street layout, they designed Raleigh, the capital city of North Carolina. One of the town's plazas, Burke Square, would become the site of the present governor's residence. The building constructed there in 1890 would become North Carolina's fourth governor's mansion.

Raleigh's origins were modest, and its original houses and public buildings were unpretentious and plain. One of the first houses built in Raleigh was purchased by the state for use as a governor's mansion. It was a two-story wooden structure that served as the official residence for only a short time before its poor condition proved embarrassing and inadequate. By the War of 1812, the town and the state began planning with more optimism than in earlier days, and architecture became a new source of pride, signifying an interest in improvements and in building projects. Between 1814 and 1816, a Governor's Palace arose that served as home to twenty governors by 1865. The two-story brick Classical Revival house was modeled after Alexander Parris's Wickham House in Richmond and "was the first building in the young

capital that explicitly emulated national architectural modes." The red-brick exterior of the Governor's Palace did not at all resemble the Wickham white stucco, but the interior layout and skylighted staircase were Parris-inspired features.[3] Another example of the building's connections with other southern architecture is that William Nichols, the architect of the Mississippi governor's mansion, is thought to have added an Ionic portico to the North Carolina Governor's Palace in 1826.[4]

Toward the end of the Civil War, Union forces overtook the capital, and General William T. Sherman used the palace as his headquarters. In the aftermath of the Civil War, a federally appointed military commander occupied the governor's mansion during military rule. The house deteriorated until it was no longer suitable for occupancy, and following the Civil War and Reconstruction, governors lived in rented places until the present governor's mansion became a reality. The new mansion had been discussed, considered, and endorsed for years, but not until Governor Thomas J. Jarvis (1879-1885) assumed leadership and prodded and pushed the legislature did they finally authorize a new residence. The old residence was razed in 1885.

In the spring of 1883, Samuel Sloan, a renowned architect with an established career of thirty-four years, left Philadelphia carrying designs for an ornate North Carolina governor's mansion. Hired at age sixty-eight by Governor Thomas J. Jarvis, Sloan died from a sunstroke while undertaking the commission. Adolphus Bauer, having moved to North Carolina with Sloan as his assistant and draftsman, stepped into his mentor's shoes and made all of the working drawings for the governor's mansion, which William J. Hicks, the master builder and construction superintendent, then executed. The project was finished five years after Sam Sloan's death.[5]

While still in his thirties, Sloan, one of the most popular architects in Philadelphia with commissions around the country, had written the widely acclaimed *The Model Architect*, which was published by three publishing houses and went through four editions. As a pattern book and as a vehicle for educating the public about American architecture, it promoted a better understanding of the environmental influences that made U.S. architecture distinctive.

Yet Sloan's popularity had peaked in Philadelphia and was in decline after 1860 due to involvement in a political scandal concerning the design competition for the Philadelphia city hall. Then he moved to North Carolina to build a governor's mansion. Those displeased with the choice of architect and design dismissed the building project as "Jarvis's Folly."[6] Other problems beset the project, causing delays in both appropriations and construction. Sloan's

3. Catherine W. Bishir and Marshall Bullock, "Mr. Jones Goes To Richmond: A Note on the Influence of Alexander Parris' Wickham House," 71, 74. Alexander Parris received the commissions to design both the John Wickham house and the Virginia Governor's Palace at about the same time in 1911.

4. Mills Lane, *Architecture of the Old South*, 152.

5. Bauer later married a Cherokee woman, thereby creating a North Carolina legend that is examined in detail in Carmine Andrew Prioli, "The Indian 'Princess' and the Architect: Origin of a North Carolina Legend."

plan calling for the use of sandstone as the primary building material was thwarted when the available experienced craftsmen refused to work with prison labor. Yet cheap prison labor was essential to the project, which meant that the more complex building method would be sacrificed. But despite criticism and setbacks, the three-story red-brick Queen Anne style house was completed in 1891 amid praise and glowing compliments.

When conceived and first designed by Sloan, this house was planned as one of the first Queen Annes in North Carolina, but by the time the residence was completed, "the Queen Anne style [had] entered the mainstream of North Carolina urban architecture."[7] It is ornate and symmetrical with a picturesque composition of materials and color, which gives it ebullience and shine. The exterior is heavily ornamented and features steeply pitched and uneven rooflines, assorted balconies and porches, and patterned chimneys.

The first governor to live in the new mansion, Daniel G. Fowle, only occupied the house a short time before dying there. His enthusiasm for the mansion project was praiseworthy and provided the push to finish the house enough to make it liveable, although not all of the fine details and installations were completed at once. Its final cost was $58,843.01.

Governor Thomas W. Bickett lived in the mansion during World War I, from 1917 to 1921, and he demonstrated his patriotism and esteem for the troops by setting up more than sixty cots in the ballroom for soldiers who were passing through Raleigh on their way to Camp Polk or Fort Bragg. The music room on the first floor was used for their entertainment and as a place to have light refreshments.

A 1925 interior modernization created a Neoclassical interior. The makeover changed the browns of wood to ivory and replaced the wooden spindle columns with Corinthian columns, without encroaching on the substance of the original first-floor plan. Atwood and Nash, a well-respected Durham architectural firm responsible for the renovation, had previously built a Neoclassical addition to the University of North Carolina. Known for their monumental projects, Thomas C. Atwood and Arthur Nash had formally trained as architects in the Classical styles. Nash served as a supervising architect with the important New York firm of McKim, Mead and White after his training at the École des Beaux Arts in Paris in 1900. The allocation from the legislature was fifty thousand dollars.

6. William B. Bushong, *North Carolina's Executive Mansion*, 28–29. A view of Governor Jarvis's management of the mansion construction is found in the *Raleigh Signal*, March 29, 1888: "the governor says 'the plans were drawn by one of the best and most experienced architects in the country,' which ought to and doubtless would settle that question, but for the well known fact that he has been superannuated and retired for a quarter century in his native town, and could not draw the plans of a dog kennel that would not cost 300 per cent more than his estimate. In fact, Sloan's knowledge of modern architecture was on a par with the governor's knowledge of finance, as shown in his hobbyhorsical defense of his pet 'folly.'"

7. Catherine W. Bishir, *North Carolina Architecture*, 342.

The decidedly Victorian interior defined by its brown tones and ultimate fretwork looked old-fashioned and was transformed to a more stately appearance in the more popular Neoclassical style of the 1920s. An overnight visit in the mansion in 1928 prompted the then-governor of New York, Franklin Delano Roosevelt, to later describe it as the most beautiful of the governors' mansions he had ever visited.[8]

Outside improvements began with brick gateposts topped with lanterns, and in 1929, the state hired Thomas W. Sears, a prominent Philadelphia landscape architect, to create a master plan for landscaping and road circulation. Sears was a leader in country estate landscape architecture, and his improvements corresponded with the balance and symmetry of the Beaux Arts architecture that was popular at the time.

During the Depression and Second World War, few renovations were performed; only essential repairs were implemented, including work on the first-floor kitchen and the addition of an elevator.

In 1949, the mansion, needing tremendous work, was so criticized for its outmoded Victorian exterior that a special commission was appointed to recommend the extent of change. On the panel of experts was Lewis Mumford, a famous and highly respected architectural critic and historian, who voiced strong praise for the building, its good exterior construction of brick and stone, and its grand interior proportion. He criticized the suggestions for remodeling in a more popular current style or painting the house all white. Instead, he called for preservation of the building's true character: "It is entitled to the same kind of respect we would pay a building done a hundred years earlier, for it represents the living history of the State of North Carolina. In approaching such a monument the utmost care should be taken to preserve and enhance all that is worth being preserved—not to demolish the existing structure, or to hide it behind a facade of a quite different age and state of culture."[9]

The respected opinions of the specialists spurred a renewed interest for preservation of the mansion. Upon their recommendation, the state fixed the roof, replaced rotten woodwork, repaired and replaced plaster, and completed a renovation of the kitchen including new appliances. New draperies and floorcloths, painting, and wallpapering were added, and the second floor was refurbished.

During Governor Terry Sanford's administration (1961–1965), the Asheville, North Carolina, Chamber of Commerce purchased a three-bedroom mountain retreat a few miles from Asheville and gave it to the state for the governor's use. Known as the Governor's Western Residence, it serves several roles besides being a retreat for governors. Sometimes it showcases North Carolina arts and crafts and home-furnishing industries; at other times, it provides a comfortable meeting destination for government officials as well as civic groups.

8. Bushong, *North Carolina's Executive Mansion,* 131.
9. Ibid., 74.

Governor Daniel K. Moore (1965–1969) started the Executive Mansion Fine Arts Commission in 1965 with the intent to promote the preservation and maintenance of the executive mansion and its interiors. A national preservation movement was under way in this country, and the National Historic Preservation Act of 1966 became law. This was the beginning of the National Register of Historic Places and the Advisory Council on Historic Preservation. First Lady Jeanelle Moore secured an appropriation from the legislature for a docent training program and the publication of a mansion guidebook.

In seeking advice on maintaining long-term stewardship of the governor's mansion, Jeanelle Moore turned to the White House. This resulted in the state's hiring of Lorraine Pearce, who, as the first White House curator, had worked with Jacqueline Kennedy on that building's restoration. At the time, many caretakers of governors' mansions were looking to the Kennedy White House as a restoration and organizational model. Jeanelle Moore then formed the Executive Mansion Fine Arts Advisory Committee, which was later permanently established through legislation and still later renamed the Executive Mansion Fine Arts Commission.

The committee prepared a twenty-year maintenance plan that included refurnishing, redecorating, renovating, and enlarging the kitchen and garage. The group's plan for improving the grounds was ambitious and included creating a more private compound and installing fencing surrounding the area. An eight-foot iron-and-brick fence was installed in 1972–1973.

The North Carolina residence was listed on the National Register of Historic Places in 1970, yet during Governor Robert W. Scott's tenure, 1969–1973, he publicly complained about the high cost of maintenance of the house and reopened the discussion of whether to build anew or to preserve. As a result, a 1971 Executive Residence Building Commission enlisted a firm to develop plans for a new house whose cost estimate turned out to be half a million dollars. A heated debate escalated over the high price and the proposed French Provincial design, and it became a campaign issue in the 1972 governor's race; the idea was ultimately rejected in favor of preservation.

When Governor James E. Holshouser Jr. (1973–1977) took office, the proposal before him was for a complete overhaul of the governor's mansion in order to extend its use as a residence for governors. Knowing it would be a costly procedure, the governor and his wife backed the restoration, preferring it to the alternative of building a new residence. This 1975 renovation required the family to vacate the mansion for nine months, and by the time of its completion, the project would cost the state $854,806. All infrastructure was replaced or brought up to code, all the brick was cleaned and tuck-pointed, and broken roof slates were replaced. Bathrooms and drains were redone, and fire and smoke detectors were installed as well as a fire escape.

The 1975 restoration made a notable change to the look of the interior by returning the grand staircase to the mellow brown beauty of its original wood. The staircase was stripped of its layers of ivory and white paint, and the warm tone of the underlying heart pine was revealed once again. During the 1977–1985 tenure of Governor and Mrs. James B. Hunt Jr., the library was returned to its original look by stripping paint from the heart pine mantel, doors, door-

frames, and wainscotting. But some of the 1920s Neoclassical polish and style yet remain, combining beautifully with the old.

Because of the constant need to prioritize, there was a history of scaling back on large master plans that were developed from time to time for the landscaping of Burke Square and the mansion area. But the priorities changed after a series of storms in the 1980s. Severe weather wiped out existing landscaping, and the development of a new comprehensive plan could no longer be delayed. Governor and Mrs. James G. Martin managed the new garden plans and planting schedules. Today, thanks in large part to their efforts, new paths and a Victorian garden enhanced by a fountain serve as a charming and useful entertainment space.

The Martins were also concerned about the ongoing funding needs of the stately old mansion. With their assistance, Mary Duke Biddle Trent Semans, of Durham, first and only chairman of the Executive Mansion Fine Arts Committee, was able to raise over $1 million in private funds.[10] The legislature then authorized matching funds of $1 million for the preservation and maintenance of the house and its furnishings. These funds became the Executive Mansion Fund, Inc., whose purpose is to provide for maintenance, ongoing restoration projects, and other needs of the mansion.

The interiors of the home are striking. The grand entrance hall is wide and long and is lined with spectacular three-quarter-length oil portraits of governors. The staircase anchors one end, and Corinthian columns are placed to visually introduce the grand staircase. The handmade red-and-gold carpet commemorates the centennial of the house and is a gift from the Executive Mansion Fine Arts Committee and the Executive Mansion Fund. The center medallion and borders memorialize the building's architects as well as the governors who lived in the mansion during its first hundred years. The border of the rug reflects the design in the plaster ceiling.

Important antique furniture, carefully selected, is on display in all the public rooms. The great hall reception area contains a baroque pier table and a nineteenth-century heavily ornamented gold mirror placed over the table. There is a pair of 1830 Regency sofas purchased in Scotland that sit against the walls facing each other and a nineteenth-century directoire cabinet.

In the rear of the hall, in the part that is under and next to the stairway, is another reception area that has a 1790s American Sheraton sofa and an English Regency library table from about 1820.

The stairway area leads to the slate-blue dining room. Its enormous nineteenth-century Austrian crystal chandelier has quite a history. It was a gift from a grateful North Carolina family named Horowitz who loved their adopted state. The chandelier hung in their estate in Germany when they were forced to flee the Nazis, leaving most possessions behind. They settled in North Carolina, and at the end of the war, they contacted the new owners of their family home, who sent the Horowitzes some of their effects—including the chandelier.

The dining room table is San Domingo mahogany. Made in England between 1800 and 1820, it seats twenty-four. There is also a seven-foot-long New York sideboard dating from 1820.

10. *The Governor's Executive Mansion*, 14.

The ballroom was originally the music room and continues to serve both purposes as well as providing space for luncheons and dinners too large for the dining room. This formal, symmetrical room holds many pairs of objects, accentuating the design. Beautifully carved matching mantels face each other. There are two pairs of exquisite mirrors here that are both French—one from Tours and one from the Loire Valley. The French Empire pair from Tours was a gift to the mansion by seven former first ladies.

There is a pair of Sheraton style mahogany demilune consoles, 1790–1800, featuring gilded carved eagles. A grouping of Victorian mahogany parlor furniture sits next to a fireplace in the ballroom. Originally it was placed in the gentlemen's parlor and used by guest visitors in the 1890s.

The gentlemen's parlor and the ladies' parlor are the south and north sides of a single parlor divided by a hall. In the more masculine gentlemen's parlor is an English Queen Anne chest-on-chest, made of burl walnut in 1714. The ladies' side has oil paintings of Jeanelle Moore and Dorothy Martin, former first ladies who did so much to promote preservation and who spearheaded the establishment of the Executive Mansion Fine Arts Committee and the Executive Mansion Fund. The portraits overhang two fine antiques: a Louis XVI gilded console table with a green marble top and a pianoforte.

In this house looks are deceiving, for there are two house styles in one. The vertical exterior looms large and whimsical, while the interior is serious and quiet. As you approach the house, you feel you are approaching an elaborate cottage in a quiet woodland clearing, rather than a featured mansion in an active historic district. The decorative colors of the roof tiles, the balustrades, and the stone steps together present the image of a busy house preoccupied with nature. There is a great deal going on—eight gables, multiple chimneys, porches with stylized spindles, overhanging eaves, and a combination of materials creating ornate decoration. Yet upon entering the house and its Great Hall, you sense a change of attitude, an understated reserve conveyed by the sedate, formal Neoclassical interiors. The ceilings are sixteen feet high, the entrance hall extends ninety feet in length, and the thirty-five thousand feet of space showcases the opulence associated with silks and fine furnishings in this impressive interior.

Nicknamed the "Gingerbread House," it presents two historic eras of American architecture, proving that good design does not require a home's style to be confined to one period. Both the 1890s Victorian and the 1920s Eclectic pay homage to time and change. The early architecture is the Queen Anne outline for the later Neoclassical interior spaces. The architects and builders who made it all possible ranged from trained, experienced professionals to aspiring journeymen to laborers from the prison. Using North Carolina hardwoods and local brick and stone, they all took their jobs seriously. The bricks made by the prison laborers display their pride, as they scratched their names on the brick surfaces. Fine craftsmanship is exemplified in the two massive newel posts carved with the shapes of oak leaves, each crowned with a single large acorn that symbolizes this City of Oaks. Raleigh is the city that never actually knew Sir Walter but nevertheless will never forget him.

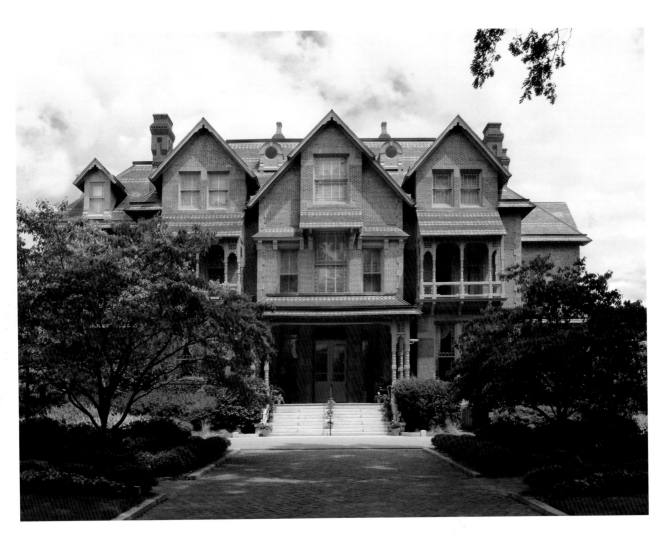

Front exterior of the North Carolina mansion displays the roof tiles, brick details, and spindles popular in Queen Anne style houses. *Photograph by Cramer Gallimore.*

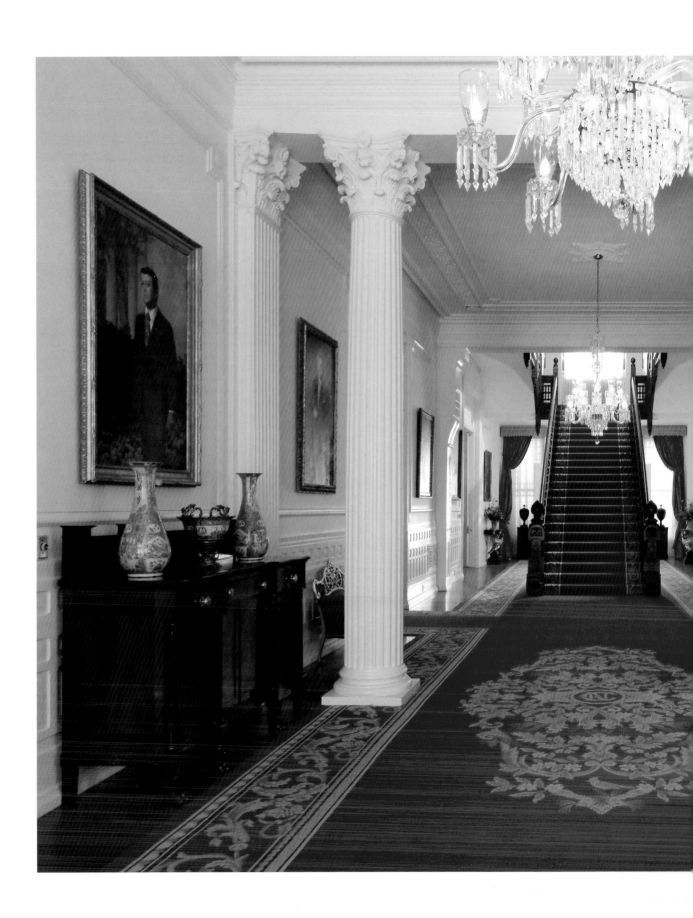

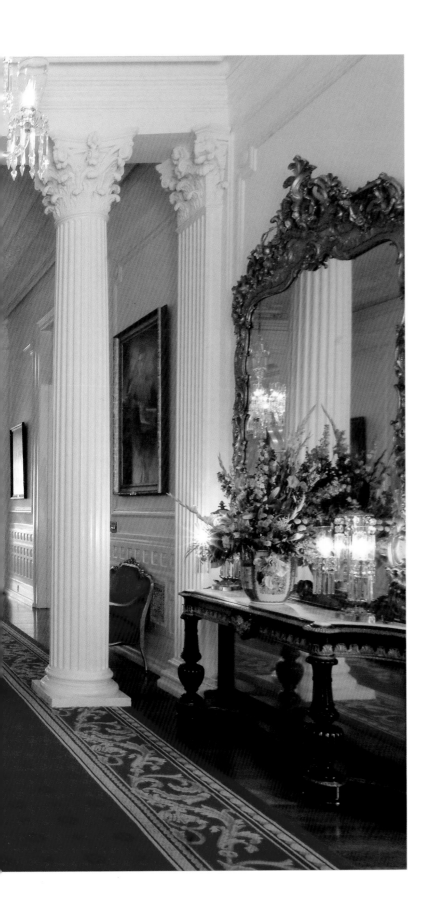

The Entrance Hall is formal, gracious, and grand, with Corinthian columns and pilasters leading to the grand staircase. The hallway features fine nineteenth-century antiques and portraits of governors. *Photograph by Cramer Gallimore.*

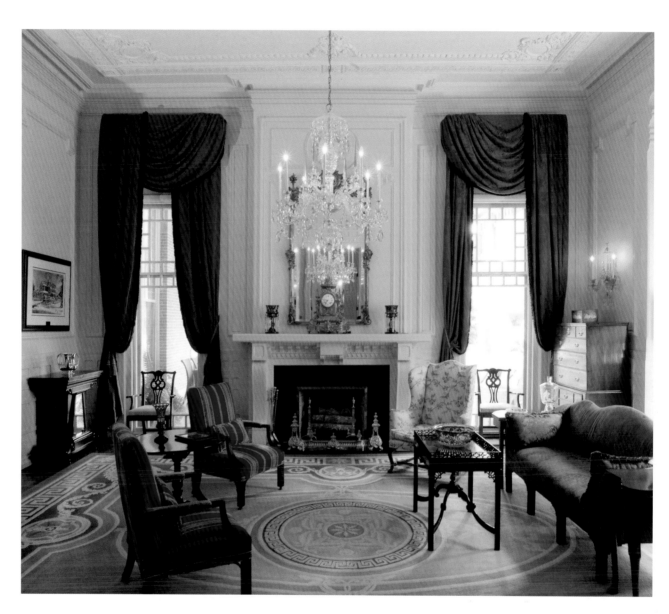

The Gentlemen's Parlor is the south drawing room and has Chinese Chippendale furnishings. *Photograph by Cramer Gallimore.*

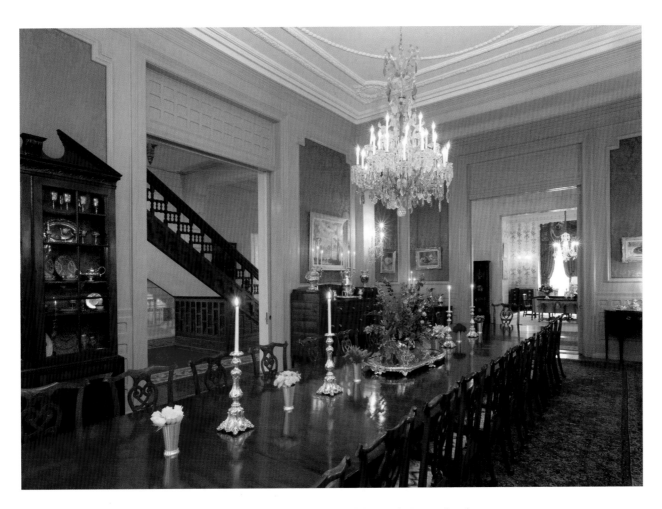

The State Dining Room features a San Domingo mahogany table, made in England in approximately 1800–1820, and the crystal Austrian chandelier given to the mansion by the Horowitz family. *Photograph by Cramer Gallimore.*

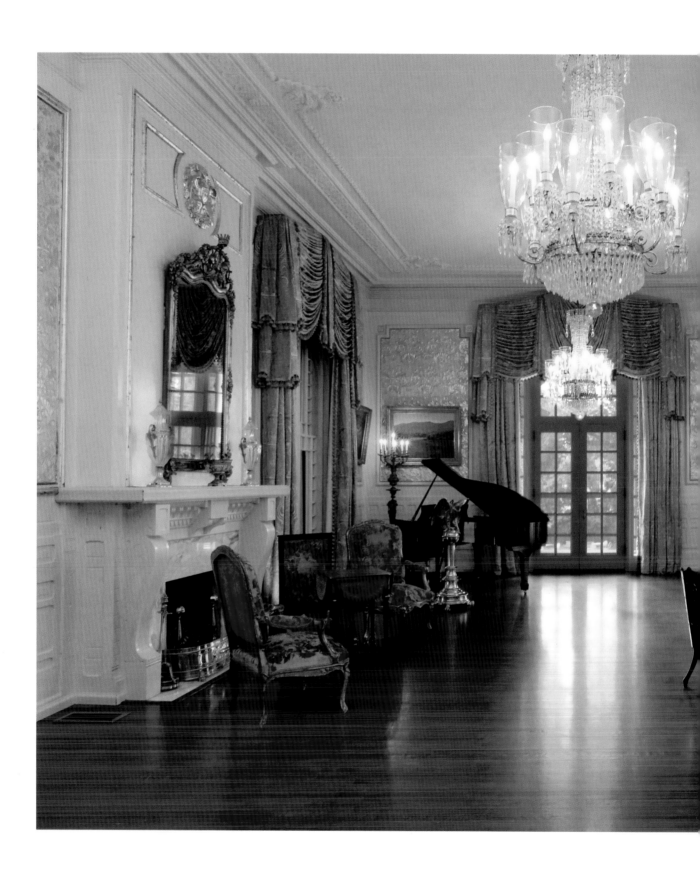

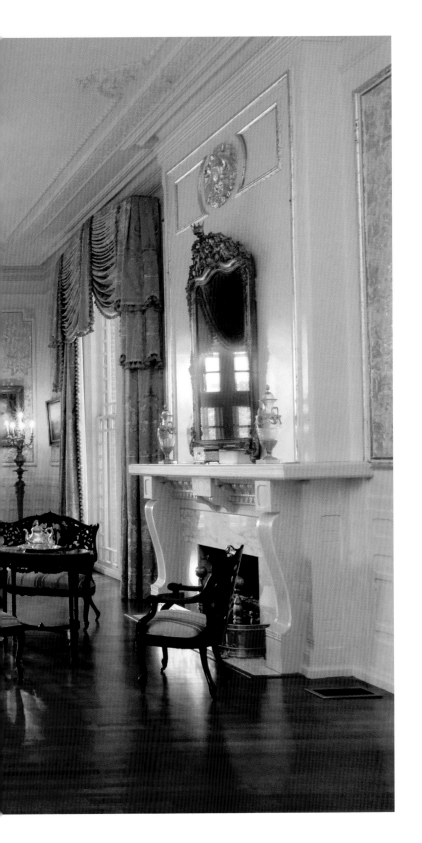

The ballroom, also known as the music room, is formal and symmetrical with gilded walls and twin facing fireplaces and pier mirrors. Note the ornamental ceiling and the Victorian parlor suite that are original to the house. *Photograph by Cramer Gallimore.*

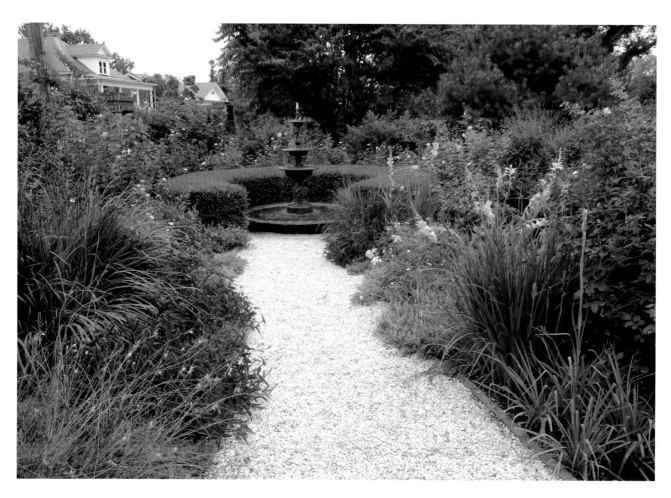

The rose garden, designed in 1986, is built close to the street to be enjoyed from both inside and outside the mansion grounds. *Photograph by Cramer Gallimore.*

South Carolina
Governor's Mansion

National Register of Historic Places

Location: 800 Richland Street, Columbia

Construction Year: 1855

Cost: $13,400

Size: 16,500 square feet

Number of Rooms: 15★

Architect: Attributed to George Edward Walker

Architectural Style: Federal

Furniture Style: Nineteenth-century American and
European antiques in the Federal, Neoclassical, and
French and American Empire styles

★ Excludes powder rooms and security
and staff offices, break room, and kitchen.

By the beginning of the seventeenth century, England had control of much of the eastern seaboard of America from New England and south. Several unsuccessful attempts had been made by the Spanish and French to colonize the eastern seaboard from Virginia south to a strip of land in northern Florida; Spain had already settled the remainder of Florida. In 1503, Queen Elizabeth died without a direct heir, ending the reign of Tudor monarchs; the Tudors were thus succeeded by their Scottish relatives, the Stuarts. Charles I, the second of the Stuart line, became king in 1625.

In 1629, Charles I granted to his friend and attorney general, Sir Robert Heath, the region south of Virginia, which Heath named Carolana, from the Latin for Charles, to honor the king. The province included today's Carolinas, Georgia, and the northern strip of Florida. King Charles I's autocratic rule and belligerence toward Parliament ignited the English Civil Wars in the middle 1600s. Oliver Cromwell triumphed, the monarchy was thrown out, and the king was beheaded. After a period of exile, the monarchy was restored, and the son of Charles I, Charles II, was crowned. In 1663 the new king revoked Heath's title and conveyed ownership of the same area to eight loyal supporters. Heath's attempts to colonize the region had been unsuccessful, and with the province an unsettled wilderness, King Charles declared the charter forfeited and bestowed ownership to the loyalists who helped restore the crown. The new administrators changed the name from Carolana to Carolina.[1]

Charles Town, founded on the Ashley River in 1670 at a site called Albemarle Point, was the first permanent English settlement in South Carolina. Within a year, there were 391 settlers, including women and children. Anticipating new arrivals from England and Barbados, new town sites were planned south of Charles Town. The geography of favorably situated land was an overriding influence in the selection of city sites. Oyster Point, a peninsula between the Ashley and the Cooper rivers, offered an outstanding harbor for incoming traffic from England, Bermuda, the West Indies, New York, and Virginia, and it became the new Charles Town, and the former Charles Town became Kiawah. The name Charles Town officially changed to Charleston in 1783.[2] Almost a hundred years later, the Charleston Harbor would endure the opening round of the American Civil War with the shelling of Fort Sumter, which lasted thirty-four hours.

South Carolina's early settlers came from North Carolina, Virginia, and Pennsylvania. The settlers from Barbados brought their slaves. In addition to the English majority, there were French Huguenot, Scottish, and German immigrants. In 1719, the disparate population uniformly agreed to ignore the oppressive and complicated rulings of the proprietors, rebelled against their authority, and caused the lords proprietors to lose control—all of which led to the introduction of the royal governors in South Carolina in 1721.

1. David Duncan Wallace, *South Carolina: A Short History, 1520–1948*, 23.
2. Ernest M. Lander Jr. and Robert K. Ackerman, eds., *Perspectives in South Carolina History: The First 300 Years*, 19–22.

The lords proprietors had treated the Carolina region as separate units for management purposes, and the "North" and "South" designations were commonly used well before the province was officially separated. Eight years intervened before North Carolina also became a royal colony in 1729. South Carolina grew and prospered, with rice the most stable lucrative crop. But unrest was mounting, and unfair taxation practices and trade restrictions placed on the colonies fueled their rebellion. As the Revolutionary War broke out in 1775, the last of South Carolina's royal governors, Lord William Campbell, fled to save his life. Charleston was attacked twice and captured by the British, but the colonists drove the British army away from the state in 1781.

A new city, Columbia, geographically central in Richland County, was surveyed on the site of a plantation as the designated capital of South Carolina in 1786. Moving the capital from Charleston to Columbia was a compromise between the planters of the low country and the farmer-settlers of the up-country. Moreover, Governor John Drayton justified moving the capital from the urbane Charleston by envisioning the strong ties, beneficial relationships, and learning that would develop in Columbia with the additional establishment of the South Carolina College, which became a reality in 1802.[3] Named for Christopher Columbus, Columbia was laid out on a grid on a two-mile-square plot. The main thoroughfares were 150 feet wide, and lesser roads were 100 feet wide; these broad main roads gave the new capital city a feeling of spaciousness.[4] Two years later, in 1788, South Carolina joined the Union as the eighth state. In the time between the capital removal in 1788 and the Civil War, the South Carolina governors lived in private residences or rental housing in Columbia.

Before the Civil War, Columbia's population and economy were growing and thriving. The Arsenal Hill neighborhood, site of today's governor's mansion, held a high status among the fine neighborhoods of Columbia. When Union Civil War general William Tecumseh Sherman marched his troops north from Savannah in a trail of destruction, they surrounded and occupied Columbia. A series of fires devastated the city, destroying private residences, businesses, and public buildings, including the Arsenal Military Academy, one of the state's dominant military schools: "The cadets attending the Academy withdrew to march toward the upstate. When they returned, only the officers' quarters remained standing."[5] Later, Governor James L. Orr (1865–1868), South Carolina's first elected governor after the Civil War, chose this lone remaining building—the officers' quarters—as the official governor's residence. Some sources identify this building as a "tenement," but despite today's equation of that term with wretched apartments, it is unlikely the building was dilapidated: "'Tenement' was the description of a residen-

3. Kenneth Severens, *Southern Architecture*, 99.

4. Patricia Hudson and Sandra L. Ballard, *The Smithsonian Guides to Historic America: The Carolinas and the Appalachian States*, 158.

5. Nancy Bunch (curator of the South Carolina governor's mansion), conversations with author, January 9, 2007.

tial unit which had several bedrooms sharing a common living space. The term lacked any pejorative meaning."[6]

The original architect is unknown, but in the 1850s, George Edward Walker worked on the state house in Columbia. He also designed the library at the College of Charleston and two Episcopal churches, and it is generally assumed that he was the architect of the officers' quarters. In 1869, an appropriation of $2,500 was granted, and Columbia architect A. Y. Lee drew plans to create a suitable single house for future governors by modifying the double brick tenement. He eliminated one of the staircases, changed a door to a window, and moved walls. The funds were spent before the renovation was completed, and the Union military governor Robert K. Scott moved into the structure without its being finished.

As governor between 1874 and 1876 Daniel Chamberlain purchased and lived in a neighboring mansion, the Caldwell-Boylston House. The state leased the governor's mansion to a private family, who, for part of the time, rented rooms to boarders. Rental income was earmarked for the governor, and Governor Chamberlain used it together with some of his own funds for improvements and repairs to the mansion rather than for his personal use. He also installed a wrought-iron fence to replace one destroyed during the Civil War.[7] Governor Chamberlain did not desert the neighborhood while he was in office, but because he and his family chose not to live in the house, one naturally concludes its condition was below par.

The Arsenal Hill neighborhood, tattered by the war and its aftermath, declined even more in the 1870s when the buildings around the mansion became a haunt for hoodlums who preyed on the residents. Governor William D. Simpson proved to be a stabilizing presence in the neighborhood by becoming, in 1879, the first governor in seven years to occupy the house. An appropriation for repairs and improvements was helpful but insufficient, and the house remained in poor condition until 1886, when Governor John P. Richardson made improvements with a sizeable appropriation of $2,700. Though these changes were largely cosmetic, they upgraded the appearance and comfort, thereby creating a nicer house for the governor's family and a more presentable home for future governors. During the next two administrations, more appropriations permitted the installation of electricity, the repair and enhancement of the fireplaces, and porcelain replacements for the tin bathtubs and toilets.

Between 1919 and 1922, when Governor Robert M. Cooper served, he led a mansion renovation that put the mansion in such good order that the next administration was able to give attention to the overlooked mansion grounds. The grounds were covered in a sandy soil—there was no grass—and in 1923, First Lady Elizabeth McLeod directed all annual funds for improvement of the grounds. An exterior plan developed by Professor C. C. Newman of Clemson College included landscaping, an irrigation system, and a greenhouse.

6. John M. Sherrer III and Lynn Robertson, *The Governor's Mansion of South Carolina, 1855–2001*, 22.
7. Virginia G. Meynard, comp., "Governor's Mansion Scrapbooks," vol. 1.

Around 1947, serious thought was being given to finding or building a new governor's mansion, as this one had serious structural problems that made it unsafe for the future. The discussions stalemated in the legislature, and the building continued to decline. By 1955, the legislature and the public could no longer postpone the inevitable restoration, and Governor George Timmerman and his wife vacated the house for a year while an urgent renovation reversed the decline by rebuilding crumbling walls, fixing the roof, and installing air-conditioning and additional heating and plumbing.

Between 1959 and 1963, the Ernest Hollings family lived in the house with their small children. They added a one-story wing at the rear, creating bedrooms and a family dining room. They also removed a staircase, which increased the kitchen and pantry space.

When Governor and Mrs. Donald S. Russell moved into the mansion in 1963, they were soon confined to half of the house. State engineers and architects discovered a five-foot crack in the main ceiling beam in the dining room and found that several beams over the large drawing room had been installed incorrectly more than a century earlier. While this structural work was under way, First Lady Virginia Russell planned a refurbishment for the mansion to begin once the repairs were finished. She had the walls painted and had the carved state seals of the fireplace mantel restored and gilded as they remain today. She installed Jean Zuber French block wallpaper in the family dining room and added a wall of bookshelves in the library. After hiring an architect to renovate the grounds, Russell added a connecting driveway, a walled garden, and a circular patio. In addition to leaving the mansion in good solid structural condition, the Russells spent their personal funds for decorating and left a newly embellished mansion.

First Lady Josephine McNair founded the Governor's Mansion Commission to raise funds for the purchase of antiques and historical furnishings for the mansion. In 1968, the commission purchased the historic Lace House and its gardens, immediately across the mall from the mansion, for $67,000. A two-story frame house built in 1855, the Lace House is named for the ornate ironwork on its piazzas and fences. The acquisition marked the start of what would become the Governor's Mansion Complex. The complex is a unique, enclosed oasis in downtown Columbia. This full city block, surrounded by four streets, gives the effect of a town square that is nevertheless almost hidden from public view. One enters from Lincoln Street to the security gate of Richland Street. When the 800 block of Richland was enclosed, it became part of the road and path system, essentially forming a mall. Each end of the street is flanked by two twelve-foot-high cast-iron gates, and the private street serves as the connecting road to the green, the fountain, the mansion, the Lace House, and a later acquisition, the Caldwell-Boylston House. Blocking the streets to traffic creates a mall of private walks.

In 1970, the legislature changed the Governor's Mansion Commission's responsibilities by giving it oversight to approve alterations, additions, and renovations for both the mansion and the Lace House. The commission became the custodian of both houses and their grounds. In 1977, during the term of Governor James B. Edwards, First Lady Ann Edwards established the Governor's Mansion Foundation, a not-for-profit group whose goal is to raise private funds to

pay for the historic furnishings. She also documented the early years of the house in the first book about the residence, *The Governor's Mansion of the Palmetto State.*

During the Edwards administration, the legislature appropriated $125,000, and together with a federal matching grant, the state was able to purchase another historic house, the aforementioned Caldwell-Boylston House, next door to the Lace House. The original owner, John Caldwell, built the two-story Greek Revival home around 1830. Caldwell was a successful Columbia businessman; the other part of the house's name comes from the prominent Boylston family. Sarah Porter Smith Boylston lived in the house for more than sixty years and created impressive gardens on two and a quarter acres of the property. These historic houses were major elements in the development of the Governor's Mansion Complex. They provide needed office space, a gift shop, and important additional space for a governor's meetings and entertaining.

First Lady Ann Riley improved and upgraded the mansion functionally as well as aesthetically, but her most important lasting contribution was the creation of the Governor's Mansion Complex. She restored the Caldwell-Boylston House's gardens and initiated the Governor's Green project. Under her leadership, the Governor's Mansion Commission, assisted by the fund-raising foundation, acquired $1.7 million for the Governor's Green.

Landscaping design in 1986 unified the mansion with the Lace House and the Caldwell-Boylston House. A three-tiered fountain and historically consistent streetlamps were installed at the front drive of the mansion itself.

The completed nine-acre Governor's Mansion Complex included a restoration of the grounds of the Caldwell-Boylston house to preserve its history and authenticity. Robert Marvin, a South Carolina landscape architect, devised a plan that was implemented by the state's horticulturist, Kay Johnson. She gave gardening training to inmates who transformed the overgrowth into a series of gardens. Formal gardens separate the Lace and the Caldwell-Boylston houses.

In 1987, when the Rileys departed, Bob Riley had been the first governor to serve successive terms. At the close of a two-term, eight-year tenure, the mansion looked its best. But its outstanding appearance disguised some of the structural problems that would require investigation and assessment.

In 1988 Charleston architect Joe Schmidt of the firm of Evans and Schmidt surveyed the house and reported the need for a full-scale renovation caused by earlier additions, emergencies, and partial repairs and rehabs. The renovation plans developed slowly over the next two administrations.

Governor Carroll A. Campbell was in office from 1987 until 1995, and during that time no major mansion improvements were considered, since everyone understood that a huge restoration was in the future. First Lady Iris Campbell added a new guardhouse to the Lincoln Street entry and oversaw the construction of the Gonzales Fountain. Donated by descendants of William Elliott Gonzales, founder of the local newspaper the *State,* it adorns the mansion complex's central plaza. This gives the complex two fountains, and each occupies a visually important site.

Throughout the tenure of governor David M. Beasley (1995–1999), the state was gearing up for the restoration that was postponed pending completion of the state house renovation. The Mansion Foundation initiated a statewide fund-raising campaign, the legislature appropriated $3.7 million, but when the project was completed in 2001, the cost of everything totaled over six million dollars.

In 1999, Governor James H. Hodges succeeded Governor Beasley. He became, except for two early governors, the first in 120 years not to occupy the mansion. The Hodges family spent two years in a two-story brick house on Heyward Street in the Shandon area. The mansion furnishings were dispersed; some went with the governor's family, while the rest were stored in the Lace House and in the Caldwell-Boylston House.

The state hired the firm of Evans and Schmidt, the same architects who did the 1988 study and survey, to renovate the mansion. Known for fine work in the field of historic preservation, they were able to bring the house into compliance with all codes, corrected structural problems, and increased the building's size by five thousand square feet, and they accomplished it all in a respectful way without distorting the historic core.

The remarkable formal entrance to the house is marked by porches of South Carolina blue granite, known as Winnsboro blue granite. The south and north side entrances are practically mirror images. The distinguished use of iron at all of the entrances reminds one of the ironworks that were so important in Columbia's early years—the city had been a central supply source for iron products, including cannonballs and artillery. The decorative and functional ironwork on the mansion attests to the versatility of iron and its continued importance in the state.

The South Carolina governor's mansion, a white house with black shutters and three arches on the facade, represents several architectural styles. The result is a beautiful Federal style house heavily influenced by the British Colonial plantation styles with arched entryways and an abundance of ironwork that harmonizes with other historic ironworks in the neighborhood.

Included in the 1991–2001 restoration was the planting of palmetto palms—the South Carolina state tree—that flank the front of the house and are featured along some of the roads. Other notable specimen trees, both in front of the mansion, are a southern magnolia and a crape myrtle—they are the two oldest of their species that have been recorded in South Carolina.

Once inside the new, larger wooden front door, which gives good light in the yellow entrance hall, one is almost pulled straight ahead to the Charleston Courtyard. This area was created in 1960 when Governor and Mrs. Hollings added a one-story wing to accommodate their larger family. Their addition was replaced during the restoration, and the new wing connects seamlessly with the old part of the house.

There is so much to see the visitor can visually tour several rooms from one spot. As you move from the back toward the entry, the two-story Charleston Garden is introduced by three arched entryways separating it from the Palmetto Dining Room. The Palmetto replaced the former family dining room and can be seen from the front of the house behind the Hall of

Governors. The formal Hall of Governors is bright with natural light and provides the transition between the older part of the house and the new addition. It extends down a long corridor from the south to the north side entrances and displays stately oil portraits of many of the state's early governors. The strikingly patterned black-and-white marble floor used to be in the state house.

A special attraction of the Palmetto Dining Room is a 1912 reissue of a nineteenth-century French wallpaper by the famous Jean Zuber and Company. Titled *A Frenchman's View of North America* and created as a brightly colored woodblock print, it covers the four walls, but only one wall of it was able to be transferred from the old family dining room. The same paper hangs in several governors' mansions and, most famously, in the Diplomatic Reception Room of the White House.

The natural light of the Charleston Garden filters through the three French doors that separate it from the Palmetto Dining Room. The secluded garden is enclosed on all sides. A lofty skylight serving as a roof soars overhead and brings nature indoors. A dolphin motif, prevalent throughout the house, is also found here as a fountain centered on the wall surrounded with plants to complete the garden's appearance.

There is a large and a small drawing room, and each holds valuable period furnishings. The larger parlor has been the site for four weddings, including the first marriage of then-governor Strom Thurmond. It is the more ceremonial and formal of the rooms. It contains a pair of circa 1770 George III chairs given to the mansion by Darla Moore, who purchased the chairs at a Sotheby's auction. She attended the auction with her friend Martha Stewart, who also wanted to bid on the chairs. They flipped a coin, and Darla Moore won the toss—and the bid. She then gave them to the Governor's Mansion Foundation during the renovation.[8]

An English Hepplewhite butler's secretary and linen press was also acquired during the renovation. It is mahogany, was made around 1810, and had previously belonged to the prime minister of Northern Ireland. A pair of late Neoclassical mahogany lyre-base card tables, dating from around 1815, flank the drawing room fireplace.

The state dining room features a nineteenth-century crystal chandelier from England that was a gift from Bernard Baruch, the financier and advisor to "every president from Woodrow Wilson to John F. Kennedy."[9] Baruch maintained close ties with his native state and was a particular friend of Governor James F. Byrnes.

The mahogany dining room table has Regency style birdcage pedestals. It was commissioned from a local cabinetmaker, Michael Craig, by the Governor's Mansion Foundation.

8. South Carolina's Governor's Mansion Docent Guide Tour Book, 7. Darla Moore is a pioneer in the banking industry; her philanthropy to her alma mater inspired the University of South Carolina to become the first major university to name its business school for a woman—the Moore School of Business.

9. Ibid., 9.

There are twenty deer-foot mahogany armchairs that fit the table when fully extended. The table can be separated into round tables, allowing the dining room to accommodate thirty to thirty-five guests.

Unique silver from the first USS *South Carolina* battleship was commissioned in 1908. Sixty-six pieces exist, but many are not on display. The unique individual pieces depicting South Carolina's native fruit and flowers are works of art.

A portrait of Governor Robert Y. Hayne, who held that office from 1832 to 1834, is over the dining room mantel. Prior to becoming governor, Hayne was a U.S. senator for nine years and was one of the best debaters in the Senate. He and Senator Noah Webster engaged in a famous debate in 1830, arguing constitutional principles and states' rights. In 1835, after leaving the governorship, he served as mayor of Charleston and pushed a significant though unsuccessful effort to launch a railroad route from Charleston to Cincinnati. His portrait was painted by Samuel F. B. Morse, who is better known as the inventor of the telegraph, which revolutionized communications.

In over 150 years of history, this house has served many masters. It survived cataclysmic events and major conflicts including the Civil War, which demolished next-door buildings, and the Reconstruction period, wherein the disparate occupants of these quarters included military officers, enemy soldiers, a carpetbag governor, a local mayor, and eventually boarders. The mansion has been a witness to history and a participant in change. From its beginnings as an officers' quarters of an antebellum South Carolina military school, to its present status as the official governor's mansion, it has flourished and developed into the great beauty and tangible asset that it is today.

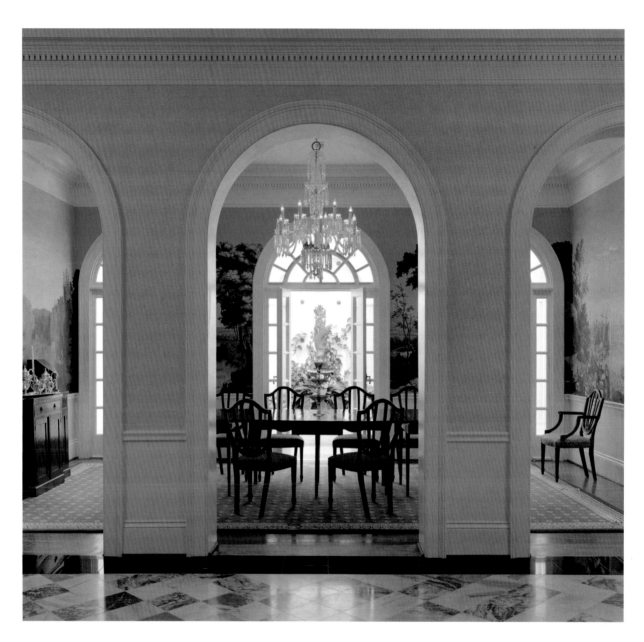

View of the Palmetto Dining Room through the arches that visually separate it from the Governor's Hallway. The Charleston Garden is visible in the background. Zuber wallpaper is a 1912 reissue of the 1834 *View of North America*.

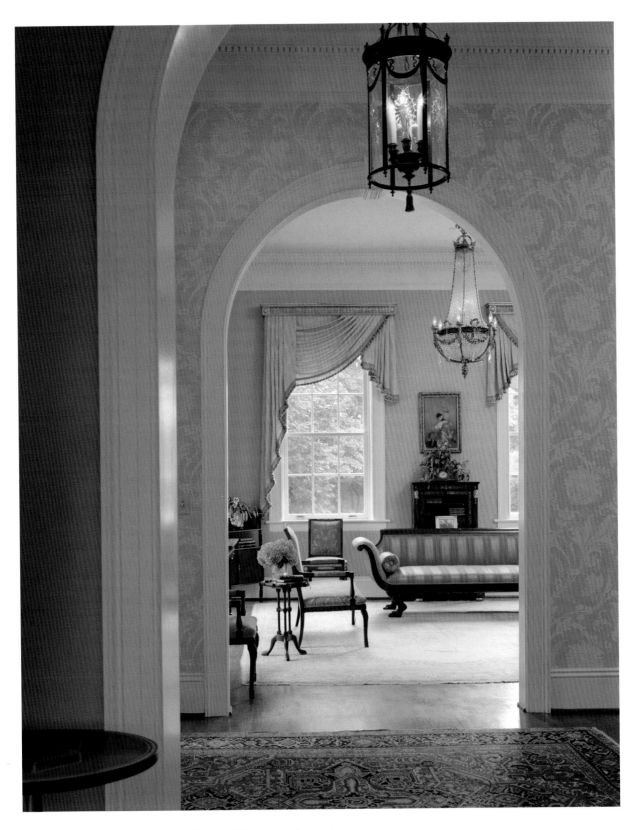

The Small Drawing Room, or first lady's parlor, from the entrance hall, featuring an American Empire sofa, circa 1820.

The Large Drawing Room is the larger of
the state reception rooms. State seals are
carved into the mantel and gilded.

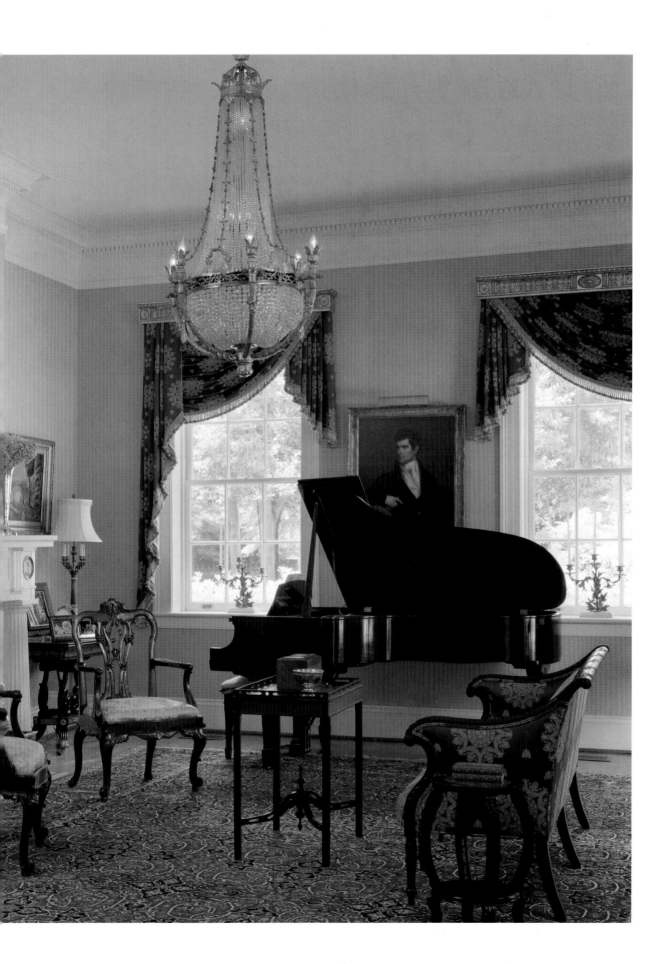

Gates introducing one of many walkway areas.

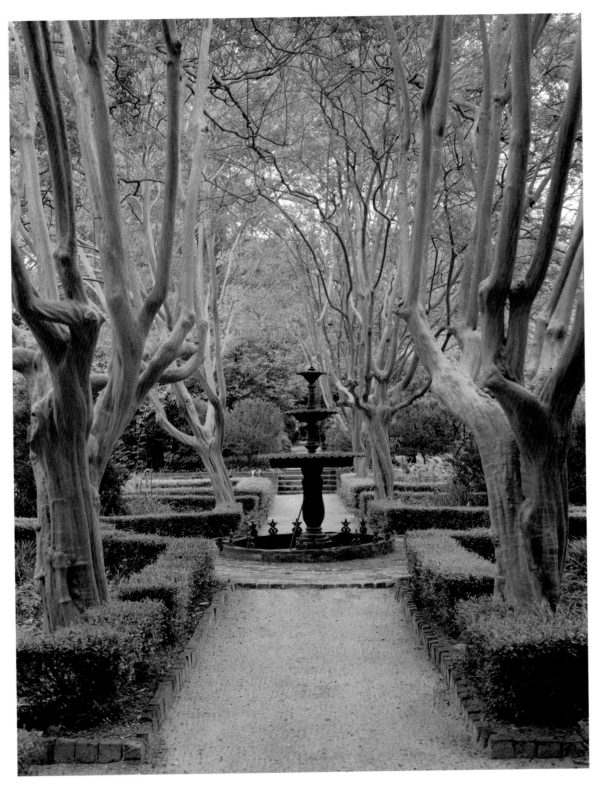

This fountain leads the eye down a garden path of crape myrtle trees that seem intertwined.

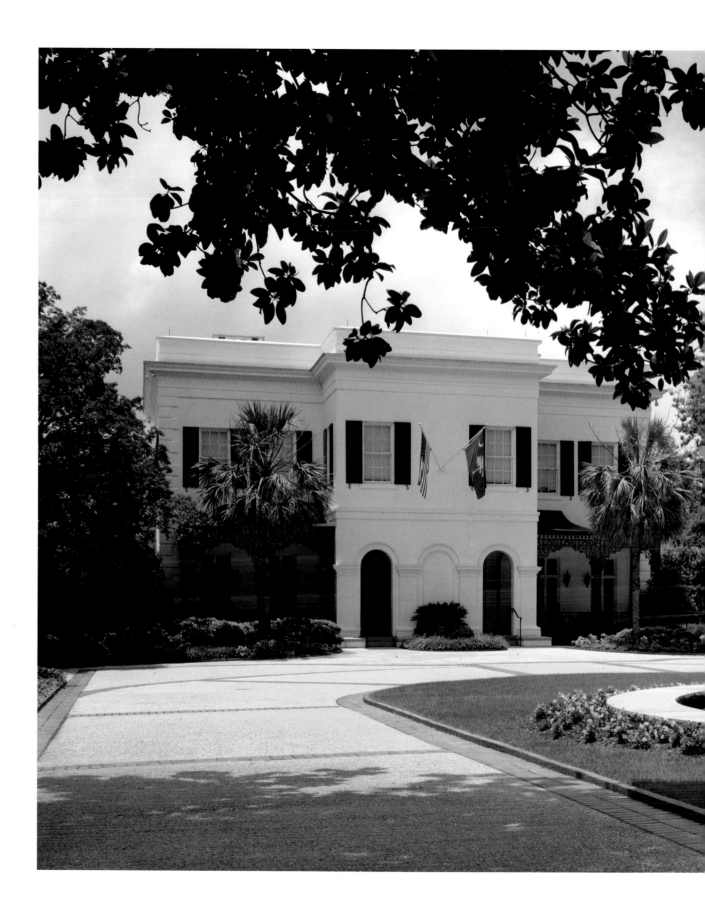

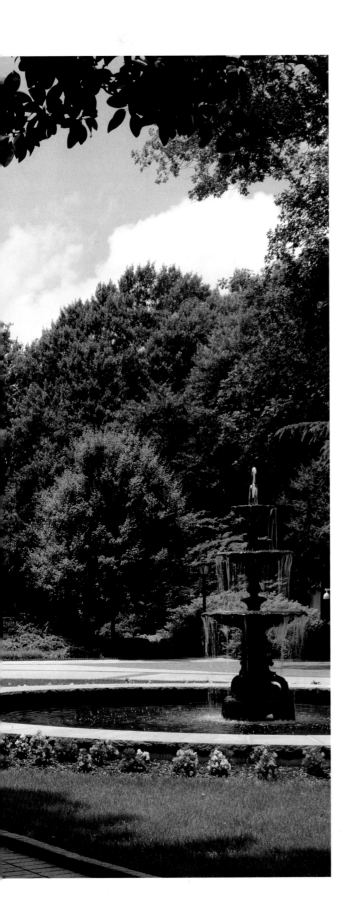

This cast-iron fence was installed during Governor Chamberlain's administration (1874–1876).

Front view of the Federal style mansion with flanking palmetto trees and fountain.

Hydrangea and fern in brick-walled garden with palmetto gates.

One of the estate gardens, with daisies.

Tennessee
Governor's Mansion

Location: 882 South Curtiswood Lane, Nashville

Construction Completed: 1931

Cost: $152,172

Size: 15,000 square feet

Number of Rooms: 20

Architect: Russell Hart

Architectural Style: Beaux Arts Georgian

Furniture Style: Eighteenth- and nineteenth-century antiques and reproductions, mostly American, in the Federal, Sheraton, and Georgian styles

In 1663, King Charles II granted American territory south of Virginia to eight loyal supporters, who became the lords proprietors of the region. The area included the Carolinas, Georgia, and part of Florida. The Tennessee region was included because it was the western extension of Carolina. When North Carolina was established as a separate province and later, in 1729, as a British royal colony, it continued to include the Tennessee region.

Between the Appalachian Mountains and the Mississippi River, the settlers who had moved westward in the Tennessee region felt themselves deserted and adrift. Tennessee, after unsuccessfully appealing to North Carolina for protection from Indians, revolted against the mother colony in 1784 by forming the independent State of Franklin, named for Ben Franklin. Efforts to achieve official statehood failed within four years, and North Carolina reasserted its control.

In 1789, North Carolina gave the Tennessee region to the United States. The federal government made it into a new territory and called it the Territory of the United States South of the River Ohio. President George Washington appointed William Blount, a North Carolina politician, as its governor, and Governor Blount chose Knoxville as the capital of the territory.

In 1796, Tennessee joined the Union as the sixteenth state and the first state to be formed from government lands. John Sevier, pioneer settler and only governor of the State of Franklin, was elected first governor of the new state. The capital remained in Knoxville, and west Tennessee was still Indian Territory.

For forty-seven years, from 1796 to 1843, the Tennessee capital moved from place to place. It essentially remained in Knoxville until 1812, although there was a quick one-day move to Kingston in 1807. In 1812, the capital moved to Nashville, in the middle of Tennessee, a few years before the first steamboat arrived there. By 1843, when Nashville became the permanent capital site, it was also an important river port, and when the Nashville, Chattanooga and St. Louis Railroad was completed in 1854, Nashville was prosperous.[1]

During the Civil War, Tennessee was the eleventh state to secede from the Union; it hosted more military engagements than any other state, except Virginia, and was the first state to return to the Union during Reconstruction. From 1862 until 1865, Andrew Johnson served as military governor of his own state; he resigned to be President Lincoln's vice president. In 1866, the state reentered the Union and returned to a civil government.[2] The state did not provide a governor's mansion, and the governors lived in Nashville hotels, boardinghouses, or their own homes.

When the legislature finally authorized an executive residence in 1907, a private mansion was purchased from a wealthy resident of downtown Nashville. John M. Gray Jr., an owner of Gray and Dudley Hardware and a member of Nashville society, sold his handsome white stone

1. Patricia Hudson and Sandra L. Ballard, *The Smithsonian Guides to Historic America: The Carolinas and Appalachian States*, 310.

2. Margaret I. Phillips, *The Governors of Tennessee*, 79–84.

house at 314 North Vine Street (Vine Street later changed to Seventh Avenue) to the state for $31,000. Originally the home belonged to John P. Williams, a Nashville banker, who built the enormous Beaux Arts house in 1889. The three-story beauty had many rooms, and there were fireplaces in most of the bathrooms. An opulent house with elaborate decorative painting, mahogany interiors, and a ballroom on the third floor, it served as the Tennessee governor's mansion for sixteen years.

The second governor to occupy the executive residence, Governor Ben W. Hooper, commented negatively on its profusion of ornamentation, its smoke-choked small lawn, and its heavy accumulation of soot and dirt. He considered the purchase of the house as a governor's residence a mistake and suggested that the structure should become an office building, perhaps for a department of state government, and that the governor's residence should move elsewhere.[3] Its convenient location notwithstanding, many urban residents were following a national trend of moving away from the congestion and the noise of commercial areas.

Governor Alfred Taylor, who took office in 1921, became the sixth governor to live in the residence. He was there only a few months before the house and all the homes on the east side of the 300 block of the street were condemned to make way for the War Memorial Building, which now stands at the location. The state next rented a house at 2118 West End Avenue for $2,500 annually, soon purchasing it for $27,500. Located in one of the best residential neighborhoods, the Vanderbilt area, it was a foursquare buff-colored two-story Neoclassical, built in 1910 by Christopher Tompkins Cheek, owner of a wholesale grocery business. Between 1923 and 1949, the West End Avenue house was home to five governors.

The last governor to live there was Jim Nance McCord. Throughout his administration, the homes in the Vanderbilt neighborhood were being vacated by prominent families, who were moving to residential areas of Belle Meade and Hillsboro Road. By 1947, the legislature no longer considered the property suitable as a governor's mansion. They appropriated $100,000 to be used with the sale amount of the governors' house to locate something more appropriate. During the 1947 search for a residence, an urban estate, Far Hills, captured attention as a good possibility until McCord rejected the choice, stating his wish for a smaller house. Sometimes all it takes is a change of the watch to clarify an issue, and with the 1948 election of Governor Gordon Browning, the possibility of acquiring Far Hills as a governor's mansion again drew attention.

Far Hills, the grand residence of the cultivated and well-to-do Mr. and Mrs. Ridley Wills, built on just over ten acres in a select area south of Nashville, was destined to become the governor's mansion. Ridley Wills I, founder of National Life and Accident Insurance Company, had hired architect Russell Hart of Hart, Freeland, & Roberts to design the Georgian Revival mansion of brick and stone in an elaborate Beaux Arts manner. Built with reinforced concrete and masonry walls, it was built to last. Its beautiful interiors of marble, limestone, and

3. Ridley Wills II, *Tennessee Governors at Home*, 18.

mahogany convey strength and durability. In the monumental entrance hall, the sweeping stone circular staircase and wrought-iron bannister finished with a carved walnut handrail create an expressive whole. At the entrance, exceptional peacock door knockers were ordered by Mr. Wills, who assured their uniqueness by having the original mold destroyed.

With six master bedrooms that included baths, a maid's room, a sewing room, a linen room, and a third-floor children's playroom, the house was well equipped to serve a governor's family, whether large or small. In addition, there was a stable and a five-car garage. Ridley Wills commenced building Far Hills in 1929 for $152,172.07 excluding the land cost, and in 1949, his family sold it to the state for $120,350 including furnishings. There can be no doubt that Tennessee made a wonderful deal.

The committee appointed to find a new governor's mansion chose Far Hills with the approval of governor-elect and Mrs. Gordon Browning, and theirs was the first executive family to move into the new acquisition.[4] Governor Browning was governor from 1949 to 1953, but this was his second term; he had earlier been governor from 1937–1939, at which time he lived in the West End residence.

In 1953, the newly elected Governor Frank Goad Clement and Mrs. Clement moved into the recently acquired residence with their three young boys. The lively household with its spirited children soon included an army of pets, ranging from 150 chickens and guinea pigs, three horses, two goats, and a monkey. In a recording of memories of the governor's residence, one of the sons, Bob Clement, remembers, "we had a real farm operation there."[5] The Clements made a few changes in the mansion by replacing a rose-colored carpet and some draperies. In order to create a swimming pool for the boys, First Lady Lucille Clement had the lily pads and goldfish removed from the reflecting pond.

A popular and charismatic speaker, Frank Clement was invited by former president Harry Truman to gave the keynote address at the 1956 National Democratic Convention in Chicago. When Clement's first term ended in 1958, he was succeeded by his campaign manager, Buford Ellington. Then, when Ellington's term expired, he was replaced by Clement, who was again followed by Ellington. Between them, the governorship was theirs for eighteen uninterrupted years.

When Governor and Mrs. Buford Ellington first occupied the home in 1959, First Lady Anna Catherine Ellington determined that the mansion should always be called the executive residence, rather than the governor's mansion. It has been called both over the years.[6] The Ellingtons oversaw extensive decoration and landscaping. Mrs. Ellington had the lilies and goldfish returned to

4. *Nashville Tennessean,* November 25, 1948.

5. Andrea Conte and Tennessee Arts Commission, *The Tennessee Residence: Memories of the Past, Visions of the Future.*

6. First Lady Andrea Conte calls it the "Tennessee Residence" (interview with author, December 20, 2006).

the reflective pool and roses planted behind it. She made flower beds in the recessed garden bordering the pool and had magnolia and pine trees planted. She supervised decorating in the mansion, choosing new draperies in the downstairs reception rooms, the state dining room, and the private quarters upstairs.

When the Ellingtons returned to office in 1967, the first lady continued to address the needs of the house. She had the house repainted and ordered the installation of new carpets and draperies in the front hall. She acquired two Louis XIV vases, several paintings, and a mirror, and during the first administration she approved the purchase of two breakfronts for the living room.

After the assassination of Dr. Martin Luther King Jr. in Memphis in 1968, Governor Ellington became more conscious of security; in fact, protestors had been able to come up into the yard. The unrest and chaos after the assassination convinced the governor and the Tennessee legislature to plan a security gate and fence for the mansion grounds. Heretofore, people could wander onto the grounds pretty much at will. Governor-elect and Mrs. Winfield Dunn approved the plans for the fence and gate, and the future first lady, Betty Dunn, contributed to its design. It was installed during their first year in the house.

Upon his election, Winfield Dunn had become the first Republican to occupy the governor's chair in fifty years. Recognizing the need for refurbishing the residence, Mrs. Dunn responded almost immediately by requesting money from the State Building Commission in early 1971. Worn-out carpets and fabrics needed replacing, and the Commission answered her plea by providing an expenditure of $92,000. She also, for the first time in history, opened the mansion for docent-led tours on a regular basis.

Mrs. Dunn established the Tennessee Executive Residence Preservation Foundation, Inc., a not-for-profit vehicle for acquiring furnishings, paintings, and interiors appropriate to Tennessee history and culture. One month later, a rare portrait of General Andrew Jackson by Samuel L. Waldo was acquired for the Tennessee governor's mansion. Jackson, Tennessee's favorite son, posed for the painting, *General Andrew Jackson at New Orleans*, in 1817, after his famous victory at the battle in that city. Betty Dunn represented the Justin and Valera Potter Foundation of Nashville at the Washington, D.C., auction in 1971 and purchased the oil for $52,000. Clement Conger, the curator of the White House, introduced himself and congratulated Mrs. Dunn. He had been bidding against her but had decided the rightful home would be Nashville.

The Tennessee Executive Residence Preservation Foundation made many historic acquisitions; one was a handsome mahogany Chippendale secretary given by prominent Memphis businessmen. At one time, it had been the property of President Woodrow Wilson; it had been handed down in his family for many years until acquired by the foundation. Other acquisitions were a fine Federal inlaid hunt board and Federal mirror to hang above. There was also a grandfather clock built in 1780 by a James Carey of Maine. Another was a circa 1790 Hepplewhite sideboard from New York with special provenance. It had once belonged to Robert R. Livingston, the U.S. ambassador to France under President Thomas Jefferson. The sideboard is thought to have been present during the negotiations for the Louisiana Purchase.

Mrs. Dunn was honored when the Nature Center at the Falls State Park was named for her. The Betty Dunn Nature Center is a lasting tribute to a first lady who did much for her state.

In 1969, when Minnie Pearl of the Grand Ole Opry and her husband, Henry Cannon, purchased the house next door, she was no stranger to the governor's residence, having performed there. As neighbors, the Cannons and the governors' families became friends during the years. The Cannon House, or as it is better known, the Minnie Pearl House, had also been built by Ridley Wills, but of the two homes, Far Hills was more grand. In 1935, Wills had built the house next door for his daughter and her family.

While in residence, Governor and Mrs. Dunn hosted a two-hour NBC special with Burt Reynolds. Using the fine governor's residence setting, an array of music stars performed, including Minnie Pearl, Dolly Parton, and Dinah Shore.

Between 1975 and 1978, Governor and Mrs. Ray Blanton lived in the house, and the Tennessee Executive Residence Preservation Foundation acquired a Chippendale chest-on-chest made by Jonathan Gostelow. Another notable gift during the 1970s was a painting of Governor Sam Houston, who served as Tennessee's seventh governor before becoming the first president of the Texas Republic and the seventh governor of Texas. The painting, a fitting gift from Texas friends, traditionally hangs in the governor's office.

First Lady Betty Blanton's outspoken interest in the grounds and landscaping influenced Nashville's Horn-of-Plenty Garden Club to rebuild the Wills family's rock garden. Mrs. Blanton's flower gardens continued their abundant blooming, supplying most of the cut flowers for the house.

Republican Governor Lamar Alexander not only served two terms beginning in 1979, but also started early, as advised by the U.S. attorney. Outgoing Governor Ray Blanton was reported to be selling pardons to prisoners for cash, and in order to prevent more prison releases, Governor-elect Alexander was urged to take the oath of office ahead of schedule. Blanton had also had a controversial dinner-party routine of lining up the prisoners who worked at the mansion and having them recite their name, age, hometown, crime, and sentence for the guests although it seems everyone but the governor was uncomfortable. Almost immediately upon taking office, Alexander ended the practice of using prisoners to work in the mansion.

Upon moving into the residence, the Alexanders found threadbare, faded draperies, well-worn rugs, and an attic and closets packed with largely useless items that had at one time or another been given to or purchased for the residence. This inventory had accumulated over eight administrations. After separating the meaningful items and saving the historic, the leftovers were sold at a garage sale amounting to more than three hundred items and earning between $25,000 and $35,000.

When First Lady Honey Alexander picked a decorator, she chose well, a local Nashville designer with a national reach and an elegant sense of formality, Tish Fort Hooker. Tish was the former wife of the two-time Democratic gubernatorial hopeful John J. Hooker and later became the face in magazines and the spokeswoman for the cosmetics company Germaine

Monteil. "I wanted to be First Lady even more than my husband wanted to be governor. So it was a great irony when Honey said, 'I don't know anyone who's taken more of an interest in this house. I want you to do it.'"[7]

Although the legislature appropriated $100,000 for the residence's makeover, the Alexanders used only leftover money from Governor Alexander's campaign to install a swimming pool and pool house. The pool house's colonial motif coordinates with the mansion design.

"When I walked throughout the mansion, the first thing I thought was, 'The state must have been given a good deal on green paint,' because it was on everything. There was institutional green everywhere, celadon green carpet to match the government green walls. It covered up the beautiful black-and-white marble of the entrance hall, and then, when we got to the sunroom and I could see the mosaic tile floor underneath, it was like finding a treasure trove. Those incredible little tiles, laid in an intricate pattern, in colors of mushroom, bittersweet, green, and vibrant blue looked like maybe they were Portuguese or Moroccan."[8] During the renovation, Tish had the heavy red velvet drapes removed along with the rug. Lighter tones prevailed, cane furniture was added, and the room came to life.

In addition to new upholstery, wallpaper, carpets, and draperies, gifts to the mansion through the Tennessee Executive Residence Preservation Foundation included a new Steinway piano, a replica of a mahogany candle stand table that Andrew Jackson sat by when he opened his mail at the Hermitage, and a five-piece Sheffield tea service from 1810 that was given by the grandchildren of Mr. and Mrs. Ridley Wills.

John M. Jones, publisher of the *Greeneville Sun,* led a campaign to acquire antiques for the family dining room from Tennesseans in Greene County. Some of the items contributed were an 1815 Sheraton cherry banquet table, a cherry chest from the same period, and a set of six Windsor chairs made by Claude Phillips, a craftsman from Greeneville. In appreciation, the Alexanders renamed the family dining room the Greeneville Room.

When Governor Ned Ray McWherter moved to the governor's residence in 1987—the first bachelor governor since Governor Prentice Cooper in 1945 and the first to live in Far Hills without a spouse—his mother, Lucille McWherter, accompanied him to the residence. Although she died during the term, it was not before forming a close friendship with next-door neighbor Minnie Pearl; Minnie Pearl gave the eulogy at her friend Lucille McWherter's funeral. Later, Governor McWherter established a beautiful memorial garden at the governor's mansion, and the Nashville Rose Society planted it with Minnie Pearl roses.

Governor McWherter remodeled the master bedroom and bath, as well as a sitting room and a library, including adding a Jacuzzi to the master bath. The remodeling also called for plumbing and wiring repairs all in the west wing of the house.

Governor and Mrs. Don Sundquist moved into the residence in 1995, and First Lady

7. Jesse Kornbluth, "Executive Order: The Tennessee Residence of Governor and Mrs. Lamar Alexander."
8. Tish Fort Hooker, conversations with author, March and April 2007.

Martha Sundquist immediately took an active interest in the residence. She revived the Tennessee Executive Residence Preservation Foundation, which had been somewhat dormant. She was particularly interested in fine art and furniture acquisition. The museum-quality acquisitions included a Philadelphia Chippendale mirror, similar to one at Mount Vernon, a blocked-front Chippendale chest from Massachusetts, and an inlaid card table for the formal dining room. The foundation also received six Windsor chair reproductions from Greeneville craftsman Bill Showalter.

The Sundquist administration addressed major deficiencies in the house by updating the heating and air conditioning system, repairing the slate roof, and replacing the security system.

During the Sundquists' first year in the mansion, they visited with next-door neighbor Minnie Pearl, who was then in a nursing home. She died soon after, and her funeral was attended not only by the present governor, Don Sundquist, but also by four earlier governors who were her friends and neighbors.

Martha Sundquist's activities for the residence will be remembered. In particular, she commissioned the publication of a beautiful book about the house, the governors and their families who had lived there, and the furniture and grounds of the ten-acre estate. She asked Ridley Wills II to write the history, and no one could have been better suited. A historian and a lifelong resident of Tennessee, he is especially well acquainted with the house; his grandfather, the first Ridley Wills, built the mansion, and the grandson spent every Sunday as well as other times of his young life visiting the house. I have relied heavily on Wills for my information about the house.

Governor Phil Bredesen and First Lady Andrea Conte, who would now otherwise be living in the executive mansion, are at the time of this writing living in their private Nashville home near Belle Meade. The executive residence is close to being a hard-hat area in that a long-term restoration of the house, to be accomplished in four phases, is in progress, spearheaded by the first lady and begun in 2003. In addition to a new slate roof costing half a million dollars, the infrastructure requires new pipes, lines, and hookups that have required parts of the yard and some of the patios to be taken apart. Moisture in the house has caused walls to crack. When visiting this governor's mansion, I was unable to enter, and Alise O'Brien's photography had to be confined to the exterior, but the exterior is magnificent. Looking in windows, I could see more of the substance of the house, the fine architecture and exquisite interiors of both carved wood and carved stone. If Alise would have made a stunning photograph of the enormous entrance hall that is the building's hallmark, the photo would have been devoid of furniture, but architecturally rich, showing the black-and-white marble flooring, the famous elliptical staircase, the moldings, and the walls—it would have been a quiet photo, almost ghostly, of the pristine hall preparing itself for the future.

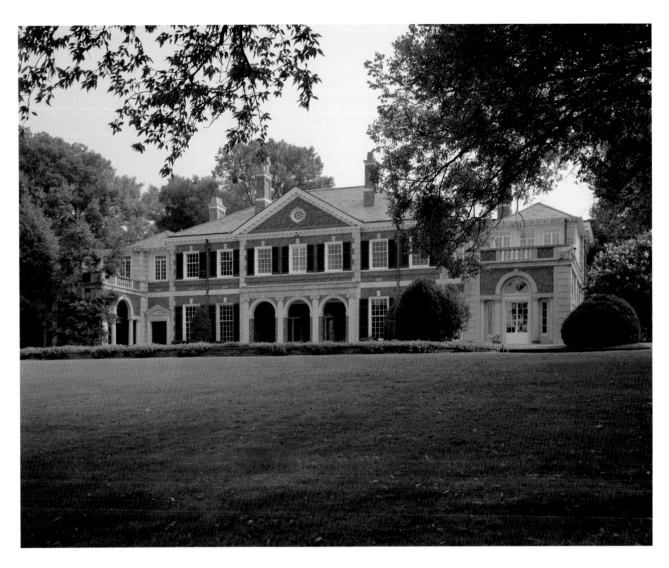

Front west exterior of mansion that faces street.

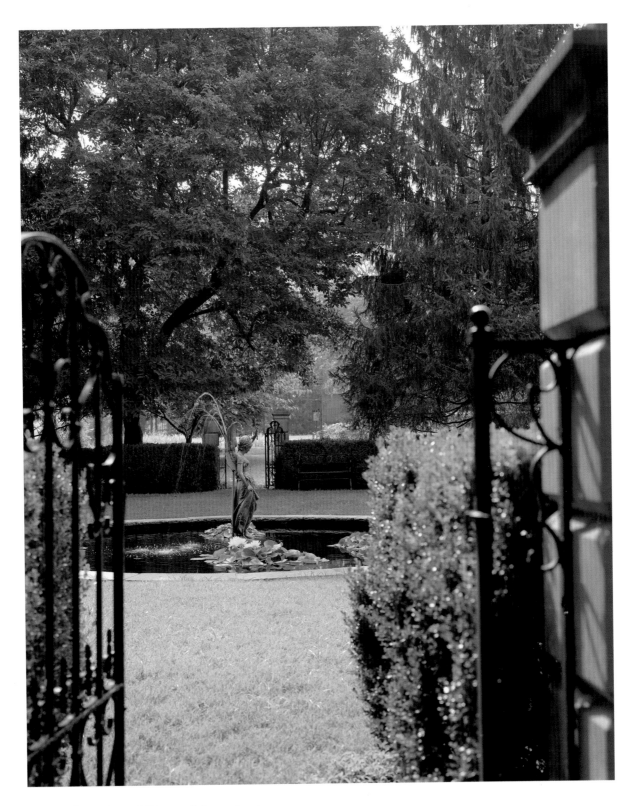

Garden fountain and lily pond through gates.

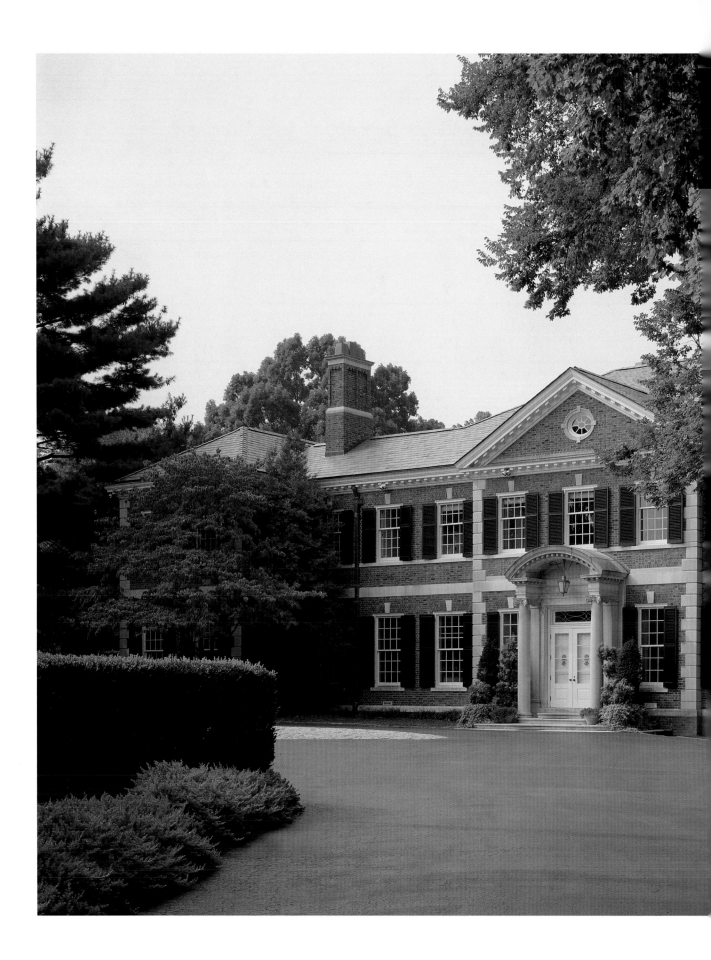

The east entrance is the main approach to the house. It is not visible from the street.

Texas
Governor's Mansion

National Register of Historic Places
National Historic Landmark

Location: 1010 Colorado Street, Capitol Complex, Austin

Construction Completed: 1856

Cost: $14,500

Size: 8,920 square feet

Number of Rooms: 21

Architect: Abner Cook

Architectural Style: Greek Revival

Furniture Style: Nineteenth-century American antiques
in the Federal through Renaissance Revival styles, with
the majority in the Federal and Empire styles

Spanish conquistadors made random sporadic expeditions into Texas in the first half of the sixteenth century, claiming the region for Spain. Alonso Álvarez de Pineda mapped the Texas coastline in 1519, Álvar Núñez Cabeza de Vaca explored parts of the area, Francisco Vásquez de Coronado traveled across west Texas, and in 1542, the remaining members of Hernando de Soto's expedition explored some of the northeast. Upon finding no gold or riches, the Spanish explorers abandoned their search and pretty much ignored the area for the next 150 years.

But in 1686, word that the French explorer La Salle had established a settlement on the Texas coast propelled the Spanish into motion with fear the French could take over the region. The Spanish pushed from Mexico into Texas, building missions and looking for religious converts to further maintain their claim of Spanish colonies while at the same time fending off French and British immigration to the Texas region. By 1731, over ninety Spanish expeditions had been launched into Spain's province of Texas. During Spanish rule, provincial capitals as well as residences for the Spanish governors were built. In San Antonio, the Spanish Governor's Palace, built in 1749, continues to exist and is now a museum and a National Historic Landmark.

In 1821, Mexico rebelled against the Spaniards, breaking away from Spain's long rule, and Texas then became part of the new Mexican Empire. Stephen F. Austin, called the "Father of Texas," brought the first three hundred settlers to Texas, commencing the colonization by Americans, who would become increasingly numerous until Mexico, fearing the challenge to its authority, cut off their migration in 1830.

Texans soon revolted against Mexico's rule, and in 1835 the Texas Revolution ensued. Mexico's dictator, General Antonio López de Santa Anna, and his army attacked the fortified mission known as the Alamo, killing the defenders who included heroes Jim Bowie, David Crockett, and William B. Travis. Despite this sacrifice, Texas eventually won its independence at the Battle of San Jacinto, and the new Republic of Texas chose its hero and military commander Sam Houston as president. A town named for Houston grew up around the site of the San Jacinto battle, and it became the first capital of the new republic.

The first executive's mansion, if you can call it that, was a one-room hovel with an attached shed, thereby making the total space two rooms. A different house was purchased the following year—it had been a two-story store—and served as a president's house for the short time the temporary capital remained in Houston.

The Texas capital was always on the move, and after two more temporary locations, when President Mirabeau B. Lamar was elected, he picked a new place, which became the capital's fourth location. Lamar, the second president of the Republic of Texas, chose his old buffalo hunting ground in south-central Texas as the capital site. The settlement, originally named Waterloo, had started in 1832 with five families. After the commissioners approved the site in 1839, Waterloo, praised for its beauty, hills, and healthful qualities, was renamed in honor of Stephen F. Austin. The Texas Republic was only three years old when the town of Austin was laid out next to the Colorado River. A scenic but isolated village on the edge of the western frontier, the land bordered Comanche country, and Indian raids were not unheard of. While

the wary Native Americans watched Austin being assembled, Texas Rangers guarded the construction workers, who were otherwise vulnerable to attack.

With a large amount of foresight, the Austin city planner and surveyor Edwin Waller had a mammoth task before him. He had to not only design, but also manage the layout and sale of the building lots; he also held responsibility for the construction of the public buildings on the 640 designated acres. Working with the hills and valleys of Austin, he created a wide main boulevard to visually enlarge the approach leading to the far hill, which was designated for the capitol building. Government department buildings would also be built on the future Capitol Square, where the surrounding streets were planted in a grid. The north and south streets were named for Texas rivers, and the intersecting ones were those named for the trees in Texas, although the latter were later changed to numbered streets.

The president's house, constructed in 1839 (it burned in 1847), was sited on a hillock and planned to have enough visibility to be the first house seen when entering the city. Not very well built, but a rather attractive white, two-story, frame house constructed of not-yet-seasoned green lumber, it only housed President Lamar before falling into disrepair.[1] Both the president's house and the capitol were built in 1839 and were intended as temporary buildings. They were hurriedly built to accommodate the legislature, and the designated capitol site was intentionally not used for the first capitol building; it was reserved for the future building, which would be a stone structure. Yet when the Congress of the new republic met in Austin for the first time, in November 1839, Edwin Waller successfully delivered a presentable capital city that was flourishing, and a month later, he was elected the first mayor of Austin.

During 1840, Governor Lamar built a stockade around Austin for protection. There was danger of a possible attack by Indians and Mexicans, and in 1842, when Mexico invaded San Antonio for the second time, Austin, as the near village to the north, seemed highly vulnerable. Sam Houston, reelected president in 1841 for a second term and succeeding Lamar, refused to live in the executive mansion, calling it dilapidated and in a ruinous condition. Furthermore, he removed the government from Austin to Houston, citing the potential danger of an invasion. Although Austin was not invaded, President Houston hoped to keep the government in Houston and attempted to move the archives from Austin. The ensuing feud, termed the Archive War, ended with victory for the tenacious Austin residents, who used guns and force to prevent the removal of documents, fearing such would signal permanent removal of the capital. In 1845, during the presidency of Anson Jones, the government returned to Austin, and in 1850, it was declared the capital for the next twenty years.

Texas joined the United States in 1845, becoming the twenty-eighth state, and although the Texas Constitution called for a governor's residence, the first four governors boarded in houses or hotels. Governor Elisha M. Pease, the fifth governor of the new state and an admirer of Greek Revival architectural style, was one of the commissioners who planned the

1. Roxanne K. Williamson, *Austin, Texas: An American Architectural History,* 4–11.

Texas Governor's Mansion. As a New Englander, he learned about the Greek Revival style from some of the fine examples that had been built on the East Coast in the 1800s. In his native Connecticut, the style was for a time one of the most popular models for houses, churches, and public buildings.

Additionally, settlers migrating to Texas from the southeastern United States brought an infatuation with Greek Revival and other Classical styles of architecture: "The entire South had fallen in love with Greek Revival architecture, and what was a waning fancy in the Northeast in the forties was still an overwhelming Southern favorite in the fifties."[2] Everyday Texans owning property were gradually developing an appreciation for culture and an interest in building houses like those they had seen in the southeast. The popularity of the Greek Revival style generally phased out around the time of the Civil War. Later, in the 1900s, various governors' families would erroneously refer to the Greek Revival style Texas mansion as a Colonial Revival or a Southern Colonial.

Abner Hugh Cook, a leading Southern builder from North Carolina, was one of many designers active in the building of early Austin, but he is the only one who remained famous for more than 160 years. Consequently he has become known as the "builder of Austin," despite the solid contributions of others. Cook moved to Austin in 1839 after working in Georgia and Tennessee and remained in the nearly deserted town, among the only nineteen families who stayed when others panicked and moved away in 1842, fearing a Mexican invasion. Cook built several Greek Revival private homes in Austin before building the governor's mansion between 1854 and 1856.

Following the popular nineteenth-century guidebooks of Asher Benjamin and Minard Lafever, and using the products from a brickyard, stone quarry, and sawmill, in which he held an interest, Abner Cook produced Greek Revival houses as well as public buildings, of which the governor's mansion is the crowning jewel. With no formal architectural school background, Abner Cook is most often referred to as a "master builder." The term describes those carpenters or builders who built houses by memory and observation and by following the models in pattern books.[3] "Cook had worked in Nashville, Tennessee, for Reiff and William Hume, who rebuilt Andrew Jackson's home there, the Hermitage. The Texas governor's mansion has many similarities."[4]

An original plan for a large Greek Revival house with two wings and surrounding fencing, drawn by Robert Payne, to whom Cook paid one hundred dollars, is the basic design Cook used in building the mansion, and only one sketch survives. In 1854, the legislature appropriated seventeen thousand dollars for building and furnishing the official governor's mansion. When Abner Cook responded to an advertisement requesting building bids, he submitted the

2. Ibid., 25–26.

3. Jean Houston Daniel, Price Daniel, and Dorothy Blodgett, *The Texas Governor's Mansion*, 29–30.

4. Virginia McAlester and Lee McAlester, *A Field Guide to America's Historic Neighborhoods and Museum Houses: The Western States*, 550.

lowest bid, which still had to be scaled back to reduce the cost. After eliminating the wings and fencing and reducing the depth, the building contractors resubmitted their bids; Cook again maintained the lowest price and won the commission.

Thomas William Ward, a trained architect from Ireland, was paid a hundred dollars "for his time" in May 1855. Architectural historian William Seale investigated the origins of the mansion and uncovered information that led him to believe that Ward was the actual architect for the finer and more complicated design aspects of the house, probably the staircase, the columns, and the cornice. According to Seale, "It would be simple enough to attribute the entire scheme to Payne, who was referred to as 'architect' in the original report. . . . But there is a quality inherent in the mansion which somehow denies the sole hands of those contractors Payne and Cook." Seale continued, saying that Ward "would have been more familiar than either Payne or Cook with houses on a monumental scale," and "he most likely was relied on for the architectural refinement and detail of the house." Payne's contribution would have taken the form of working drawings, as he lived in Panama during the building phase.[5]

But not all are in agreement on the issue. "While Seales' speculation may someday prove to be true, contemporary reports, tradition and circumstances point to Richard Payne as having drawn the plans and to Abner Cook as the master builder responsible for the design."[6]

When completed, the two-story, unpainted, brick-and-stone house was the finest house in Austin, made from the best materials, and it was then, as now, a source of pride for Texans. Originally planned for one nearby location and changed to take advantage of prevailing winds, the house's perfect two-acre setting was the top location in Austin, providing enough space for a carriage house and future gardens with a vista of broad green fields and a full view of the capitol grounds.

Six Ionic columns, fluted and thirty feet tall, extend the full width of the front of the house, which measures fifty-eight feet. They define the front perimeter of the veranda and support a six-foot entablature that hides the low-hipped roof, making the roofline appear flat and square. This monumental house is grand in nearly every way. The second-story balcony did not originally extend to the columns, but during the early years it was pulled out, making it like the veranda below. The railing design is seen in other Abner Cook houses. It is a delicate bundled-stick design, a Cook hallmark. Thin slats are bunched together to form an open-diamond pattern known as crowfoot balusters.[7] The design on the balcony differs slightly, distinguishing it from that of the veranda.

The doorway to the house is original, but the wide-plank flooring of the entryway was replaced during a major restoration in 1979–1982, reproducing the original. When one enters

5. From chapters 1 and 2 of the William Seale Report, submitted August 5, 1975, as reprinted in Daniel, Daniel, and Blodgett, *Texas Governor's Mansion*, 308–9.
6. Daniel, Daniel, and Blodgett, *Texas Governor's Mansion*, 32.
7. Gordon Echols, *Early Texas Architecture*, 135.

the foyer, the most noticeable feature is the sweeping walnut staircase—it is original, and in the earliest days, it comprised the entire depth of the house. A 1914 two-story addition pushed out the far end, giving the house a new kitchen and service area, more bedrooms, and a conservatory. All the first-floor rooms open to the large center hall, which is the original arrangement. Before air-conditioning, this floor plan allowed for the best ventilation; with the front and back doors open, breezes could move throughout the downstairs. This also happens to be the typical symmetrical arrangement of a Greek Revival house's floor plan. The four original rooms are the two parlors, library, and dining room, and each has one fireplace—except the dining room, which has two.

The double parlors are the original dimensions—changes have been only cosmetic. Built to accommodate a plain, but solid lifestyle, elegance was not a foremost consideration when the mansion was conceived. Elaborate cove moldings for the sixteen-foot ceilings as well as carved mantels for the fireplaces were added in 1914, contributing to the sense of formality. The fireplace mantels were later returned to the original style, but the cove ceiling moldings are still present and featured.

The parlors open to each other and are used together as one large space when needed. They have stunning collections of nineteenth-century antique furnishings purchased for the house by the Friends of the Governor's Mansion during the 1979–1982 restoration.

The library contains the only mantelpiece that is original to the house—it served as the model during the restoration. A portrait of Stephen F. Austin hangs over the fireplace. The library also displays a desk belonging to Austin, given to the mansion by his heirs in 1923. It is the most historic piece in the room. An American Empire sofa, given to the mansion by descendants of Governor and Mrs. Pease, the first residents of the house, fits with the room's history and beauty.

A hero of the Battle of San Jacinto and the first president of the Texas Republic, Sam Houston narrowly won the Texas gubernatorial election twenty years later, in 1859. He was forced out of office in 1861 when, after issuing the Texas secession proclamation, he nevertheless refused to take the Confederate oath. Houston entered the governor's mansion as a controversial figure and left amid chaos and a bit of scorn. It was understood from the outset that he disliked the town of Austin, and many felt he had stunted Austin's growth by removing the capital and would have insured her decline had he been successful in attempting to remove the public archives. During his governorship, the mixed emotions surrounding his popularity caused lively discussions in the legislature, specifically around mansion appropriations. Furniture in the mansion was sparse, and basic things were needed to make it liveable for the large Houston family, who moved in with seven children and one to be born in the mansion. When the dissension more or less settled, furniture was purchased, and in time, Governor Houston's mahogany bed—originally costing thirty dollars—was elevated from a mere inventory item to becoming the focal point of the official Sam Houston Bedroom. It is assumed to have been in the mansion since its purchase. Over time, Sam Houston regained recognition as

a giant among patriots of Texas and the country. A plaque at the foot of the bed reads: "This bedstead was used in the Executive Mansion by Governor Sam Houston and this tablet [has been] placed thereon by Mrs. Charles A. Culberson to identify and preserve it for future generations. January 16, 1899."[8]

When the Civil War ended, Texas began Reconstruction under military rule and carpetbag influence lasting nine years. Appointed or elected military governors lived in the governor's mansion, and amid the chaos and turmoil, there were allegations of fraud and improprieties. Furniture was broken and missing. Mansion maintenance was conducted on an as-needed basis and therefore not entirely neglected, and although some appropriations for painting and repair were forthcoming, it was generally a dilapidated mess.

In 1869, Edmund J. Davis, who won the governor's election (although its validity was questionable), later became a vilified figure in Texas politics. As the most unpopular of all Texas governors, he nonetheless propped up a mansion in decline. After levying usurious taxes and spending the state almost into collapse, he had plenty of money earmarked for special interests. Yet he essentially restored dignity to the languishing house. He had the house modernized, repaired, replastered, and painted; he purchased furniture and prepared the grounds by creating a lawn and walks.

Governor Richard Coke won election as governor and served from 1874 to 1876. As a former Confederate, his election returned the state to a more popular election process than that of the military and carpetbagger regime. Reconstruction was over, and in 1874 and 1875, legislative appropriations for upgrading the mansion included installation of gas lighting and chandeliers. This big accomplishment was in addition to the governor's task to reduce the huge state debt run up by his predecessor.

Although the governor's mansion was only twenty-seven years old in 1884, suggestions to remove it and build anew began surfacing that year. The popularity of the Victorian Picturesque style had surpassed that of the Greek Revival style, and some wished to tear down the old and start over. The ever-present problems pertaining to maintenance continued to loom large, and appropriations never seemed to be enough to keep the house and grounds in order. The discussion on renovation versus rebuilding continued off and on before a commitment to fully restore the house, made by the Clements administration, would be implemented one hundred years later.

Between 1883 and 1885, a $4,500 appropriation for repairing and refitting the house, including painting, gave the house a new look. The exterior was painted shades of dark green for the shutters, cornice, and pillars. Trained vines on the pillars complemented the overgrown nature of the exterior. The picturesque landscape presented a wild appearance.

Miss Ima Hogg lived in the mansion from 1891 until 1895 during her father's tenure. Governor James S. Hogg, the first Texas-born governor to live in the mansion, moved his fam-

8. *The Governor's Mansion of Texas: A Tour of Texas' Most Historic Home*, 115.

ily into a worn-out house in shabby disrepair. Ima, his only daughter, recalled holes in the walls and ceilings, which the family had replastered and wallpapered for the first time.[9] Interior painting and carpentry were followed by the installation of lace curtains in the tall windows. The family purchased rattan furniture and replaced some of the carpets. Traffic in the house was heavy during the Hogg tenure. Their many friends and visitors came and went freely, and their children, who were included in most aspects of mansion life and entertaining, kept a menagerie of pets. After leaving office and retiring from public life, Governor Hogg created a fortune that reached new heights after his death. As stewards of great wealth and generous benefactors, his children used his fortune to enhance and enrich the state of Texas for future generations.

The Sayers administration, 1899–1903, used some of its eight-thousand-dollar appropriation to install electric lights. They removed the folding doors between the two parlors in order to mount a wooden fretwork valance. Outside the house, the Sayers team built a new, nicer brick stable with a tower and a room in the attic.

When Governor and Mrs. Oscar B. Colquitt lived in the mansion between 1911 and 1915, they replaced the fretwork valance between the double parlors with damask hangings. They also made a major change in the house that proved to be useful, not disastrous. Using a legislative appropriation of twelve thousand dollars, they added a new, larger, two-story ell at the rear of the house, replacing the original ell. A conservatory was created in back of the dining room, where before, gallery doors had opened to the back porch. Smaller and less formal than the state dining room, but no less elegant, the yellow conservatory, with its many windows, is used as a family room and a family dining room, as well as an entertaining room. It contains a portion of the mansion's silver collection, American Empire furniture, and a large gilt mirror with the Texas seal, a gift from a grandson of Sam Houston. Additional sleeping rooms were added to the second floor. After completion of the 1914 addition, the mansion was painted white, except for green shutters.

Between 1927 and 1931, Governor and Mrs. Dan Moody initiated the idea of the Board of Mansion Supervisors, but it was not until the beginning of Governor Ross Sterling's term in 1931 that the proposal to the legislature became official. The new governor appointed Mrs. Moody as chairman of the board and Miss Ima Hogg as a board member. In these years, the mansion's interiors took on a new formality. They became more decorated and coordinated; they matched up.

During the administration of Governor Coke R. Stevenson, 1941–1947, Acting First Lady Scottie Stevenson, the Stevensons' daughter-in-law, used the expertise of Miss Ima Hogg of the Board of Mansion Supervisors to help with acquisitions for the mansion. With a New York designer, Ima Hogg developed a working plan for mansion furnishings. In 1943, she gave a 1790s sideboard to the mansion, and several pieces of furniture were purchased with her help,

9. Daniel, Daniel, and Blodgett, *Texas Governor's Mansion,* 119.

including the Sheraton Regency dining room table that seats eighteen. Personally generous, she purchased, loaned, and made numerous gifts to the mansion. Her influence prevailed over acquisitions for twelve years, until 1947, when Governor Beauford H. Jester did not reappoint her to the Board of Mansion Supervisors. Although her interest continued, she had no official role until she was formally reappointed some twenty years later.

Ima Hogg began collecting antique furniture in 1920 with her first acquisition of an eighteenth-century Queen Anne style chair from New England. With her collection of American furnishings growing, she and her brothers hired architect John F. Staub in 1927 to build Bayou Bend, a fourteen-acre Latin Colonial estate in the River Oaks section of Houston. Over the years, she amassed a museum-quality collection of seventeenth-, eighteenth-, and nineteenth-century American antiques, and in 1966, after converting Bayou Bend from a residence to a museum, she turned over to the Houston Museum of Fine Arts the entire estate and its valuable contents. Ima Hogg died while on a trip to London in 1975 at age ninety-three. It is worth noting that First Lady Jackie Kennedy had appointed her to the Fine Arts Committee for the White House in 1962.

During the tenure of Governor Jester, the legislature appropriated fifty thousand dollars for major mansion repairs including roofing, painting, replacement of woodwork and window shutters, electrical wiring, and new kitchen equipment. Outside, the greenhouse was replaced with a pool and a fountain.

When Governor and Mrs. Allan Shivers moved into the executive mansion, there was more repair work to do. Some of the older mansion furniture was sent to auction, and some new items were purchased. New draperies and carpets were installed in the double parlors. The kitchen received new appliances. Marble facing was added to the fireplaces, the roof was replaced, and air-conditioning and heating installed. Over $102,000 was spent during the Shivers's eight-year incumbency, between 1949 and 1957. The double parlors, with rose-colored moiré draperies, were painted turquoise and given new matching carpets. The library walls were papered with green and carpeted in deep green to complement the window draperies of imported brocade with green velvet valances. These were the days of flocking on wallpaper, damask and brocades, and exceedingly rich fabrics. Wall-to-wall carpeting was popular, as was velvet on chairs and sofas. It was a time when everything was expected to harmonize. Extensively decorated, the house was in its most complete state up to that time, in 1957, when Governor and Mrs. Price Daniel moved in.

The Daniels removed the screens from the second-story balcony that had been added during an earlier administration to form a sleeping porch. This restored the balcony to its original outward appearance. They also stabilized the central stairway, walls, and foundation. First Lady Jean Houston Daniel—whose great-great-grandfather was Sam Houston—researched the governor's mansion thoroughly and wrote books about the mansion as well as a book about the U.S. state capitols and governor's mansions. Her knowledge has been useful for succeeding generations, occupants of the house, and the general public.

The 1963–1969 occupancy by Governor and Mrs. John Connally immediately opened serious discussions regarding a new mansion. The Connallys intended to turn the original old house into a museum and then to acquire a new governor's residence. In 1965, the governor established the Texas Fine Arts Commission to replace the Board of Mansion Supervisors. The State Building Commission then asked the legislature for one million dollars for the new mansion. While serious discussions about new versus old abounded and eventually stalled, First Lady Nellie Connally in 1966 launched a statewide effort to raise money for landscaping the mansion grounds. A campaign committee successfully raised more than the $150,000 goal, and within one year the extensive project was opened for viewing. The installation of white-painted brick extended around the entire block perimeter as a tall privacy fence in some places and low and decorative in others. Today's unique iron fencing that features a Texas Lone Star motif is placed atop the lower brick fencing. At an earlier time, this ironwork had surrounded the state capitol. The brick wall curves at the front of the property and flanks the entrance, where brass replicas of the Texas official seal welcome visitors. Mrs. Connally installed red-brick walkways, steps, and a porch as well as formal gardens, a gazebo, and a new brick courtyard.

In 1962, the mansion became a Texas Historical Landmark, and in 1970, the house was placed on the National Register of Historic Places by the Department of the Interior. The Interior Department later also designated the house as a National Historic Landmark.

Between 1969 and 1973, while Preston Smith was in office, seventy-eight pieces of mansion furniture and accessories were moved to storage, and thirty-five pieces of furniture were reupholstered. The mansion's governing body changed from the Texas Fine Arts Commission to the Texas Commission on the Arts and Humanities and grew in size to a board of eighteen.

The mansion established a decor policy using the advice of White House curator Clement Conger in 1973, even before the inauguration of new governor Dolph Briscoe. The general plan was to replace current objects deemed inappropriate and select a furniture period appropriate for the mansion. Conger emphasized American Empire and Early Victorian periods and called for the elimination of eighteenth-century items.

During the 1974 residency of Governor Briscoe, the nationally recognized consultant on American decorative arts William Seale, hired by the Texas Commission on the Arts and Humanities, researched and reported to the commission the need for a permanent mansion collection as well as a storage plan to save mansion items not currently in use. Recommendations made in his report were referred to during the 1979–1982 restoration, and through the years his report has continued to be an important reference.

Governor William P. Clements Jr. served a first term between 1979 and 1983, and First Lady Rita Clements pursued the historic preservation of the mansion throughout that tenure. As a member of the Fine Arts Committee of the State Department Reception Rooms, her knowledge of period furnishings and historic preservation benefited the governor's mansion. After an assessment for preservation of the mansion, an appropriation from the legislature of one million dollars for repair and restoring the structure of the house was announced. In addition,

Governor and Mrs. Clements raised privately three million dollars for refurbishing the interiors and purchasing furnishings. Governor and Mrs. Clements lived in an apartment for almost three years while the house was historically preserved and the 1856 portion of the house and its 1914 addition were restored.

The work included reactivating nine fireplaces that had been closed since the 1950s when central heating was installed, reconstructing five blocked chimneys, and replacing mantels, hearths, and fireplace facings with appropriate materials. Woodwork and limestone masonry were finished as originally intended in order to return the house to its original simplicity. A new wooden porch at the front door and new wooden steps as well as wide-plank pine flooring on the interior testified to the integrity of the preservation. Virtually all of the decorative efforts of previous occupants were removed in order to transform the house's interiors as a background for the museum-quality furnishings. Some of the famous furniture makers represented in this collection are Charles Lannuier, Duncan Phyfe, and Samuel McIntire. Texas was serious about building up its collection: "Bidding for some of the rare pieces . . . was in competition with leading American museums, and the prices were in the five figure range."[10]

Friends of the Governor's Mansion, a not-for-profit group formed by Governor and Mrs. Clements, chose to adhere to the historic look of the nineteenth century. This had been the advice of William Seale in his 1975 report. The Victorian furniture was placed upstairs, and Federal through Renaissance Revival furniture was collected for the downstairs rooms. There are special pieces from early Texas governors, but the overarching plan to collect furniture finer than had actually been present in the mansion in olden days contributes to the grandness of the interior.

The public rooms were completed during the restoration, and the Friends of the Governor's Mansion continues to acquire Texas paintings for the mansion. The most valuable hangs in the entry hall. It is a huge, seven-by-five-foot, nationally recognized 1903 oil by Robert Jenkins Onderdonk, *Fall of the Alamo,* contributed to the mansion through the Friends by two private families in Houston. In 1983, the Friends started a permanent endowment fund for maintaining the interior collections.

In one of the official recognitions bestowed on the house when restoration was completed, the Texas Society of Architects gave the 1982 Design Award for Historic Preservation to the architects, Burson, Hendricks and Walls. Additional awards were granted from the Austin Heritage Society, the San Antonio Conservation Society, the Texas Commission of the Arts, and the Texas Historical Commission.

Always recognized as a landmark, this house has generated a sizeable amount of ambivalence. Some have sought to put the mansion on parade as a museum entirely, but the present course seems best. In lending it to the governors, the state continues to pursue history in the making rather than treating the house only as a quiet repository of the past. It is a wonderful

10. Ibid., 278.

privilege for a governor's family to live in the home previously occupied by Texas champions and luminaries and to introduce heads of state as well as schoolchildren to Texas history while providing hospitality in a nineteenth-century setting that reflects Texas history. When future president George W. Bush became governor of Texas in 1995, he noted that "living amid the personal belongings and artifacts of Texas' great hero, Sam Houston, really underscored the historical significance of his new role as governor."[11]

Governor and Mrs. Rick Perry moved to the mansion in 2001. Anita Perry actively participated with volunteers seeking early Texas paintings for the house, and both the governor and first lady were champions of the preservation of the historic house. Their fundamental interest in maintenance of the mansion met a great challenge when an inspection in early 2007 by the Texas Historical Commission determined that infrastructure repairs were necessary, requiring the first family to vacate the mansion for eighteen months.

Some of the work included replacing a 1914 sewer pipe and restoration of the nineteenth-century windows. There were also mechanical, electrical, and safety issues to resolve, such as installing a sprinkler system and extending the smoke-detection system upstairs.

Every piece of furniture and every collectible was carefully wrapped, removed, and stored pending completion of the ten-million-dollar job, which was scheduled for early 2009—and then disaster struck. Early in the morning on Sunday, June 8, 2008, a catastrophic, arson-caused fire swept through the mansion, leaving much of the historic building severely damaged. Fortunately, no one was in the home at the time, and all the valuable art and furnishings had been removed for the restoration project. The damage to this historic mansion—which belongs not to its occupants but to the people of Texas—was devastating, from the charred columns, to the buckling roof, to the destruction of the building's high-quality longleaf pine wood that is unavailable today, to the architectural ornamentation that cannot be repaired.

As this book goes to press, the state of Texas is optimistic that the mansion can and will be completely restored so that future generations will be able to reflect not only upon the elegance of this mansion and the role it has played in the history of Texas and America, but also upon the lessons learned from this latest, tremendous challenge and the efforts to preserve this majestic symbol of the proud history of Texas.

11. *Governor's Mansion of Texas,* 152.

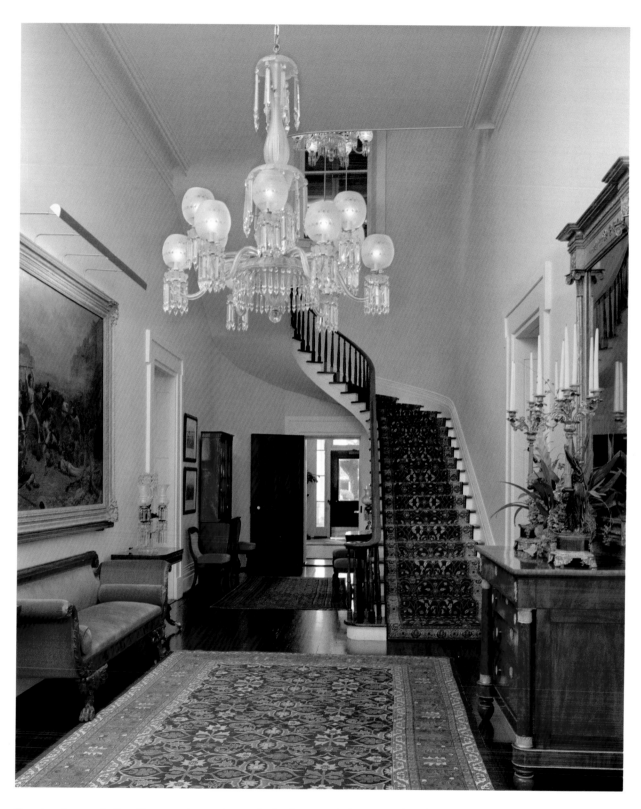

Front entrance hall with sweeping staircase in background. An exceptional painting, circa 1903, by Robert Onderdonk authentically depicts the *Fall of the Alamo*.

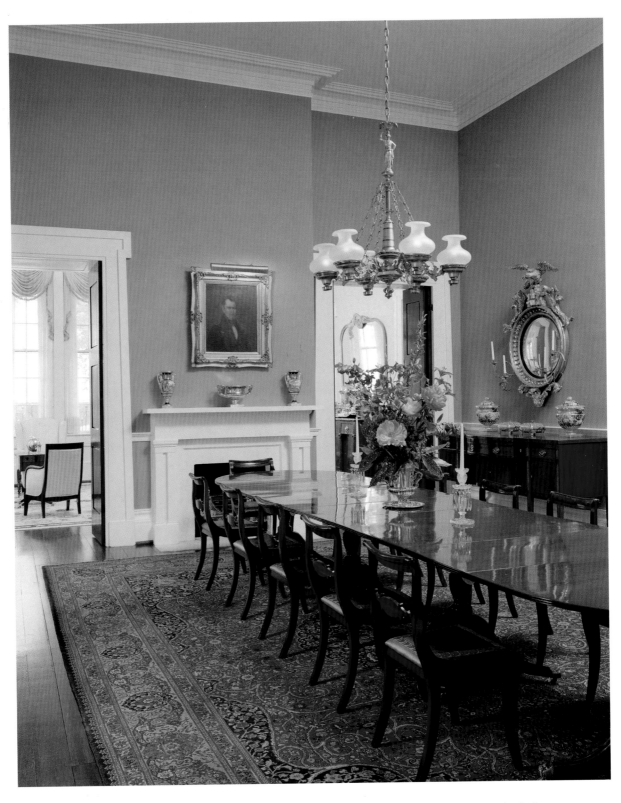

The Sheraton Regency dining table seats eighteen in the State Dining Room. There are twin facing fireplaces; the chandelier, patented in 1843, was acquired during the Briscoe administration.

Antiques in the Small Parlor are early eighteenth-century American. Above the ornate pianoforte is a portrait of Sam Houston painted by Martin Johnson Heade.

The Empire sofa in the library belonged to Governor and Mrs. E. M. Pease. He was the first governor to live here. Other fine antiques include the shelf clock, lyre-base table, and, although it is not pictured, a desk used by Stephen F. Austin, the Father of Texas, which was given to the house in 1923.

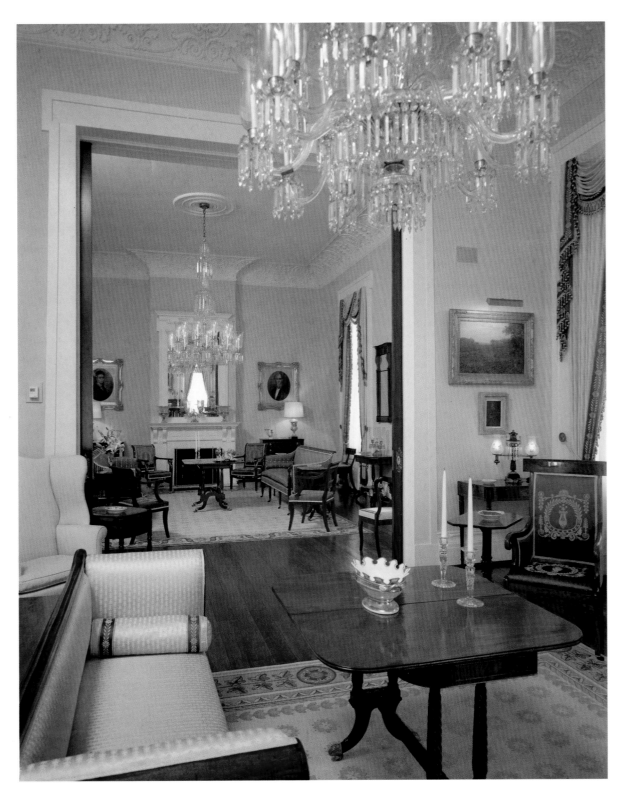

This view shows the Small and Large Parlors as they are combined
to function as double parlors or one large space.

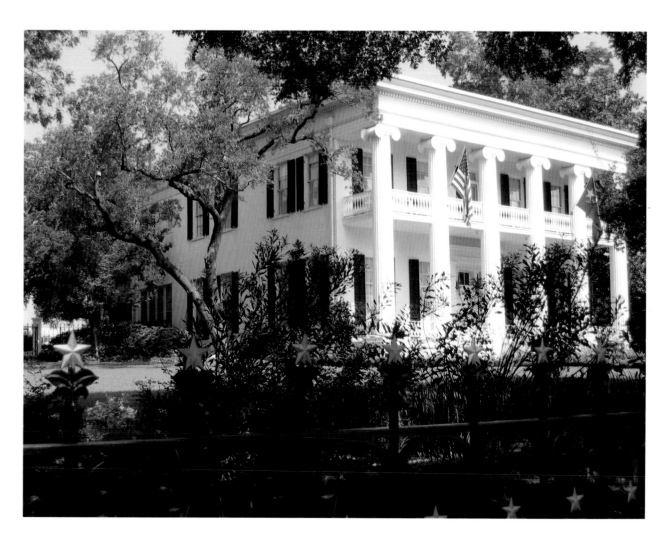

This exterior view shows the front of mansion among the live oak trees. The historic iron fence is topped with stars that represent Texas, the Lone Star State. *Photograph by Ewell Muse.*

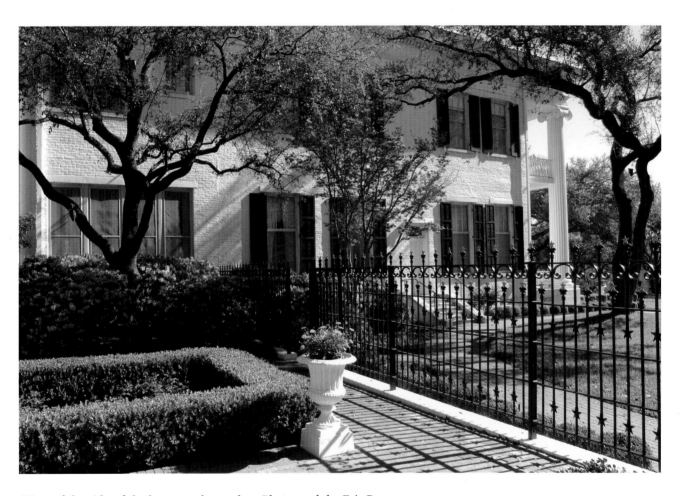

View of the side of the house and a garden. *Photograph by Eric Beggs.*

Virginia
Governor's Mansion

National Register of Historic Places
National Historic Landmark

Location: Capitol Square, Richmond

Year Completed: 1813

Cost: $18,871.82

Size: 15,000 square feet

Number of Rooms: 16

Architect: Alexander Parris

Architectural Style: Federal

Furniture Style: A mixture of American and
European antiques in Neoclassical styles

After Columbus discovered America in 1492, there were numerous attempts by competing European countries to expand their territories and create a foothold in America, but permanent settlements did not follow immediately.

Spain dispatched many explorers, including de Soto, Coronado, Ponce de León, and Balboa, but its first permanent settlement was made by Pedro Menéndez de Avilés in 1565. Assigned by King Philip II to found a colony in Florida, Menéndez de Avilés formally established St. Augustine, which is now not only the oldest city in America, but also a modern city and a thriving center for American history.

Sir Walter Raleigh, closely associated with England's effort to create a colony in North America, began sending expeditions there in 1584 in the name of Queen Elizabeth I. When his explorers landed on Roanoke Island, he gave the name Virginia to the entire coastline, applying it to all the territories in North America claimed by the British. The name was in honor of Elizabeth, who, having never married, was known as the "Virgin Queen."

Jamestown is on the James River, some forty miles upstream from where the Chesapeake Bay flows into the river. In 1612, only five years after the beginning of the settlement, the settlers began farming tobacco, thus creating a cash crop and establishing Virginia's strong economic future.

In spite of the fact that "Jamestown had tobacco growing in its streets and open spaces," it was a most difficult place to create a colony.[1] The low, swampy settlement was so often besieged with malnutrition, contamination, and mosquitoes that its population was nearly wiped out by disease. The colony was also frequently surrounded by the Powhatan tribe, and in 1622 the Indians attacked and killed over three hundred colonists.

Although Jamestown prevailed as the capital of Virginia until 1699, its surviving population decreased as its settlers migrated to other parts of the Virginia colony, which were more attractive for their fertile soils: up and down the James, and the lands near tidal rivers, and the lands to the west on the eastern edge of the Piedmont.

Despite the previously mentioned problems of the settlement of Jamestown, the Virginia colony itself managed to reach a population of almost five thousand by 1635, and by the end of the seventeenth century, it had grown to more than sixty thousand and was the largest North American colony.[2] The emphasis on tobacco cultivation and the proliferation of plantations heightened the importation of slaves, who helped clear the wilderness, build crude roads, and create new villages. After a series of fires destroyed the Jamestown statehouse, the government moved the capital ten miles upriver to Middle Plantation, a village with a college and a future, located halfway between the James and York rivers.

Middle Plantation, settled in 1633, became home to the College of William and Mary in 1693, when a royal charter, granted by King William and Queen Mary, inspired a developing

1. Kenneth Severens, *Southern Architecture,* 10.
2. Mills Lane, *Architecture of the Old South,* 19–20.

plan that in time made this little hamlet the stage for displaying colonial America worldwide. When the capital was moved there in 1699 the name of Middle Plantation was changed to Williamsburg to honor King William.

When the capital moved to Williamsburg in 1699, the little town was not brimming with architecture as we know it today, but it provided a safer, more healthful haven on higher ground than that provided by the swamps around Jamestown. And it was not long before Williamsburg displayed a European architectural appearance in its arrangement of squares and rectangles, creating open spaces for vistas of geometrical public buildings.

An early promoter of Williamsburg, Royal Governor Francis Nicholson designed the town around the college. Instrumental in the capital move, he linked the college to the government buildings by locating the two institutions three quarters of a mile apart on Duke of Gloucester Street. Angling off the central axis was the site of the Governor's Palace. The style of architecture reflected that of London. The symmetrical design of Williamsburg, and its red bricks, steep roofs, and cupolas, is textbook Georgian, which became a dominant American style.

The original governor's palace was completed in 1720. Royal Governor Alexander Spotswood, the first governor to reside in the new mansion, arrived from England in 1710 just in time to influence its building and garden design. He planned a grandiose mansion, an American showplace whose architecture mimicked the epitome of English style. As Clifford Dowdey states in *The Virginia Dynasties,* "In all truth, the building designed by Spotswood was palatial, at least by colonial standards."[3]

The earliest governors of Virginia were royal governors appointed by the king and officially represented England. They prevailed over the colony from 1705 until the start of the Revolutionary War. John Murray, the last of the royal governors, fled at the outset of the war, thereby ending England's rule in Virginia.

In 1776, as a result of the declaration of American independence, Virginia became a free commonwealth, no longer governed by England. Its first elected governor, the Revolutionary hero Patrick Henry, lived in the Governor's Palace until Thomas Jefferson's election in 1779. While living in the Governor's Palace, Jefferson made sketches for changes he wished to make in the residence. With his avid interest in Neoclassical architecture and a dislike of Virginia's architecture, he thought the house could be improved. Of greater concern to him was the capital site. In 1776, Jefferson had introduced a bill proposing to relocate the government; the bill failed. With the passage of a revised bill in 1779, the capital moved to Richmond in 1780.

The residence had been the official home of seven royal governors and provided a residence for the first two elected Virginia governors. During the revolution, the legislature moved the capital of the state to the town of Richmond, still on the James River, but farther inland. Richmond, established in 1737 as a trading center and mill, was thought to be less vulnerable to British attacks.

3. Clifford Dowdey, *The Virginia Dynasties: The Emergence of "King" Carter and the Golden Age,* 264.

In 1781, one year after the capital moved to Richmond, the Governor's Palace in Williamsburg burned to the ground. Many years later, in 1930, flooring and foundation sections and cellar walls that were several feet high and included passageways and steps were discovered intact. These, along with hundreds of uncovered historic artifacts, proved to be extremely valuable to the reconstruction that was then taking place.

For 150 years, Williamsburg, the center of so much early American history, culture, and architecture had languished. It was largely overlooked and somewhat ignored until 1926, when a local Episcopal minister, Dr. W. A. R. Goodwin, and philanthropist John D. Rockefeller Jr. planned a restoration. Their design included a recreation of the eighteenth-century town, its houses, streets, shops, and public buildings, including the Governor's Palace.

From 1930, with the beginning of excavation, until 1934, when the rebuilt (on its original foundation and almost precisely as it had been before) Governor's Palace opened to the public, the restoration of an entire village was in process and in the national limelight. This monument of eighteenth-century American colonial life is visited by millions of people worldwide. The three-hundred-acre historical area illustrates and reminds us of the struggle for America's independence from England.

For a short time after the capital relocated to Richmond, governors rented temporary living quarters. A second official governor's residence was built in Richmond during the latter part of the eighteenth century. It was a simple wooden house of no special distinction and provided residency for twelve administrations. In 1811, Virginia's Governor John Tyler addressed the legislature, stating that the house "is intolerable for a private family, there being not a foot of ground that is not exposed to three streets, besides a cluster of dirty tenements immediately in front of the house with their windows opening into the enclosure."[4] The legislature reached a decision to build a new official residence, and while the new house's construction was under way, the old house was dismantled.

Alexander Parris (1780–1852), a New England architect with a solid grounding in carpentry, shifted into an architectural career as a young apprentice in Massachusetts. He settled in Maine in 1801 and, demonstrating an interest in antiquities, he designed large houses with Classical details. In 1807 he left Maine to seek work in Boston, New York, and Philadelphia. He obtained a contract in Richmond in 1810 to build a house for a local businessman, John Bell. This commission was followed by two others—the John Wickham House and the Virginia governor's mansion. Enthralled by the new archeological styles of master architects Benjamin Henry Latrobe and Charles Bulfinch, Parris created plans for these houses inspired by their Classical work and using Classicism as a model for his design. The Neoclassical Wickham House, a few blocks from the governor's mansion, is today a part of the Valentine Museum. The Adam mode, or early-phase Federal style, in which Parris designed the governor's mansion, incorporated Neoclassical features that created a grand Classical interior while the exterior remained restrained and sedate.

4. William Seale, *Virginia's Executive Mansion*, 12.

A Classical revival in architecture was afoot in America. Thomas Jefferson, influential and hugely devoted to the architecture of ancient Greece and Rome, created a plan for the governor's mansion while planning the Virginia capitol. It was rejected for being too monumental and massive for a governor's house in those times. Instead, the Parris design of a scaled-down mansion, for which he was paid fifty dollars, won the approval of the commission. It was completed in 1813, shortly after the start of the War of 1812, and its total cost was $18,871.82. The first resident of the new house was Governor James Barbour.

The governor's mansion sits on a twelve-acre wedge in downtown Richmond that constitutes Capitol Square. A few yards from the mansion is the capitol, designed in 1785 by Thomas Jefferson with the assistance of Charles Louis Clerrisseau, "one of the most correct architects of France."[5] The Classical design was modeled on the Maison Carrée, a Roman temple built in Nîmes, France, in the first century AD.

The second governor to live in the residence, Wilson Cary Nichols, hired Maximilian Godefroy, a French engineer who, after moving to the United States, taught engineering in Baltimore, where he also designed the first Gothic Revival church in the United States. Godefroy's charge was to renovate Capitol Square and replace the scruffy pasture and vacant lot with a park more hospitable to the gentry than to the wandering cows. (Although in 1837, Governor David Campbell obtained special permission to graze a cow on Capitol Square.) Godefroy's landscape design was a complicated, grand French Baroque plan that seemingly took several administrations to implement. Major aspects that were probably completed in the next six years included the straight, mirroring line of trees leading to the mansion and forming an allée. Terracing and lines of trees created formal promenade areas in stepped levels of the hillside. The semicircular wide drive path in front of the mansion was of gravel, maintaining a tamped-down surface, allowing more space for promenading.

Capitol Square, once an ungraded, overgrown, uneven site, has blossomed into the green park at the center of Richmond. In addition to the Federal style Governor's Residence, the Neoclassical capitol building, and the towering 1858 equestrian statue of George Washington, there is much else to view—the sloping green lawns, wide paths, and fountains, not to mention the historic cast-iron fence and park benches, where one can see the Victorian Gothic Old City Hall, the Classical Revival churches, and the Greek Revival house where General Robert E. Lee's family lived during the Civil War. All of this broadens one's historical exposure and exalts the monumental setting. With picturesque landscaping, this lively outdoor green space, an urban park of changing vistas for more than 150 years, has evolved to become a busy central hub bordered by high-rise office buildings. Virginia's governor's mansion is the oldest in the United States that continues to be used for its intended purpose.[6]

5. Fiske Kimball, *The Capitol of Virginia: A Landmark of American Architecture,* 14.

6. While the original governor's residence in Frankfort, Kentucky, is older than the Virginia house, it is now used as a residence for Kentucky's lieutenant governor. Kentucky built a new residence for its governors in 1914.

The Virginia governor's residence, a large, two-story, rectangular, brick building painted the color of butter, has dark green shutters and white trim. It is an imposing, symmetrical house that has a graceful columned front portico that was added in 1830. Originally there was no front porch; there were wooden steps, and over the front door was a semicircular window (a fanlight). When the house was built, the building commissioners recommended adding the front portico as well as adding parapets to the roof above the eaves to soften the overall angular look to the house. When these additions were made in 1830, the house's original red brick was painted for the first time. The exterior brick of the house was laid in Flemish bond, a decorative pattern used for its beauty and durability—the frequent choice of builders for the finest architecture in Virginia. The restored Governor's Palace in Williamsburg is another example of Flemish bond brickwork. According to William Seale, in his book *Virginia's Executive Mansion,*

> Virginia's "state house" or "government house," as the Executive Mansion was often confusingly called in its early period, was the finest official house of any governor in the United States. . . . When a state bought or built a governor's mansion, the house normally met the philosophical requirement of being roomy but somewhat ordinary. In contrast, the governor's house of Virginia was imposing, set back on its graveled approach, with formal lines of trees planted along the sides.[7]

In the 1850s, Richmond hired Philadelphia architect John Notman to again redesign Capitol Square. He envisioned a more fashionable and rural style for the park than the formal design that had been in place since 1816. Thus a picturesque new style soon replaced the Classical design. Notman improved the square's parade grounds and promenade areas to serve as a suitable environment to surround the giant equestrian statue of George Washington. Created by Thomas Crawford, an American sculptor living in Rome, it is said to be the finest equestrian statue in the world. Mounted on a granite pedestal, the horse and rider overlook Capitol Square, Richmond, and the James River. On lower plinths surrounding Washington are statues of seven famous Virginians, including Thomas Jefferson and Patrick Henry. In 1858, on the 126th anniversary of Washington's birthday, the statue of him was officially unveiled amid a formal program of speakers, marching military, and a public evening reception in the governor's mansion. The dedication—attended by hordes of people in the worst of February rain and snow—celebrated the end of a multiyear project.

John Letcher, who was governor from 1860 to 1864, presided over a state in disarray. In response to President Abraham Lincoln's call to arms, Letcher appointed Colonel Robert E. Lee to the post of major general in command of Virginia's military. Western delegates refusing secession broke away from Virginia, forming a new state. The new state of West Virginia joined the Union in 1863. Confederate president Jefferson Davis became a neighbor to Governor

7. Seale, *Virginia's Executive Mansion,* 32.

Letcher, announcing Richmond as the capital of the Confederacy and moving it from Montgomery, Alabama. When the Wheeling Convention elected Francis Harrison Pierpont as a pro-Union governor, he took charge of the captured parts of Virginia, setting up the pro-Union Virginia government. Thus Virginia had two capitals—the Union and the Confederate—as well as two governors at the same time.

Richmond burned and was devastated by the Civil War, but although the governor's mansion was seriously damaged, it remained stable thanks to a bucket brigade that doused the flames before they engulfed the house. At war's end, and with the evacuation of Confederate militia and government, the Confederate governor and his family fled a burning Richmond. Governor Letcher's term had ended in 1864, and former governor William "Extra Billy" Smith had returned to office for what would become the final year of the war. President Andrew Johnson, successor to President Lincoln and in office only one month, officially appointed Francis H. Pierpont as the governor of Virginia on the same day in May 1865 that he officially removed Smith from office.

Neglect of the mansion continued throughout Reconstruction and into the 1880s and 1890s. Virginia's economy had been ruined, its farms and factories were in tatters, recovery was painfully slow, and consequently only the basic repair work in the residence seemed necessary.

In 1902, Governor Andrew Jackson Montague began serving a four-year term. Following military occupation and carpetbagger government, few pieces of furniture remained. First Lady Elizabeth Montague was appalled at the sight of the beautiful house fallen on such hard times. Only three antique pieces of furniture remained amid the Victorian clutter, and Mrs. Montague requested an appropriation for repairs and furnishings from the Virginia legislature. Once it was granted, she collected fine things from antique dealers, a few of which were said to have been in the house when originally built.

When Governor Montague moved his office from the governor's mansion to the capitol, he set a new precedent that moved the noise and bustle away from his residence; now, petitioners no longer packed into the mansion office, smoking and chewing tobacco and creating noise and confusion while waiting their turn. This improvement spared the wear and stress on the house and its occupants, making it more habitable and comfortable as a residence.

In 1906, the house was enlarged under the direction of Governor Claude A. Swanson, and the design that was adopted then is basically what is intact today. The 1906 changes enhanced the prominent interior. By adding a large oval dining room at the back of the house and removing a common wall between the back drawing room and the dining room that heretofore had been the rear of the house, the architect, Duncan Lee, joined the original parlors, creating a large ballroom that incorporates the hall in between. Mansion manager Amy Bridge says that "the ballroom, in the Colonial Revival style, is consistent with the historical styles that were the specialty of architect Duncan Lee."[8]

8. Amy Bridge (director of the Virginia Executive Mansion), interview with author, September 12, 2005.

The new millwork was consistent with the old. The Classical Revival columns as well as the Georgian Revival fireplace were suitable additions that complement the originals and contribute to Duncan Lee's design.

Before Governor Harry F. Byrd's inauguration in 1926, the house again required rebuilding. A Christmas fire, ignited by a sparkler innocently held by the five-year-old son of Governor Elbert Lee Trinkle, damaged parts of the 1906 changes. When restoring the house after the fire, Governor Byrd made two serious alterations. He removed the large fireplace in the center of the back wall of the dining room, and he pared down the arches in front of the matching staircases. In each instance, he deprived the house of some of its drama. His intention in doing away with the lovely fireplace was to accommodate a dining room sideboard as a matter of convenience. Today, the scene looking toward the dining room holds a different prize, a spectacular sixteenth-century oil portrait of the state's namesake, Queen Elizabeth I. Her portrait, regally overlooking the dining room sideboard, displays the queen beau monde, with yellow hair, a taffeta gray ruff, full leg-of-mutton sleeves embroidered in gold, and a dress of bright pink silk. Her portrait creates enough sparkle to light up the room.

In the case of the stair arches, the change pared down the more elaborate moldings of Duncan Lee's design. Reducing decorative moldings may have been an economy measure: "Given the evidence of the structural repairs made at that time, the refurbishing that took place was on a fairly modest budget."[9]

Governor and Mrs. Linwood Holton began their occupancy of the governor's mansion in 1970; he was the first Republican governor after about ninety years of Democrats in the governor's mansion. Holton introduced legislation to establish the Citizens' Advisory Council for Interpreting and Furnishing the Executive Mansion, thus initiating new requirements for future decoration. The new order emphasized the history of the house and insisted on historical refurbishment. The committee used the Colonial Williamsburg Foundation and the White House as advisors.

Some mansion furnishings that were collected before the research could be completed, coupled with the short span of a four-year administration, hindered the redecoration from reaching the historical accuracy that it would later achieve. Mansion decor was to be based on historical periods of the eighteenth and early nineteenth centuries, but it began as a generic rendering that has continued to be refined over the years.

When Governor and Mrs. Mills Godwin began their occupancy of the governor's mansion in 1966, they had no way of knowing they would be returning to the mansion in 1974 to serve another four-year term. Governor Godwin served his first term of office as a Democrat and his later term at the request of the Republicans. Former first lady Katherine Godwin told the author, "the second term had a lot more problems than the first, and it was more difficult.

9. James E. Wootten (executive director, Capitol Square Preservation Council, Richmond), telephone interviews with author, March 2006 and July 6, 2007.

When Mills ran on a different ticket, it was not because he changed; the man was the same, but the party had changed."[10]

Katherine Godwin wrote a handbook to serve as a guide to the mansion in 1977. Commissioned by the Virginia Chamber of Commerce, her book, *Living in a Legacy,* is a lovely and somewhat personal story of the house. The volume also contains historical information, menus, and recipes. Godwin summarized all the house had been through: "The mansion has been the home of Virginia's governors since 1813. It has been burned, haunted, added to, diminished, decorated, cherished, abused, renovated, restored, explored, deplored, written about, and gossiped over for more than 160 years."[11]

During the incumbency of Governor Douglas Wilder in 1993, Richmond native and tennis great Arthur Ashe died; he was the first black man to win singles titles at the U.S. Open and at Wimbledon. After his death, Ashe's body lay in state in the mansion, and over five thousand people came there to pay their respects. It was a touching recognition; the first of such tributes had been given in 1863, in the midst of the Civil War, by Governor John Letcher for his friend Stonewall Jackson, who died from complications of wounds sustained at the Battle of Chancellorsville. The governor provided a formal military procession from the train station to the governor's mansion, where Jackson lay in state. Then, over a hundred years later, Governor and Mrs. Mills Godwin's daughter Becky died after being struck by lightning, and she, too, lay in state in the mansion.

After two years of planning, research, and documentation, the Virginia legislature appropriated $7.2 million in 1999 to repair and restore the mansion and its outbuildings. In addition to new heating, air-conditioning, ventilation, and security systems, the plumbing and wiring needed upgrading. The building also needed a handicapped-accessible restroom and an elevator. The major parts of the project were the repairs and replacements of the infrastructure of the house; in some places, the walls had to be taken down to the studs.

Governor James Gilmore and his wife, Roxanne, oversaw the entire restoration, with Mrs. Gilmore leading the way as chairman of the Executive Mansion Renovation project. She worked with John Paul Hanbury, a Norfolk architect of the firm Hanbury, Evans, Newill, Vlattas & Company. Both Mr. Hanbury and the contractor, Samuel W. Daniel, specialized in historic preservation. The Foundation for the Preservation of Virginia's Executive Mansion raised contributions from private sources for some of the interior decor.

The remaining Alexander Parris design elements were carefully preserved and restored to their intended appearance. The two first-floor front rooms retain their Federal style, and the later 1903 Duncan Lee ballroom and dining room remain true to their Colonial Revival style. Upon entering this 1813 Federal house, one passes through history; from the front door to the

10. Katherine Godwin, interview with author, September 14, 2005.
11. Katherine Godwin, *Living in a Legacy: Virginia's Executive Mansion,* 1.

dining room, the architectural emphasis changes from Federal with Classical flourishes to Colonial Revival. Amy Bridge, the mansion's manager, sums it up: "as you move through the house you move through time."[12] Three successive Neoclassical arches over the broad hall usher a person through the corridor, with opportunities to stop off in the Old Governor's Office to the left, the Ladies' Parlor to the right, or continue down the hall to the twin staircases and finally to the ballroom, and then to the last arched walkway, which frames the dining room dedicated to Queen Elizabeth.

Historical research uncovered original wall colors, and new wall coverings in other rooms were chosen from early-nineteenth-century designs. Window hangings were designed from information from the era, and the carpet patterns, popular in the 1800s, were chosen by Roxanne Gilmore, who traveled to England and researched the archives of Woodward Grosvenor and Company, a carpet company that saved the old point papers from the eighteenth and nineteenth centuries.

After one hundred and eighty years of giving something a coat of paint, the buildup can almost obliterate fine workmanship. When removed, the detail of the woodwork and mantels started to show through, some of it broken, but all of it exquisite. Repairing the deterioration of columns, porticos, and bases as well as the parquet floors returned them to their beauty and coherence. In addition, an elaborate procedure of injecting acrylic material into the wooden floors remedied their creaking. Some floorboards were reinforced, and parts of the foundation were replaced.

Although no original furniture remains in the mansion, an array of antique furnishings has been collected with selective care. A descendant of Governor Thomas W. Gilmer gave the mansion a 1784 Adam style table. An 1830 spinet came from the estate of Governor James Barbour.

A group of outbuildings on the south side of the residence and not visible from the front may predate the mansion. In olden times, the little buildings included a stable, a two-story cookhouse, servants' quarters, a laundry, a necessary, a cannon house, a carriage house, a live-stock garden, and a stable built in 1792. Throughout the 1800s, they underwent several mutations and ultimately were transformed for modern use. When change and progress brought indoor plumbing as well as a new kitchen into the main house, the outbuildings answered the growing need for more office space as well as a guest cottage.

In 1954, the noted Richmond landscape architect Charles Gillette accepted a commission to design and reinterpret the garden area. He unified the entire space, including the outbuildings, joining the former servants' quarters and the former kitchen to make office spaces and a guest cottage. The garden mix contained holly and boxwood with azalea, camellia, crape myrtle, and daffodils. Gillette created two square parterres with urns in the center of a miniature boxwood

12. Amy Bridge, interview with author, September 12, 2005.

border design. The garden is contained by a brick wall that frames the private space and serves as a backdrop for a rectangular pool.

Since the 1999 restoration, the little buildings consist of a guest cottage and a carriage building. Overlooking the garden, compact and visually strung together through the use of horticulture, their exterior appearance is that of an English mews.

In 2000, the Garden Club of Virginia restored the 1950s Gillette Garden, replacing as well as maintaining the authenticity established by Gillette. As a very large formal but lively space, frequently used for governors' receptions, the garden is invigorated by its brick borders, the water, the urns and bronze sculpture, as well as the plants, trees, and walks.

Virginia has a lot to boast about. Few states have spawned so many heroes and statesmen, including Patrick Henry, eight men who became presidents of the United States, and many who fought for freedom from England first in the Revolutionary War and then again in the War of 1812. Some of America's finest architectural examples from the eighteenth and nineteenth century are found in Virginia. For example, there are the Carter family's house at Shirley Plantation, General Robert E. Lee's Stratford Hall, William Randolph III's Wilton, George Washington's Mount Vernon, and Thomas Jefferson's Monticello. The governor's mansion in Richmond keeps good company.

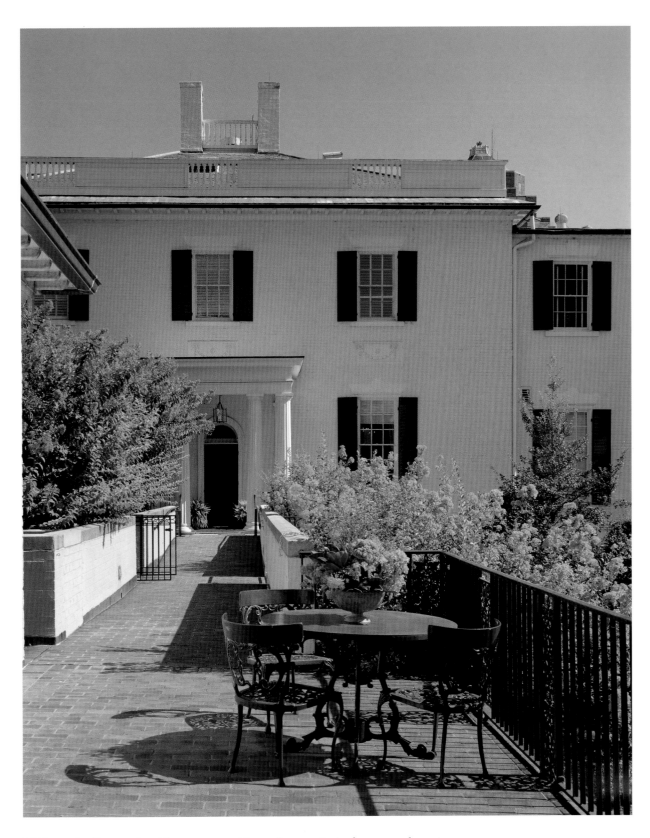

Walkway leading to the side entrance with outdoor patio in foreground.

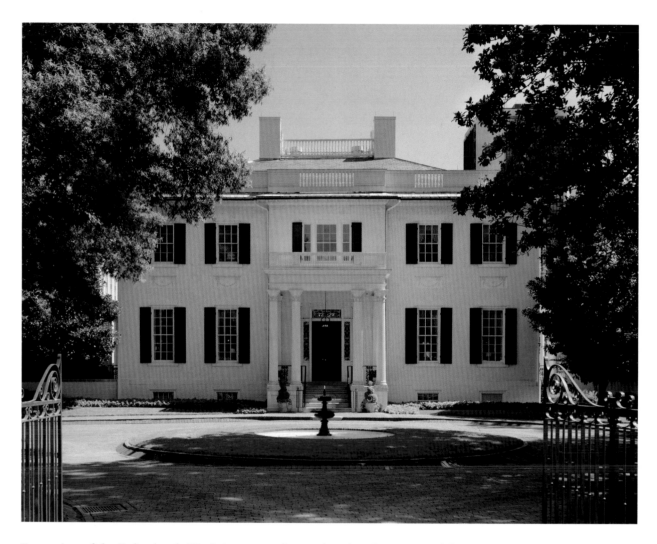

Front view of the Federal style Virginia governor's mansion showing gates and fountain. The house dates to 1813 and is the oldest in America still used for its originally intended purpose.

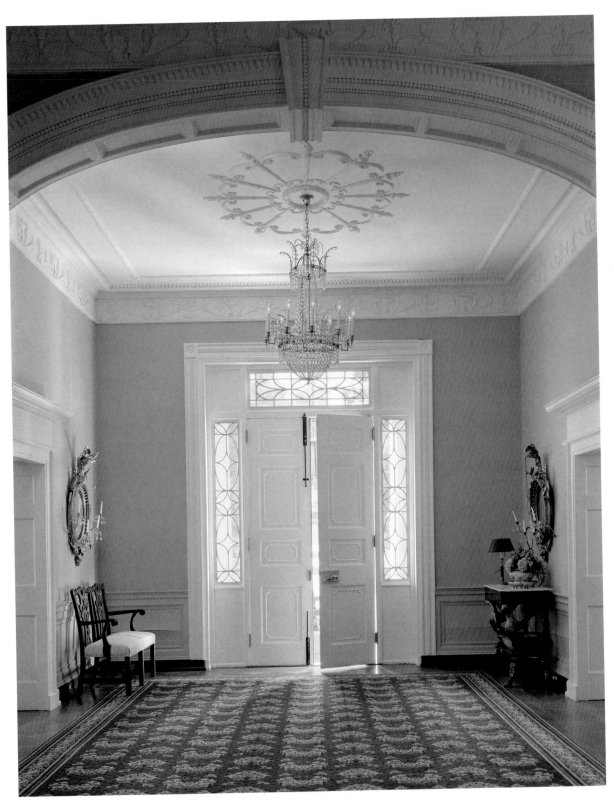

View of the front door entrance from within the house. This 1830 double front door replaces the original.

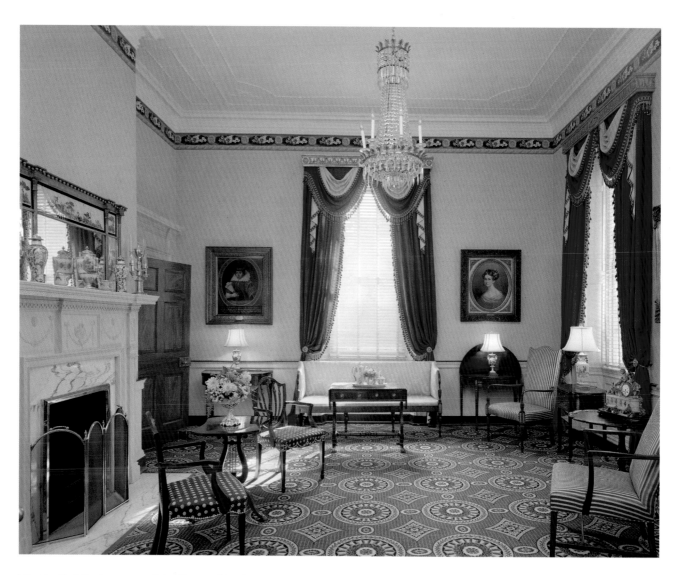

The Ladies' Parlor was originally used by first ladies for receiving visitors.
The pattern in the Brussels carpet is a repeat of the ceiling medallion.

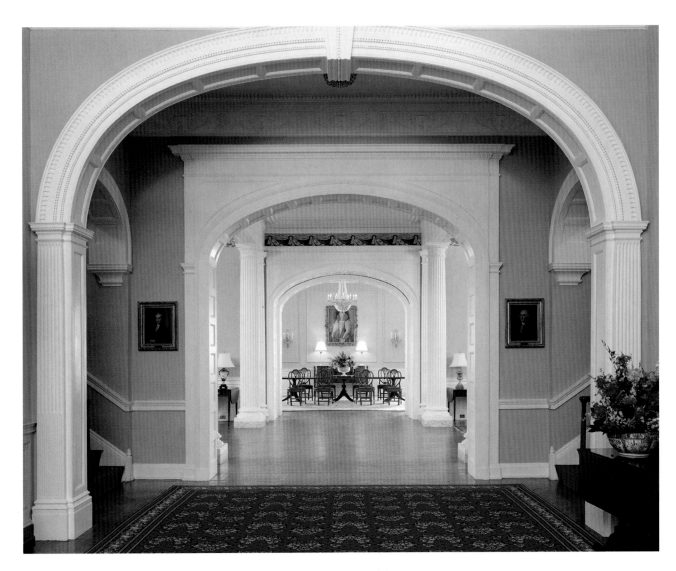

View from the front door entrance toward the dining room. Double staircases
frame the ballrooms. The ballrooms are joined together by incorporating the
hall to form one large ballroom space when needed.

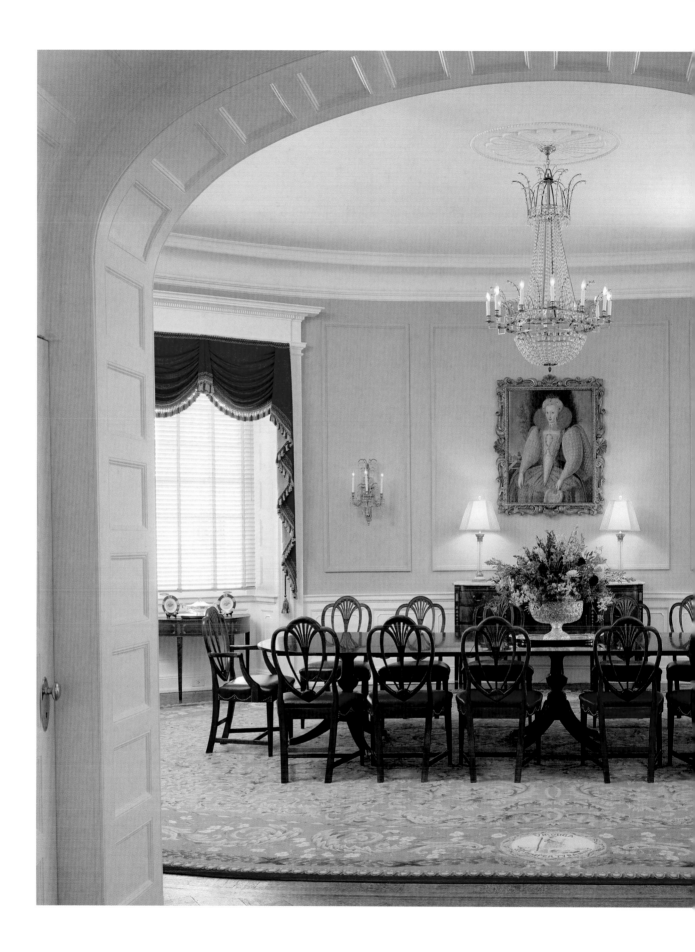

The dining room, not part of the original house, was added to the rear of the house in 1906. Before that addition, the rear of the house was defined by the double parlors, which in 1906 became the ball-rooms. The painting illuminating the dining room is generally believed to be of Queen Elizabeth I and dates to the late sixteenth century.

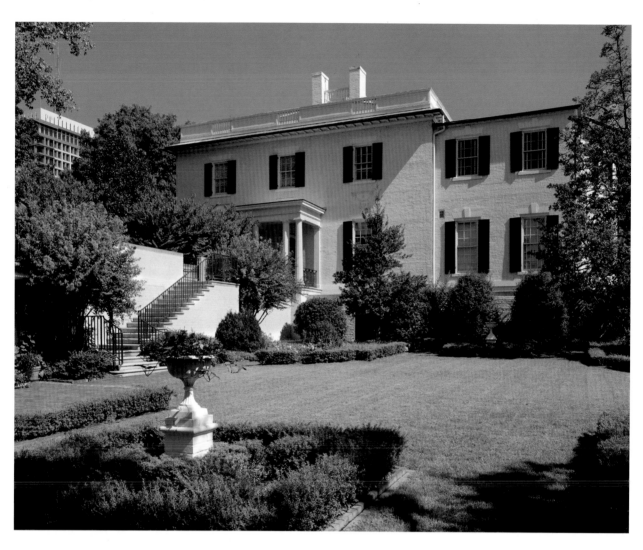

South entrance and the Gillette Garden. This walled garden is frequently used for outdoor entertaining.

West Virginia
Governor's Mansion

Location: 1716 Kanawha Boulevard, Charleston

Construction Year: 1925

Cost: $203,000

Size: 21,000 square feet

Number of Rooms: 30

Architect: Walter F. Martens

Architectural Style: Georgian Colonial

Furniture Style: Eighteenth- and nineteenth-century antiques
and reproductions in the Federal and Empire styles

West Virginia's present land area originally belonged to the Virginia colony. In 1606, King James I granted permission to a group of British investors to settle a massive area of Virginia that extended from present-day South Carolina to Pennsylvania and then north and northwest until the land ended at the Pacific Ocean. This vast land grant would become part of several states that now form our nation.

From Jamestown, the first permanent British settlement in America, the colonists moved up the James River toward today's Richmond, to settle a relatively small portion of Virginia and use the land for growing tobacco. German and Scots-Irish immigrants made new settlements on land farther west, now known as West Virginia. By 1775, about twenty thousand settlers lived in the area that later became West Virginia. The mountainous terrain presented them with new challenges, unlike those faced by the settlers who remained in the east. Western Virginia's land was not favorable to cultivation of tobacco.

Physically separated by the Allegheny Mountains, the eastern and western portions of Virginia became somewhat estranged, holding separate views and staying culturally at arm's length. Geography added to their disputes. The mountainous west was not in step with the slave-based economy of the eastern tobacco growers. As early as 1776, settlers in the west began demanding their own government, and during the early 1800s, the differences became more pronounced. The western area discovered mineral deposits, and disputes erupted because the east controlled the state's finances, and the sections could not agree on the use of public money. Proposals from the west for internal improvements were largely ignored, and inequalities in representation in the General Assembly were perpetuated by the Virginia constitution.[1] With the onset of the Civil War, the state of Virginia joined the Confederacy and the western part of the state professed loyalty to the Union and became a separate state.

To this end, West Virginia's citizens formed a government, adopted a constitution amid border disputes, and the Union admitted it in 1863 during the Civil War. West Virginia suffered the wrenching effects of the Civil War and the ensuing Reconstruc-tion period along with the rest of the South. Vengeance by the North visited upon Southern sympathizers could be violent, and those with Confederate leanings were arrested as prisoners of war: "Although West Virginia was a Union state during the last two years of the Civil War, her political and social history during Reconstruction were scarcely less traumatic than those of the states of the former Confederacy."[2]

When Wheeling became the first capital of the new state, a permanent decision on capital placement was still twenty years away. The fledgling river town of Charleston, with a population of three thousand and no railroad, was designated by the legislature in 1869, but with complaints about the inaccessibility of the site, the capital was moved back to Wheeling in 1875. After a public referendum in 1877, the winner was Charleston, and there the capital became permanent in 1885.

1. Charles Henry Ambler, *History of West Virginia*, 75–76.
2. Otis K. Rice, *West Virginia: A History*, 154.

Charleston's settlement began with one thousand acres along the Kanawha River purchased by Colonel Thomas Bullitt in 1773. Occupation occurred quickly, but no permanent settlements were made until 1788. George Clendenin, a Virginia state commissioner charged with the layout and construction of the first wagon road from Lewisburg to the Kanawha, bought the tract from the Bullitt family. He laid it off into lots and built a two-story, bulletproof log house for himself and a stockade fort for protection. About a mile above his house, he built a blockhouse for family to live in. A surveyor laid out the town with a group of forty one-acre lots. Identified as Clendenin's Settlement in Kenawha County (later changed to Kanawha), it officially became Charles Town in 1794. The name honored Clendenin's father, Charles, who lived and died in the blockhouse and whose final resting place was near the front fence, in what would have been its front yard (had there been one). Sometime later, the name changed to Charleston.

Many have believed that Daniel Boone had settled near the Kanawha River as early as 1786; it is certain, however, that Boone was a surveyor near the Kanawha River in 1789. He and George Clendenin represented Kanawha County in Richmond as the elected legislators to the Virginia Assembly: "Boone went to Richmond and returned, on foot."[3] In 1799, the restless Boone moved on to Spanish Missouri Territory.

Obliged to live in the capital city of Charleston during their tenure, the early governors bore expensive housing burdens. For the first thirty years of statehood no official residence existed, and the governors rented or purchased their own residences. By 1892, a governor's salary was $2,700 a year. Upon leaving office in 1893, Governor A. B. Fleming, the eighth governor of the state, in his final address, pushed the legislature to allocate money for an official house and his success produced an appropriation of $22,000.

Governor William MacCorkle, who followed Governor Fleming into office, would be the first to occupy the first governor's mansion, a huge, white, two-story Queen Anne wooden house with a veranda. This house had been built a few years earlier as a residence for the wealthy Jelenko brothers, who were Charleston pioneers and wholesale merchants. Across the street from what we now remember as the "old" capitol building in downtown Charleston, it served as the official residence for eight administrations between 1893 and 1925.

In 1921, after the old capitol burned, Governor Ephraim F. Morgan, always a visionary, urged the legislature to approve a new governor's mansion appropriation. With a new capitol complex in mind, the legislature passed a sales tax to provide for construction along with an appropriation for the governor's mansion. A site was purchased for $64,270—the price of three parcels of land purchased by the state from private owners—one for $30,000, another for $25,000, and a much smaller one for $9,270. By the time the project was completed, it cost almost $200,000, including land, construction, and furnishing.

Groundbreaking for both a new governor's mansion and a new state capitol occurred almost simultaneously. The young local architect chosen for the mansion, Walter F. Martens, was far less experienced than the venerable Beaux Arts–trained Cass Gilbert, who was chosen for the

3. John P. Hale, *Trans-Allegheny Pioneers: Historical Sketches,* 170.

capitol. Because the state sought an expert opinion regarding the suitability of the new mansion's design, Martens traveled to New York to meet and discuss building plans with Gilbert. They found that the Georgian Revival style Martens planned for the mansion was the same that Gilbert envisioned and sketched as his recommendation.

Governor Morgan chose an architect with a bias for Classical styles and a good reputation. He influenced Martens not only to seek the endorsement of Gilbert, but also to consult the White House staff before and during the project. Governor Morgan only lived in the new mansion six days before his term ended.

Martens designed other Charleston homes and churches that remain within today's historic district. The houses of Virginia inspired Martens's design for the mansion. Georgian style dominated the architecture of the colonies in the 1700s; the tall white Corinthian columns, the red brick laid in Flemish style, and the stone surrounds were all reminiscent of England, whose architecture informed Virginia styles and later continued to impact Britain's colonies with revival styles.

To gain more information about the social requirements for the governor's mansion, Martens visited the White House to determine how best to plan for crowd control in the mansion. After several visits, he devised a floor plan that would accommodate large parties entering, moving through receiving lines, eating, and exiting. Thus he planned wide dual staircases that provided access from all the first-floor public rooms, fostering a systematic flow of traffic. Patterned after the White House, but scaled down to size, this plan allows the mansion to handle two thousand visitors at a time when the occasion arises.

Built between 1924 and 1925, the red-brick Georgian Revival governor's mansion has an unobstructed view up and down the Kanawha River, of the Morris Harvey College, and of the mountains beyond the beautiful city of Charleston. Across the road from the Kanawha River, as a part of the capitol complex, the governor's mansion and the adjacent capitol building itself are close enough neighbors to share walks and grounds. The grounds of the old governor's mansion that was torn down after Governor Morgan moved out are now a part of the roadway around the capitol complex.

The mansion is a quiet jewel, and if it were not so large it could be considered understated. The broad outside appearance is monumental and bold with a high, two-story portico supported by four Corinthian columns. A three-story rectangular house, faced in red Harvard brick, the Georgian beauty is trimmed with decorative stone lintels and insert panels below the roofline. The mansion was originally finished as a two-story building, but with blueprints for a third floor, which was added in 1946 along with a slate roof. In a 1926 building project, the construction of a garage, service wing, and enclosed gardens completed the original plan.

A specially designed and ordered sculptured brass door knocker decorates the front door. Presented to Governor Smith in the 1960s by the president of Powhatan Brass and Ironworks, the impressive solid brass knocker, emblazoned with the Great Seal of West Virginia, is a fitting introduction to the impressive house.

The wide reception hall or foyer is spacious, dramatic, and formal. Its flooring is of black Belgian and white Tennessee marble, and a magnificent double mahogany Georgian staircase with cut crystal finials on the newel posts gives even more drama to the first floor. A pair of Empire sofas and matching tables with gilded eagles as bases were a part of the first governor's mansion and now furnish the reception hall. In this room, there is also an 1830 English Regency table acquired by the West Virginia Mansion Preservation Foundation in the 1980s.

The ballroom chandeliers historically belonged to a downtown drugstore in the early days of Charleston. The ballroom also contains a white mantel of classic design from an old Irish castle. Another formal space is the drawing room, across the hall from the ballroom. It contains a 275-year-old grandfather clock, carved in mahogany by Jan Henkels and made in Holland.

The mahogany dining room table and sideboard, gifts from a generous benefactor, are eighteenth-century English. The table extends to seat twenty-two or twenty-four. The library paneling is of butternut, also called white walnut, a native West Virginia hardwood. The foundation also purchased a Turkish Oushak rug for the library.

During Governor Hulett C. Smith's term in office from 1965 to 1969, the mansion required extensive renovation, refurbishing, redecoration, and refurnishing. A little over three hundred thousand dollars was ultimately necessary. Some of the work included steel reinforcement of sagging floors, replacement of broken marble sections in the foyer floor, and installation of windows. In 1966, First Lady Mary Alice Smith reported the estimated cost of building a new house for the governor would be one million dollars, and if that choice were made, the history and sentimental value attached to the mansion would be lost. Citing the model set by Jackie Kennedy during the White House restoration and its focus on preservation and the fine arts, Mrs. Smith's pursuit of historic preservation of the mansion in West Virginia prevailed.

In 1969, Governor and Mrs. Arch Moore moved into the governor's mansion and began serving what would eventually be three terms. Governor Moore's first two terms ended in 1977; before his third term commenced in the eighties, Governor John D. Rockefeller occupied the house.

When Governor and Mrs. John D. (Jay) Rockefeller IV moved into the mansion in 1977, they brought with them some of their personal furnishings and antiques and redecorated the house using more color than the house had ever seen before. Quiet gray walls became lacquered shiny sunny yellow, and subtle furniture covers became bright with flowers or stripes. The sedate interior was transformed into a warmer, more personal atmosphere.

While on their honeymoon, the Rockefellers had purchased a pair of 250-year-old Japanese antique screens depicting the four seasons. They contributed the screens to the mansion's permanent furniture collection.

After Arch Moore became governor for the third time, First Lady Shelley Moore in 1985 established the West Virginia Mansion Preservation Foundation, a nonpolitical fund-raising group committed to maintaining the integrity of the interior decor to best enhance the historic value of the governor's mansion. In its first twenty months, the foundation raised $179,000; almost all was spent on acquisitions.

The governor's mansion began an association with Carleton Varney, a nationally famous decorator and former dean of the University of Charleston School of Design, which is now named the Carleton Varney School of Design. Varney continues to collaborate with the mansion's fund-raising foundation and governors, providing advice for decorating and collecting. In 1985, approximately five hundred thousand dollars was spent to acquire mostly Federal furniture. Before then, many governor families brought their own furnishings to the mansion, and there was little furniture that remained in the house that was permanent.

Shelley Moore planned to put the house in first-rate condition as a way to prevent the necessity of large-scale projects in the future. She noted that by using the available state funds for maintenance and in not allowing furnishings to wear out, the future need to overhaul the interiors could be minimized.

It is no surprise that in 2005, when Governor Joe Manchin III and First Lady Gayle Manchin moved to the governor's residence, they discovered that it had been largely untouched for twenty years, and that it was again time for structural repairs and redecorating. The structural repairs, estimated at $1.2 million, were begun, and the Manchins spent $450,000—funds that had been left over from the governor's campaign money—to repair and remodel the family spaces on the second and third floors. They have also raised private funds for refurbishing the first floor.

Despite the theory that a single, proper overhaul followed by assiduous maintenance should insure the continuing health of a governor's mansion, there are a number of factors at any given time that can affect priorities for state money. When the mansion is in need of attention, state funds may not be available right away. This situation occurs in most states to some degree. To ensure that funds are available when needed, some mansions have established endowments that are usually led by a subcommittee of a "Friends" group or a mansion-preservation organization.

The landscaping of the West Virginia governor's mansion is unified with that of the capitol complex. The mansion gardens are somewhat secluded and private. The entire complex is historic, green, and pastoral. From the limestone exterior of the Beaux Arts capitol building to the Cultural Center, the outbuildings, the commemorative statues, and the red-brick governor's mansion, West Virginia's history holds forth amid the spectacular beauty of the Appalachian Plateau.

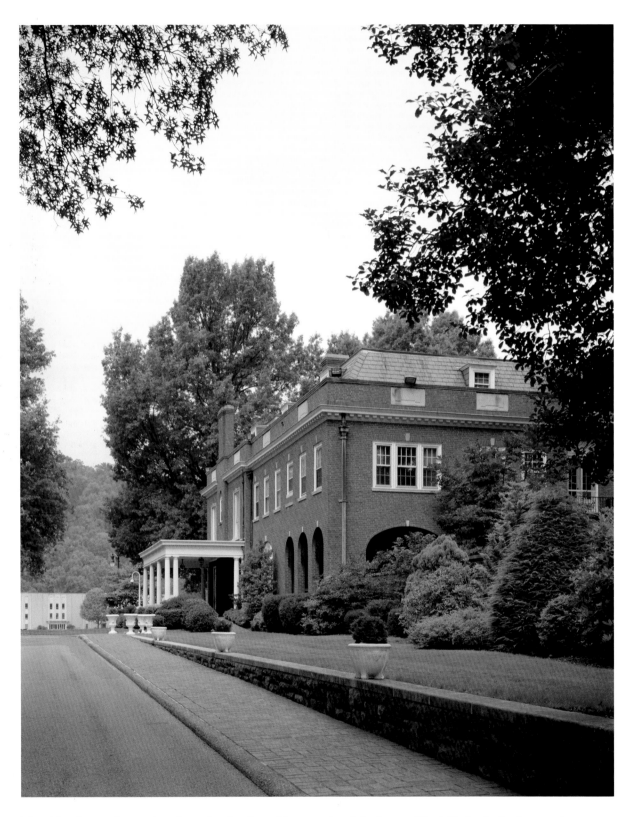

The side view and entrance show the depth and large scale of the house. The hills in the background are on the far side of the Kanawha River. The river runs in front of the mansion, between the mansion and the hills.

The grand foyer, whose dual Georgian staircases have crystal finials on the newel posts, has black Belgian and white Tennessee marble flooring. A pair of Empire sofas and a pair of gilded eagle tables are from the first governor's mansion.

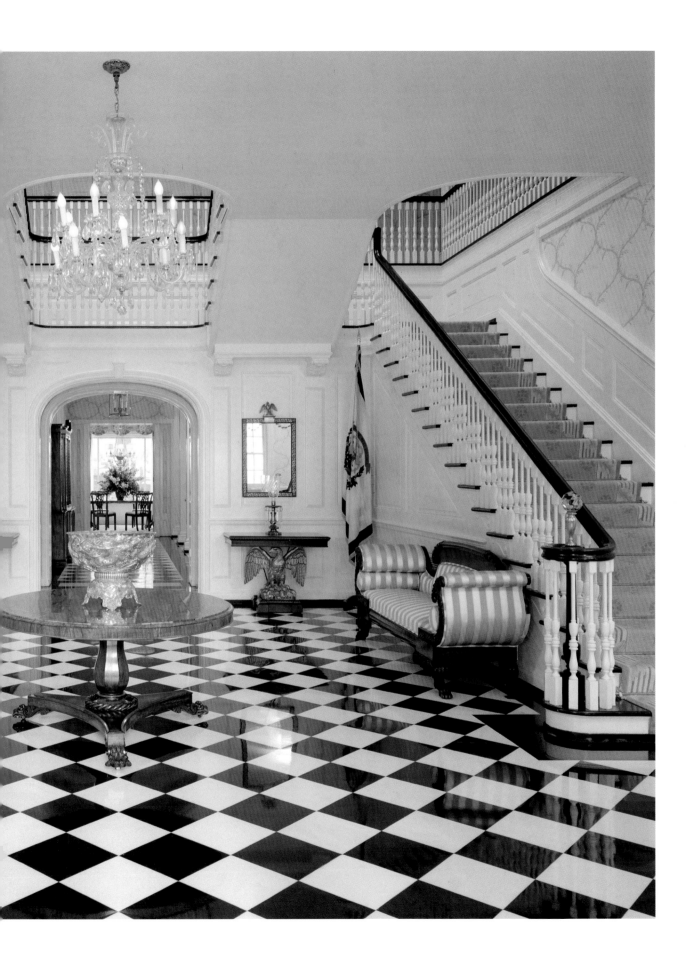

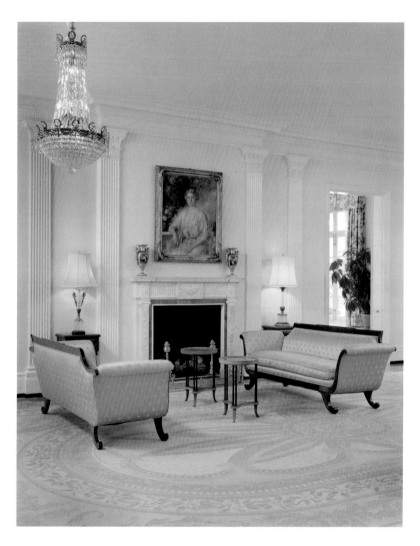

The ballroom is one of the state rooms and features a mantel from a castle in Ireland and chandeliers that once hung in Scott's drugstore in downtown Charleston.

The Drawing Room, looking into the library, which features butternut paneling. The Drawing Room chandeliers formerly graced the old Kanawha Hotel in Charleston.

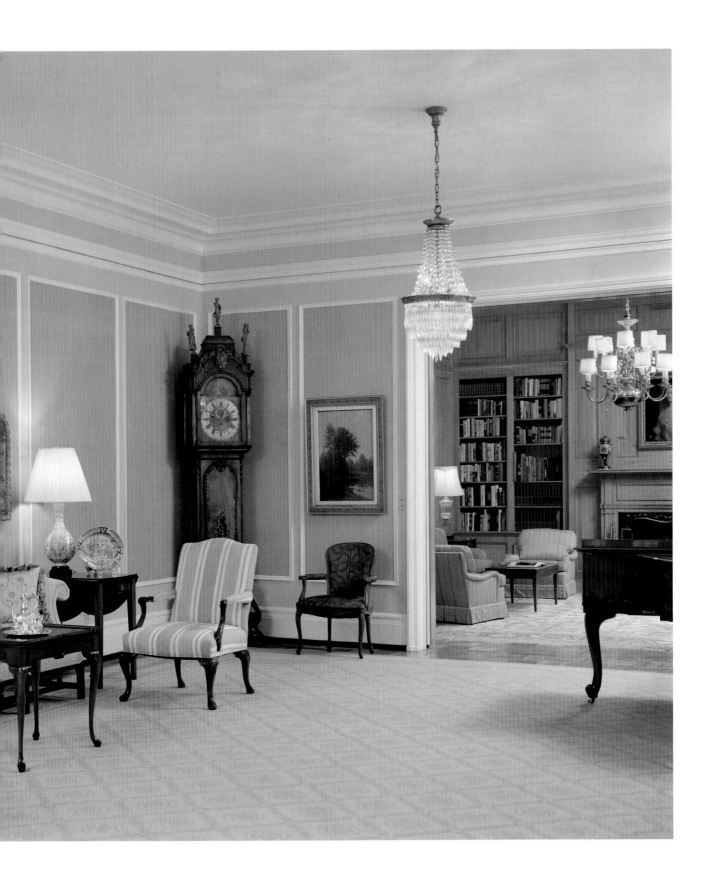

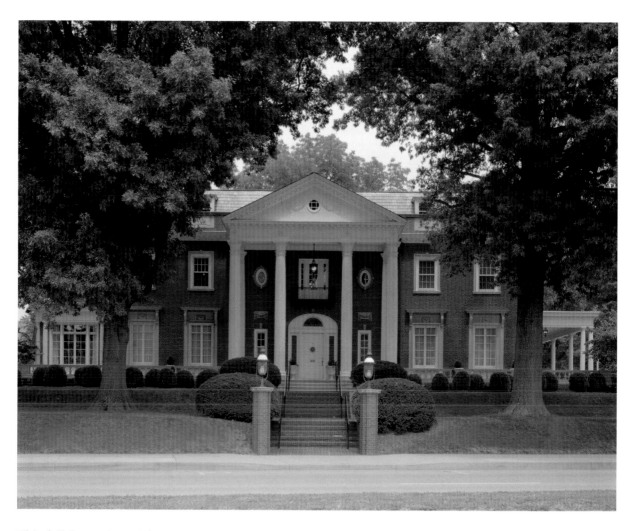

This full front view of the Georgian West Virginia governor's mansion is taken from across the street. The house sits close to the road, above the Kanawha River.

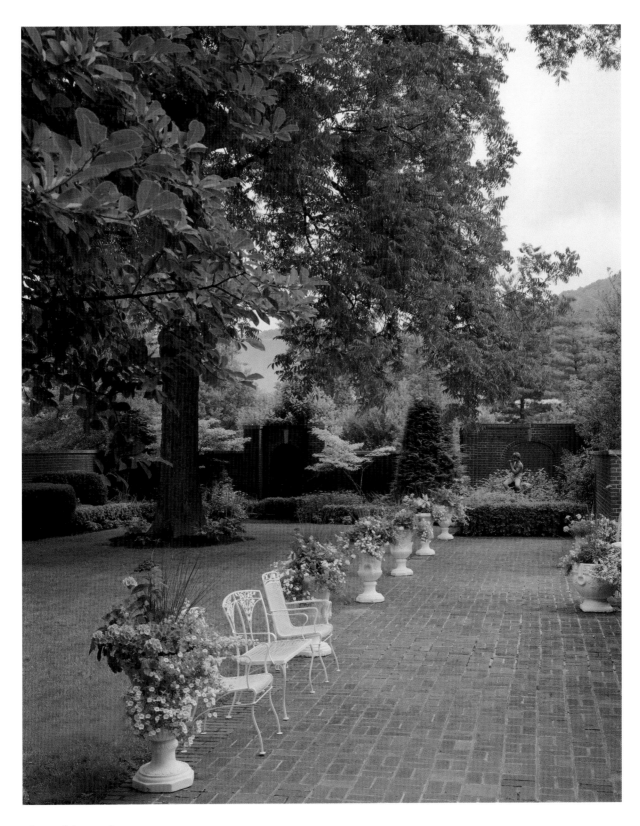

One of the garden areas.

Conclusion

At one time or another, all states face the issue of whether to renovate and restore a governor's mansion or simply to build anew. Controversy abounds, and whenever a final decision is reached, it is not without its naysayers. In most cases, once the new place is completed or the old place restored, the criticism fades and it is only from time to time that one hears lingering sentiments or quiet regrets about the past. Yet while change is inevitable, it is always important to preserve enough of the old to maintain an authentic history of a state and the great traditions that were part of that history.

During the settlement years, states were in the process of establishing their identities, and in creating their unique and elegant governors' mansions, they demonstrated their state's political and social progress. These houses were not experiments; they were established by forward-thinking people with hopes and dreams for the times to come. Their foresight encouraged popular excitement about the mansions because these buildings illustrated confidence in the state's future.

Just as the mansions demonstrated the stake in the future claimed by our forebears, they play a dynamic role at the center of public and private life today. Many great Americans have lived in them. As enduring, existing institutions, they are among the few that provide gravity and ceremony for many important events.

Bibliography

Newspapers

Alabama

Alabama Journal, October 13, 1950; November 26, 1950.
Birmingham News, August 9, 1950; January 14, 1951; May 12, 1963; May 29, 1966.
Clayton Record, November 9, 1972.
Ledger Enquirer, October 3, 1973; November 17, 1977; November 19, 1978.
Mobile Register, February 20, 2000.
Montgomery Advertiser, January 4, 1951; February 2, 1951; May 18, 1959; July 26, 1959;
 October 2, 1965; March 16, 1973; June 1, 2000.
New York Times, March 25, 1997.

Arkansas

Arkansas Democrat, January 1950; January 3, 1965.
Arkansas Democrat Gazette, July 11, 1996; September 6, 1997; July 24, 2002; July 28, 2002.
Arkansas Gazette, January 1, 1950; January 5, 1950; January 15, 1950; October 19, 1987.
Arkansas Times, May 25, 2006.
New York Times, January 15, 1967; June 11, 1967.

Florida

Florida Times, October 30, 1955.
St. Petersburg Times, August 30, 1953; May 31, 1991.
Tallahassee Democrat, January 4, 1949; March 24, 1968; March 28, 1974; December 14, 1980;
 November 21, 1983; December 7, 1986; June 1, 1993.

Georgia

Atlanta Constitution, December 25, 1869; June 25, 1921; January 26, 1964; August 6, 1964; June 6, 1964; November 26, 1964; June 27, 1965; July 3, 1965; June 29, 1967.

Kentucky

Frankfort State Journal, December 4, 1967; December 3, 1972; July 2, 1978.
Kentucky Gazette, July 30, 1996; April 2, 2002.
Lexington Herald-Leader, March 14, 1954; April 18, 1983; October 27, 2002.
Louisville Courier Journal, October 27, 1944; December 5, 1967; June 2, 1968; June 5, 1968; November 14, 1968; July 13, 1969; March 19, 1972; October 17, 1972; November 24, 1972; June 13, 1980; March 12, 1981; June 28, 1981; September 29, 1981; August 6, 1982; August 22, 1982; September 23, 1982; September 28, 1982; May 15, 1983; November 27, 1988.

Louisiana

New Orleans Item Tribune, June 1, 1930.

Mississippi

Atlanta Constitution, July 26, 2001.
Biloxi and Gulfport Daily Herald, "Know Your State," by Ray M. Thompson, 1963 (no month).
Commercial Dispatch, April 14, 1986.
Daily Clarion Ledger, April 16, 1908; September 24, 1961; April 9, 1968.
Jackson Daily News, September 20, 1961; June 8, 1975; December 2, 1984.
Northside Sun, June 25, 1987.
Union Appeal, August 24, 1983.

Tennessee

Knoxville News Sentinel, June 15, 1980.
Nashville Tennessean, November 25, 1948; July 4, 2005; December 20, 2006.

Texas

Austin American Statesman, March 10, 1895; June 18, 1931; July 9, 1932; February 28, 1937; August 4, 1954; August 25, 1954; August 12, 1956; May 7, 1959; August 27, 1961; September 13, 1966; April 7, 1968; August 30, 2007.

Corpus Christi Caller-Times, January 16, 1963.
Dallas Morning News, May 26, 1960; June 3, 1963; March 20, 1966; March 22, 1966; March 23, 1966, March 26, 1966.
Dallas Times Herald, January 13, 1963.
Houston Chronicle, September 25, 1936; December 33, 1936; March 1, 1964; August 20, 1975.
Houston Post, June 12, 1932; September 15, 1958.
New York Times, October 23, 1932.
On Campus, May 10, 1976.
San Antonio Express, July 9, 1932.
San Antonio Light, January 3, 1982.

Virginia

New York Times, January 4, 1999.
Richmond News Leader, February 22, 1988.
Richmond Times, August 1, 1998.

West Virginia

Bluefield Daily Telegraph, June 4, 1987.
Charleston Daily Mail, June 19, 1932; October 24, 1977; December 13, 1978; June 3, 1987.
Charleston Gazette, March 3, 1966; November 28, 1979; February 22, 2005.
Huntington Advertiser, March 31, 1924.
Inter-Mountain, September 27, 1985.
Wheeling News-Register, March 14, 1967.

Brochures and Pamphlets

Alabama Governor's Mansion (handout during Riley administration).
Establishment of the Louisiana Governor's Mansion Foundation, Inc., May 8, 1996.
Facts about the Louisiana Governor's Mansion, 1963.
Fort Raleigh. U.S. National Park Service handbook. Washington D.C., series 16, revised 1956.
Georgia Governor's Mansion (brochure during Perdue administration).
Georgia Governor's Mansion Outline for Tour Guides.
Kentucky Governor's Mansion (brochure), 1977.
Kentucky Governor's Mansion (brochure during Brown administration).
Kentucky Governor's Mansion (brochure during several administrations).
Louisiana Governor's Mansion (pamphlet).
Louisiana Governor's Mansion (printout describing connection to Oak Alley).

Louisiana Governor's Mansion Self-Guided Tour (brochure during Foster administration).

Louisiana's Old Governor's Mansion (brochure).

Mississippi Governor's Mansion (brochure during Barbour administration).

North Carolina Executive Mansion (foldout brochure).

South Carolina Governor's Mansion Docent Guide Tour Book.

Tennessee Governor's Mansion (brochure during Dunn administration).

Texas Governor's Mansion (brochure during Smith administration), 1973.

Texas Historical Marker Dedication, 1969.

Texas Report of the Superintendent of Public Buildings and Grounds, 1879–1914, December 1988.

Virginia Executive Mansion's Ceremony of National Historic Landmark Designation, 1989.

Virginia Executive Mansion's Gillette Garden Program Presentation, April 16, 2001.

Virginia Executive Mansion's tour guide outline, 2000.

Virginia's Executive Mansion (booklet), 1965.

Virginia's Executive Mansion (brochure during Warner administration), 2004.

West Virginia (pamphlet from the *Daily Telegraph*).

West Virginia Governor's Mansion (brochure during Rockefeller administration).

West Virginia Governor's Mansion (tour outline).

West Virginia State Capitol, Mansion (brochure during Manchin administration).

West Virginia State Capitol, Mansion (brochure during Wise administration).

References

Abernathy, Thomas P. *From Frontier to Plantation in Tennessee*. Southern Historical Publications, no. 12. University: University of Alabama Press, 1967.

Albornoz, Miguel. *Hernando De Soto: Knight of the Americas*. New York: Franklin Watts, 1986.

Albrecht, A. C. "The Origin and Settlement of Baton Rouge, Louisiana." *Louisiana Historical Quarterly* 28 (1945): 5–68.

Ambler, Charles Henry. *History of West Virginia*. New York: Prentice Hall, 1933.

Andrews, Wayne. *Architecture, Ambition, and Americans*. New York: Free Press, 1978.

Aron, Stephen. *How the West Was Lost*. Baltimore: Johns Hopkins University Press, 1996.

Ashley, Liza. *Thirty Years at the Mansion*, Little Rock, Ark.: August House, 1985.

Ashmore, Harry S. *Arkansas: A Bicentennial History*. New York: W. W. Norton, 1978.

Bakeless, John. *Daniel Boone*. New York: William Morrow, 1939.

Baker, John Milnes, AIA. *American House Styles: A Concise Guide*. New York: W. W. Norton, 2002.

Bishir, Catherine W. *North Carolina Architecture*. Chapel Hill: University of North Carolina Press, 1990.

Bishir, Catherine W., and Marshall Bullock. "Mr. Jones Goes to Richmond: A Note on the Influence of Alexander Parris' Wickham House." *Journal of the Society of Architectural Historians* 43 (March 1984): 71–74.

Bistany, Judy. "The People's House." *South Carolina Homes and Gardens,* September–October 2001, 58–69.

Burchard, John, and Albert Bush-Brown. *The Architecture of America: A Social and Cultural History.* Boston: Little, Brown, 1961.

Bushong, William B. "A. G. Bauer: North Carolina's New South Architect." *North Carolina Historical Review* 60, no. 3 (July 1983): 304–32.

———— . *North Carolina's Executive Mansion.* Raleigh, N.C.: Executive Mansion Fine Arts Committee and Executive Mansion Fund, 1991.

Cain, Helen, and Anne D. Czarniecki. *An Illustrated Guide to the Mississippi Governor's Mansion.* Jackson: University Press of Mississippi, 1984.

Calhoun, H. M. "Twixt North and South: 1866–1933." Franklin, W.Va.: McCoy Publishing, 1974.

Calvert, Robert A., Arnoldo De Leon, and Gregg Cantrell. *The History of Texas.* 3d ed. Wheeling, Ill.: Harlan Davidson, 1990.

Cantrell, Gregg. *Stephen F. Austin: Empresario of Texas.* New Haven: Yale University Press, 1999.

Carson, Barbara. *The Governor's Palace.* Williamsburg, Va.: Colonial Williamsburg Foundation, 1987.

Caruso, John Anthony. *The Southern Frontier.* New York: Bobbs-Merrill, 1963.

Chinn, George Morgan. *Kentucky Settlement and Statehood, 1750-1800.* Frankfort: Kentucky Historical Society, 1975.

Clark, Thomas D. *A History of Kentucky.* New York: Prentice Hall, 1937.

Clark, Thomas D., and Margaret A. Lane. *The People's House: Governor's Mansions of Kentucky.* Lexington: University Press of Kentucky, 2002.

Chiles, Rhea, ed. *700 North Adams Street.* Tallahassee: Florida Governor's Mansion Foundation, 1997.

Coker, William S., and Jerrell H. Shofner. *Florida from the Beginning to 1992.* Mission Viejo, Calif.: Pioneer Publications, 1991.

Coleman, Kenneth. *Colonial Georgia: A History.* New York: Charles Scribners and Sons, 1976.

Collins, Richard. *History of Kentucky.* Covington, Ky.: Collins, 1882.

Connally, Ernest A. "Architecture at the End of the South." *Central Texas: Journal of the Society of Architectural Historians* 11, p. 4.

Conte, Andrea, and Tennessee Arts Commission. *The Tennessee Residence: Memories of the Past, Visions of the Future.* Documentary DVD, Bredesen administration, 2005.

Cook, James F. *Carl Sanders: Spokesman of the New South.* Macon, Ga.: Mercer University Press, 1993.

Coulter, E. Merton. *A Short History of Georgia.* Chapel Hill: University of North Carolina Press, 1933.

Daniel, Jean Houston, and Price Daniel. *Executive Mansions and Capitols of America.* Waukesha, Wis.: Country Beautiful, 1969.

Daniel, Jean Houston, Price Daniel, and Dorothy Blodgett. *The Texas Governor's Mansion.* Austin: Texas State Library and Archives Commission and Sam Houston Regional

Library and Research Center, 1984.

Dowdey, Clifford. *The Virginia Dynasties: The Emergence of "King" Carter and the Golden Age.* Boston: Little, Brown, 1969.

Duncan, Fannie Casseday. *When Kentucky Was Young.* Louisville, Ky.: John P. Morton, 1928.

Echols, Gordon. *Early Texas Architecture.* Fort Worth, Tex.: Texas Christian University Press, 2000.

Fay, Hempstead. *Pictorial History of Arkansas: From Earliest Times to the Year 1890.* St. Louis: N. D. Thompson, 1890.

Fehrenbach, T. R. *Lone Star: A History of Texas and the Texans.* New York: Macmillan, 1968.

Ferguson, Ernest B. *Ashes of Glory.* New York: Alfred A. Knopf, 1996.

Gannon, Michael. *Florida: A Short History.* Rev. ed. Gainesville: University Press of Florida, 2003.

Garrett, Franklin M. *Atlanta and Environs: A Chronicle of Its People and Events.* Vols. 1 and 2. 1954. Reprint, Athens: University of Georgia Press, 1969.

Godwin, Katherine. *Living in a Legacy: Virginia's Executive Mansion.* Richmond, Va.: State Chamber of Commerce, 1977.

Gordon, Alice, Jerry Camarillo Dunn Jr., and Mel White. *The Smithsonian Guides to Historic America: Texas and the Arkansas River Valley.* New York: Stewart, Tabori, and Chang, 1990.

Gordon, Elisabeth K. *Florida's Colonial Architectural Heritage.* Gainesville: University Press of Florida, 2002.

The Governor's Executive Mansion. 6th ed. Raleigh, N.C.: Executive Mansion Fine Arts Committee and the Executive Mansion Fund, 1993.

The Governor's Mansion: A Pictorial History. Jackson: Mississippi Executive Mansion Commission, 1975.

The Governor's Mansion of Texas: A Tour of Texas' Most Historic Home. Austin: Friends of the Governor's Mansion, 1997.

Gray, Daniel Savage. *Alabama: A Place, a People, a Point of View.* Dubuque, Iowa: Kendall/Hunt, 1977.

Griffith, Lucille. *Alabama: A Documentary History to 1900.* University: University of Alabama Press, 1968.

Hale, John P. *Trans-Allegheny Pioneers: Historical Sketches.* Bowie, Md.: Heritage Books, 1988.

Hamlin, Talbot. *Greek Revival Architecture in America.* New York: Dover Publications, 1944.

Harrisse, Henry. *The Discovery of North America: A Critical Documentary and Historical Investigation.* 1892. Reprint, Amsterdam: N. Israel, 1961.

Hatton, Hap. *Tropical Splendor.* New York: Alfred A. Knopf, 1987.

Herndon, Dallas T. *Why Little Rock Was Born.* Little Rock: Arkansas History Commission, 1933.

Huber, Leonard V. *Louisiana: A Pictorial History.* Baton Rouge: Louisiana Governor's Mansion Foundation, 2003.

Hudson, Patricia, and Sandra L. Ballard. *The Smithsonian Guides to Historic America: The Carolinas and the Appalachian States.* New York: Stewart, Tabori, and Chang, 1998.

Huston, Charles G. F. *Journal of the Alleghenies* (Marshall University, Huntington, W.V.), fall–winter 1963–1964.

James, D'Arcy. "The Hogg Family." *Texas Parks and Wildlife,* August 1974, 3–10.

Kastor, Peter J. *The Great Acquisition: An Introduction to the Louisiana Purchase.* Great Falls, Mont.: Lewis and Clark Interpretative Association, 2003.

Katz, Ron. *French America: French Architecture from Colonization to the Birth of a Nation.* New York: Editions Didier Millet and French Heritage Society, 2004.

Keating, Cathy. *Our Governors' Mansions.* New York: Harry N. Abrams, 1997.

Kimball, Fiske. *The Capitol of Virginia: A Landmark of American Architecture.* Richmond: Library of Virginia, 1989.

Kornbluth, Jesse. "Executive Order: The Tennessee Residence of Governor and Mrs. Lamar Alexander." *Town and Country Magazine,* December 1985.

Lander, Ernest M., Jr., and Robert K. Ackerman, eds. *Perspectives in South Carolina History: The First 300 Years.* Columbia: University of South Carolina Press, 1973.

Lane, Mills. *Architecture of the Old South.* New York: Abbeville Press, 1993.

——— . *Architecture of the Old South: Mississippi and Alabama.* New York: Abbeville Press, Beehive Press, 1989.

Lefler, Hugh Talmage, and Albert Ray Newsome. *The History of a Southern State: North Carolina.* Chapel Hill: University of North Carolina Press, 1973.

Lofaro, Michael A. *Daniel Boone: An American Life.* Lexington: University Press of Kentucky, 2003.

Logan, William Bryant, and Vance Muse. *The Smithsonian Guides to Historic America: The Deep South.* New York: Stewart, Tabori, and Chang, 1989.

McAlester, Virginia, and Lee McAlester. *A Field Guide to America's Historic Neighborhoods and Museum Houses: The Western States.* New York: Alfred A. Knopf, 1998.

McBride, Robert. "The Historical Enrichment of the Governor's Residence." *Tennessee Historical Quarterly* 30, no. 2 (summer 1971): 215–19.

McElroy, Robert McNutt. *Kentucky in the Nation's History.* New York: Moffat, Yard, 1909.

McLemore, Richard A., ed. *A History of Mississippi.* Vol. 1. Hattiesburg: University and College Press of Mississippi, 1973.

Meadows, Denis. *Five Remarkable Englishmen: A New Look at the Lives and Times of Walter Ralegh, Captain John Smith, John Winthrop, William Penn, James Oglethorpe.* New York: Devin-Adair, 1961.

Menton, Jane A. *The Grove: A Florida Home through Seven Generations.* Tallahassee: Sentry Press, 1999.

Meynard, Virginia G., comp. "Governor's Mansion Scrapbooks." [Microfilmed newspaper articles and interviews about South Carolina governor's mansion.] Vols. 1–6, 1868–1955. Archives at the Caldwell-Boylston House, Columbia, South Carolina.

Milanich, Jerald T. *Laboring in the Fields of the Land.* Washington: Smithsonian Institution Press, 1999.

Moore, Albert B. *History of Alabama.* University: Alabama Book Store, 1934.

Morris, Allen, and Joan Perry. *The Florida Handbook.* Tallahassee: Peninsula Publishing, 2001.

Muhlstein, Anka. *LaSalle: Explorer of the North American Frontier.* New York: Arcade Publishing, 1992.

Mullins, Lisa C., ed. *The Southern Tradition.* The Architectural Treasures of Early America. Harrisburg, Pa.: National Historical Society, 1988.

Newcomb, Rexford. *Old Kentucky Architecture.* New York: William Helburn, 1940.

Parker, John H. *A Concise Dictionary of Architectural Terms.* New York: Dover Publications, 2004.

Parker, P. J. "Timeless Treasures: Within the Governor's Mansion." *From House to Home: Tallassee's Home and Design Magazine,* October–November 2004, 24–27.

Patrick, Rembert W. *Florida under Five Flags.* Gainesville: University of Florida Press, 1960.

Phillips, Margaret I. *The Governors of Tennessee.* Gretna, La.: Pelican Publishing, 1978.

Pierson, William H., Jr. *American Buildings and Their Architects.* New York: Doubleday, 1978.

Price, David A. *Love and Hate in Jamestown.* New York: Alfred A. Knopf, 1996.

Prioli, Carmine Andrew. "The 'Indian Princess' and the Architect: Origin of a North Carolina Legend." *North Carolina Historical Review* 60, no. 3 (1983): 283–303.

Pusey, William Allen. *The Wilderness Road to Kentucky.* New York: George H. Doran, 1921.

"A Regal Setting for Our Best Known Mansion." *Austin Chamber of Commerce* 9, no. 2 (July 1967).

Rice, Otis K. *West Virginia: A History.* Lexington, Ky.: University Press of Kentucky, 1985.

Richard, Charles. *A Place Worth Preserving.* Baton Rouge: Louisiana Governor's Mansion Foundation, 2004.

Ross, Margaret. *The Quapaw Quarter: A Guide to Little Rock's Nineteenth-Century Neighborhoods.* Ed. Thomas E. Wilkes. Little Rock, Ark.: Quapaw Quarter Association, 1976.

Rubin, Nancy. *American Empress: The Life and Times of Marjorie Merriweather Post.* New York: Villard, 1995.

Sansing, David G., and Carroll Waller. *A History of the Mississippi Governor's Mansion.* Jackson: University Press of Mississippi, 1977.

Seale, William. *The Kentucky Governor's Mansion: A Restoration.* Louisville, Ky.: Harmony House, 1984.

——— . *Virginia's Executive Mansion.* Richmond: Virginia State Library and Archives, 1988.

Severens, Kenneth. *Southern Architecture.* New York: E. P. Dutton, 1981.

Sherrer, John M., III, and Lynn Robertson. *The Governor's Mansion of South Carolina, 1855–2001.* Columbia, S.C.: Governor's Mansion Commission, 2002.

Sloan, Samuel. *Sloan's Victorian Buildings.* New York: Dover Publications, 1980.

Tallmadge, Thomas E. *The Story of Architecture in America.* New York: W. W. Norton, 1927.

Tebeau, Charlton W. *A History of Florida.* Miami: University of Miami Press, 1971.

Thompson, George H. *Arkansas and Reconstruction.* Port Washington, N.Y.: Kennikat Press, 1976.

Uguccioni, Ellen J. *First Families in Residence: Life at the Florida Governor's Mansion.* [Tallahassee]: Florida Governor's Mansion Foundation, 2006.

Wallace, David Duncan. *South Carolina: A Short History, 1520–1948.* Columbia: University of South Carolina Press, 1951.

Williams, Henry L., and Ottalie K. Williams. *Great Houses of America.* New York: G. P. Putnam's and Sons, 1966.

Williams, John Alexander. *West Virginia: A Bicentennial History.* New York: W. W. Norton, 1976.

Williams, Lindsey, and U. S. Cleveland. *Our Fascinating Past.* Punta Gorda, Fla.: Charlotte Harbor Area Historical Society, 1993.

Williamson, Roxanne K. *Austin, Texas: An American Architectural History.* San Antonio, Tex.: Trinity University Press, 1973.

Wills, Ridley, II. *Tennessee Governors at Home.* Franklin, Tenn.: Hillsboro Press, 1999.

Winsberg, Morton D. *Florida's History through Its Places: Properties in the National Register of Historic Places.* Gainesville: University Press of Florida, 1995.

Yetter, George H. *Williamsburg Before and After: The Rebirth of Virginia's Colonial Capital.* Williamsburg, Va.: Colonial Williamsburg Foundation, 1988.

Index

Varney, Carleton, 196
Versailles Palace, 65, 67
Victorian Picturesque architectural style, 158
Victorian style, 109, 112, 161, 162
Virginia: in American Revolution, 182; architectural landmarks in, 182; capitals of, 173, 174; capitol building of, 176; Capitol Square in Richmond, 176, 177; in Civil War, 141, 176, 178, 192; Colonial Williamsburg in, 35, 62, 66, 174, 175, 177, 179; colony of, 173–74, 192; as commonwealth, 60; Jamestown colony in, 105, 173, 192; and Kentucky County, 60; naming of, 173; Native Americans in, 173; Reconstruction in, 178; and Roanoke Island, 105, 173; statehood for, 3. *See also* specific governors
The Virginia Dynasties (Dowdey), 174
Virginia governor's mansion: architects and architectural style of, 2, 172, 175–81; ballrooms in, 178, 180, *187;* in colonial era, 2; construction date of, 2, 3, 172, 176, *184;* cost of, 172, 176, 180; dining room in, 178, 179, 180, 181, *187, 188–89;* front door entrance in, *18;* front view of, 177, *184;* furniture in, 172, 178, 181, *185–89;* garden and grounds of, 176, 181–82, *190;* Governor's Palace (1911), 107*n*3; Jefferson's proposed design for, 2, 46; Ladies' Parlor in, 181, *186;* location of, 172, 176; Mount Vernon in, 20, 147, 182; as National Historic Landmark, 2, 93, 172; in National Register of Historic Places, 93, 172; as oldest governor's residence, 2, 176, *184;* outbuildings of, 181, 182; painting in, 179, *189;* preservation of, 180–81; renovations of, 178–82; side entrance with outdoor patio of, *183;* size of, 172; South entrance of, *190;* staircases in, 179, *187*
Virginia's Executive Mansion (Seale), 177

Waldo, Samuel L., 144
Walker, George Edward, 121, 124
Wallace, Cornelia, 9, 10
Wallace, George, 9
Wallace, Luraleen, 9
Waller, Edwin, 154
Waller, Lady Carroll, 97
Wallpaper, 35, 36, *42,* 125, 128, *130*
Ward, Thomas William, 156
War Memorial Building (Nashville, Tenn.), 142
War of 1812, 78–79, 92, 106, 144, 176, 182
Warren, Fuller, 33

Washington, George: bronze bust of, 48; equestrian statue of, in Richmond, Va., 176, 177; and Mount Vernon, 20, 147, 182; portrait of, 49; and Tennessee territory, 141
Weber, C. C., 64
Weber, E. A., 64
Weber, Werner and Adkins architectural firm, 64
Weber Brothers architectural firm, 59, 64
Webster, Noah, 129
Weiss, Dreyfous and Seiferth architectural firm, 79
Welty, Eudora, 93
West Virginia: Boone in, 61; capitals of, 192–93; capitol building in, 193–94, 196; Civil War in, 177, 192; statehood for, 3, 177, 192. *See also* specific governors
West Virginia governor's mansion: architect and architectural style of, 191, 193–94; ballroom in, 195, *200;* brass door knocker on front door of, 194; chandeliers in, 195, *198–201;* construction date of, 2, 3, 191; cost of, 191, 193, 195, 196; dining room in, 195; drawing room in, 195; first governor's mansion, 193, 194; front view of, *202;* furniture in, 191, 195–96, *198–201;* gardens and grounds of, 194, 196, *197, 203;* grand foyer in, 195, *198–99;* library in, 195, *201;* location of, 191; preservation of, 195; renovation in, 195–96; side view and entrance of, *197;* size of, 191; staircases in, 194, *198–99*
West Virginia Mansion Preservation Foundation, 195
Wheeling, W.Va., 192
White, Frank, 21
White House: as advisor for construction of West Virginia governor's mansion, 194; as advisor for Virginia governor's mansion renovation, 179; curators of, 110, 161; Diplomatic Reception Room in, 128; Fine Arts Committee for, 3, 160; and Edward Vason Jones, 96; and Jacqueline Kennedy, 3, 35, 110, 160, 195; Louisiana Old Governor's Mansion compared with, 79; Zuber wallpaper for, 35, 128
Whitney, Eli, 45–46
Wickham House (Richmond, Va.), 106–7, 107*n*3, 175
Wilder, Douglas, 180
Wilderness Road, 60
William, King of England, 173–74
Williams, Jim, 49–50